Remnants of 1981 surround us. Many of us still have some yellow ribbon around the house. There is a crisp paper flag stuck in a vase on top of the TV. Sis has ticket stubs from a Rolling Stones concert still hanging on her mirror. Uncle Jake is carrying some unused baseball tickets in his billfold. Brother covered his walls with posters of Brooke Shields. Mom clips everything she can find on the Polish Solidarity story. Some members of her family are steel workers in Gdansk. Aunt Jeannie bores us with two subjects of conversation: Nancy Reagan's wardrobe and Princess Diana's wardrobe. She keeps scrapbooks of pictures of famous women.

Teddy is collecting plastic models of the space shuttle and Freddy collects high scores on the video games at the shopping mall.

Uncle Rob tells anyone who will listen about the starving children of the world. Last Sunday he put a ten dollar bill in the plate at church. He was told it would buy milk for one infant for one week. He said the pictures of the children made him weep.

Dad told him to save his money; that we are coming into hard times. But then he is upset too; he expects to be laid off from work next week.

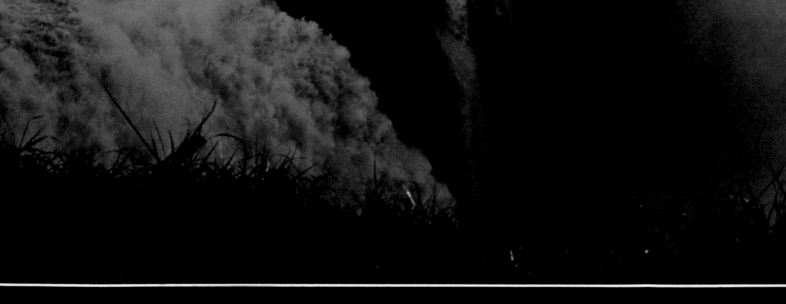

THE BEST OF
PHOTOJOURNALISM/7

An annual based on the 39th Pictures of the Year competition
sponsored by the National Press Photographers Association,
the University of Missouri School of Journalism
and supported by a grant to the University from Nikon, Inc.

Victoria Falls on the Zambezi River in Zimbabwe, the country once known as Rhodesia.

VEITA JO HAMPTON, editor
 Assistant: William H. Ebersole

BILL KUYKENDALL, designer
 Assistant: Steve Yarbrough

Special assistance: Pete Schropp,
Paula Nelson, Joseph L. Hampton,
Betty and Angus McDougall

Copyright © 1982
National Press Photographers Association
University of Missouri School of Journalism
Columbia, Missouri 65205

Library of Congress Catalogue Number
77-81586

ISBN 0-89471-179-2

Printed and bound in the United States of
America by the Publications Division of
Jostens/American Yearbook, Topeka, Kansas
66609

Distributed by Running Press Book Publishers,
Philadelphia, Pennsylvania. Canadian
representatives: John Wiley & Sons, Canada
Ltd., 22 Worcester Road, Rexdale, Ontario
M9W 1L1. International representatives:
Kaiman & Polon, Inc. 2175 Lemoine Avenue,
Fort Lee, New Jersey 07024. This book may
be ordered directly from Running Press, 125
South Twenty-Second Street, Philadelphia,
Pennsylvania 19103. Please include $1.00 for
postage and handling.

For information concerning the Pictures of the
Year competition, contact Director of POY,
School of Journalism, University of Missouri
Box 838
Columbia, Missouri 65205

*Cover Photograph: After their
wedding Doug and Roseann
Hutchins stopped for dinner
at J.B.'s Big Boy in Logan,
Utah. (page 72)*

FIRST PLACE FEATURE PICTURE, OWEN STAYNER,
HERALD JOURNAL, LOGAN UTAH

SECOND PLACE SPOT NEWS, PHOTOGRAPHER ANONYMOUS, ASSOCIATED PRESS

A gunman wearing an Egyptian army uniform fires an automatic rifle into the reviewing stand October 6, 1981, during an attack that killed Egyptian President Anwar Sadat.

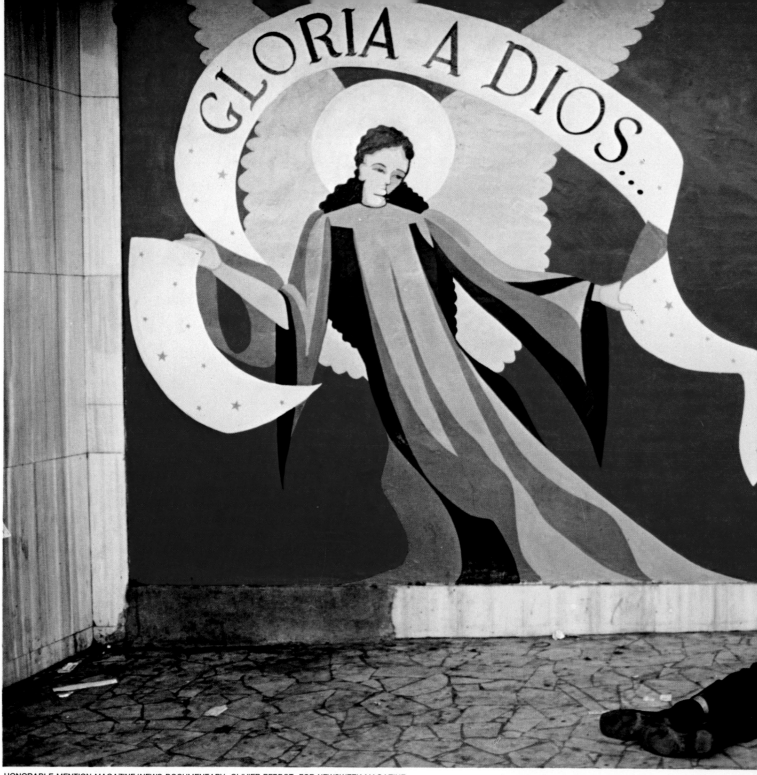

HONORABLE MENTION MAGAZINE/NEWS DOCUMENTARY, OLIVIER REBBOT, FOR NEWSWEEK MAGAZINE

San Francisco Gotera, El Salvador TIME magazine photographer, Harry Mattison inspects the wounds of Olivier Rebbot, Newsweek magazine photographer. Rebbot was shot in the chest by a Leftist guerrilla sniper during one of the daily attacks on the besieged mountain village. He died three weeks later.

"Gloria A Dios" labels a wall painting over the victim of the continuous strife in El Salvador and increases the irony in this combination of pictures — it is one of the last photographs to be made by photojournalist, Olivier Rebbot. A second irony is that Rebbot was wearing an 18-ply "bullet-proof" vest at the time he was shot. He was hit approximately four inches below the collar bone on the right-hand side. These facts prompted the South Florida vest manufacturer to increase the thickness to 27-ply and design fit for the individual.

A third irony is that an autopsy revealed Rebbot was suffering from malaria and a brain tumor which likely prevented the bullet wounds from ever beginning to heal.

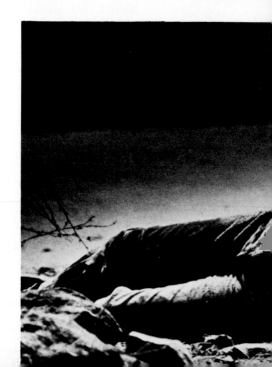

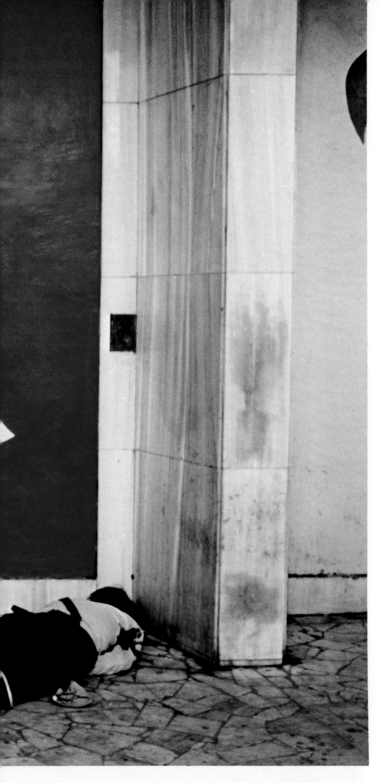

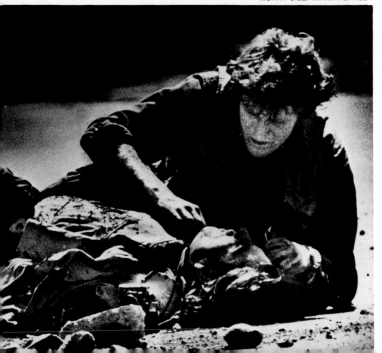

MURRY SILL, MIAMI HERALD

Photojournalists covering war and strife risk danger and death often becoming targets in the world's conflicts

To satisfy the world's hunger for information, photojournalists travel great distances to make pictures. To give the world hope and courage, photojournalists are accepted into the private lives of families convinced that their story will help someone else cope. To help tell the truth about conflict among men and nations, some photojournalists die. Like Olivier Rebbot, some do not return from foreign assignments. Some become subjects of the shooting and that shooting comes from guns, not cameras. The year was one full of shock, despair, paradox, pomp and patriotism ... grim resolution, even amusement at the horror stories in the news. And horror in 1981 did, considerably, outweigh happiness. A numbing series of assassination attempts sobered editors and photojournalists for several days: two presidents and the Pope.
One attempt was successful;
Anwar Sadat is dead.

The space shuttle, Columbia, kaboomed into outer space with astronauts aboard, and returned safely, a technological accomplishment that boosted American pride.

Skywalks fell in a Kansas City hotel and killed 114 people.

While Americans killed, applauded, or rescued each other, and while American photojournalists recorded the strife of other peoples' aim at freedom, drowned bodies of freedom-seeking Haitians washed ashore on the sands of the brave and the free.

The 52 Americans held in Iran for 444 days returned to a glorious yellow-ribboned welcome in a newly developed fervor of
continued to page 8

7

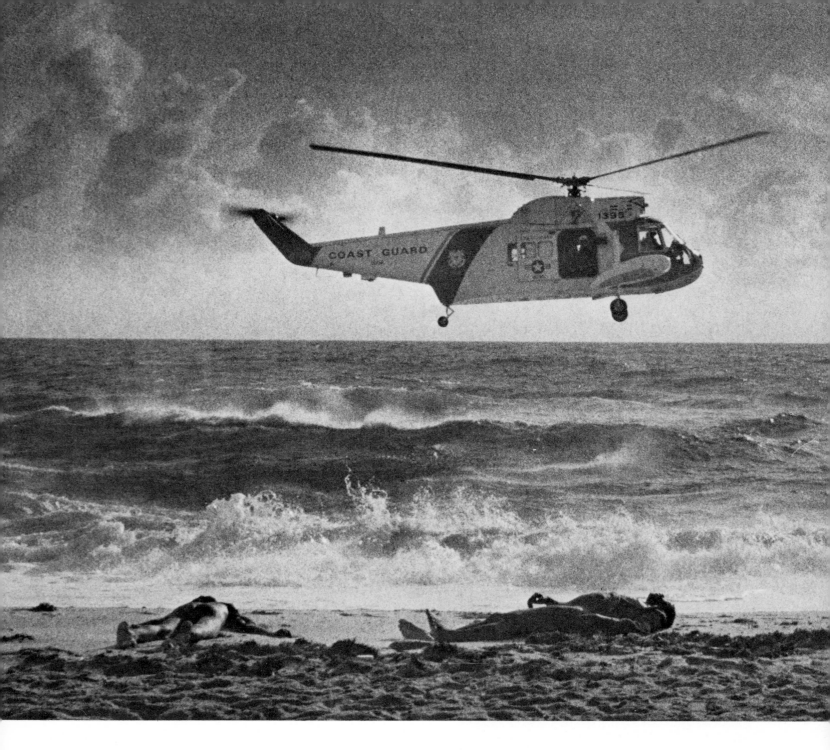

continued from page 7

American patriotism, yet Vietnam veterans continued their quest for a similar welcome and tried, with professional help and family support, to stop fighting the war in their minds.

Children threw rocks at tanks and trucks in Ireland; some even pretended to fight for photographers. In Georgia, 27 children were murdered and no motive for the killings is yet known. In Somalia and Calcutta, children died from lack of food and water. All over the world, teams of medical professionals worked to save lives, especially those born prematurely, and thousands of women chose not to become mothers by aborting their fetuses. In some places, a new interest in midwifery and home-birth allowed small children to watch their own brothers or sisters being born.

A camera is merely glass in a metal box, a mechanical eye. It is a powerful tool and can be used as sword, shield, magnifier, recorder, talisman or status symbol.

A photographer can be a powerful artist or reporter. A photojournalist's responsibility is to interpret, comment and entertain. He is characteristically curious and bold, and often just plain lucky.

A picture is a two dimensional medium. It can be the most useful and effective form of

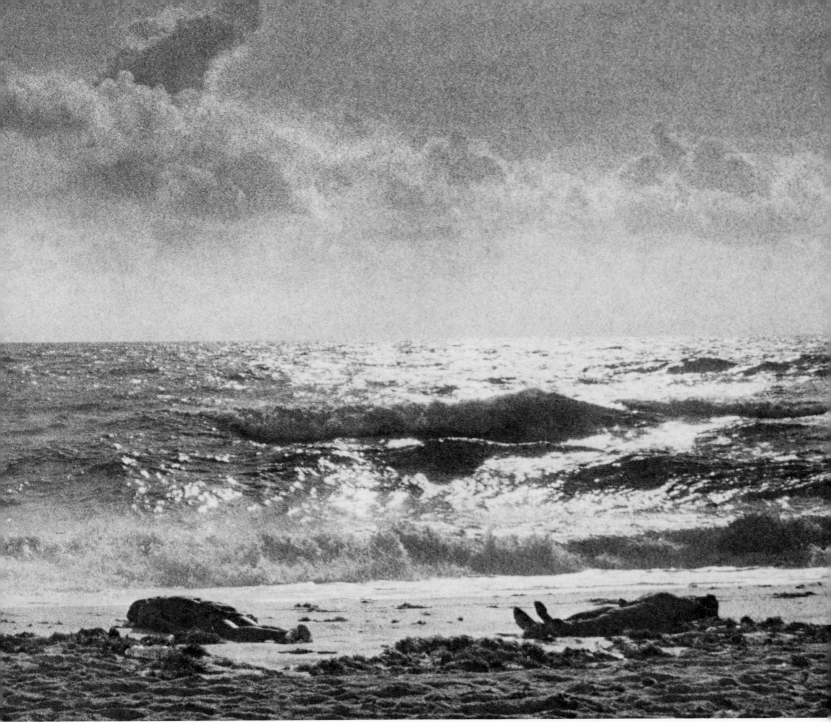

communication available to man and like touch or music universally appeals to the human imagination. Pictures satisfy our need to understand the most simple or complex details of our existence.

Combined with language, photography is the common and necessary means of communicating information to large groups of people.

Photojournalism at its best helps us understand ourselves. It makes us accept the horrors or share the joys of life with other human beings. For these reasons, we love and hate pictures, buy and sell pictures, live and die for the sake of telling stories with pictures.

October 26, 1981
Sixty-seven Haitian refugees aboard a 25-foot fishing boat were on the final leg of their escape to America. Within a hundred yards of shore, the leaky wooden sailboat broke up in the heavy surf. At daybreak, condominium dwellers woke to the sight of 33 Haitian bodies scattered along the Florida beach at Hillsboro.

"Only God is immortal"'

ROBERT AZZI, WOODFIN CAMP & ASSOCIATES, NEW YORK

Newsweek used a tightly cropped version of this picture of Sadat taken in 1975. A write-up on the photograph in American Photographer (March 1982) explained that at the time the Sinai had just been returned to Egypt. It was decided to shoot on location. "Discounting the time it took to sweep the area for land mines, the entire session took ten minutes." Robert Azzi said, "Sadat was a natural actor; he loved cameras. He had a view of himself in destiny, and he used the medium to convey that." Newsweek said Sadat was a man who "took risks . . . that virtually no world leader took him seriously when he succeeded Nassar in 1970 . . ." Anwar Sadat

was born on Christmas Day, 1918, and died October 6, 1981, the anniversary of the 1973 day when Egypt crossed the Suez Canal.

Newsweek used the pictures by Kevin Fleming who was on assignment for National Geographic at the time Sadat was assassinated. Fleming was 25 yards away from Sadat when the attack began. Soldiers tried to keep him away. Fleming said he would make a picture, put the camera behind his back and move on. "Because I had on a coat and tie and was carrying only two cameras, I looked like everyone else in the reviewing stand." His film was immediately released for publication and

appeared in some 15 magazines including Newsweek. It was his second foreign assignment for National Geographic.

Elegant, courageous and visionary, Anwar Sadat shared the 1978 Nobel Peace Prize with Menachem Begin of Israel. He was buried at the spot of this salute, the tomb of the unknown soldier in Cairo. Three years before his death, he had written his own epitaph. The words on the black marble tombstone, read, "President Mohammed Anwar Sadat, hero of war and peace. He lived for peace and was martyred or his principles."

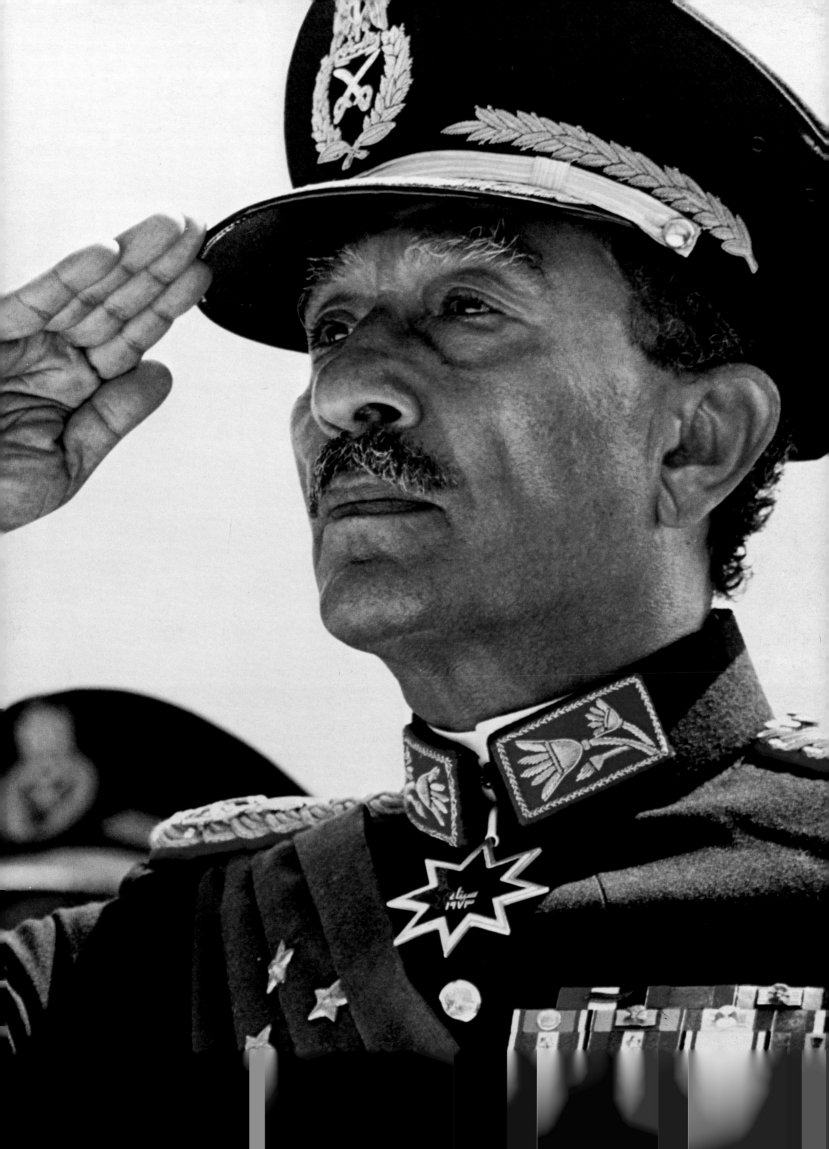

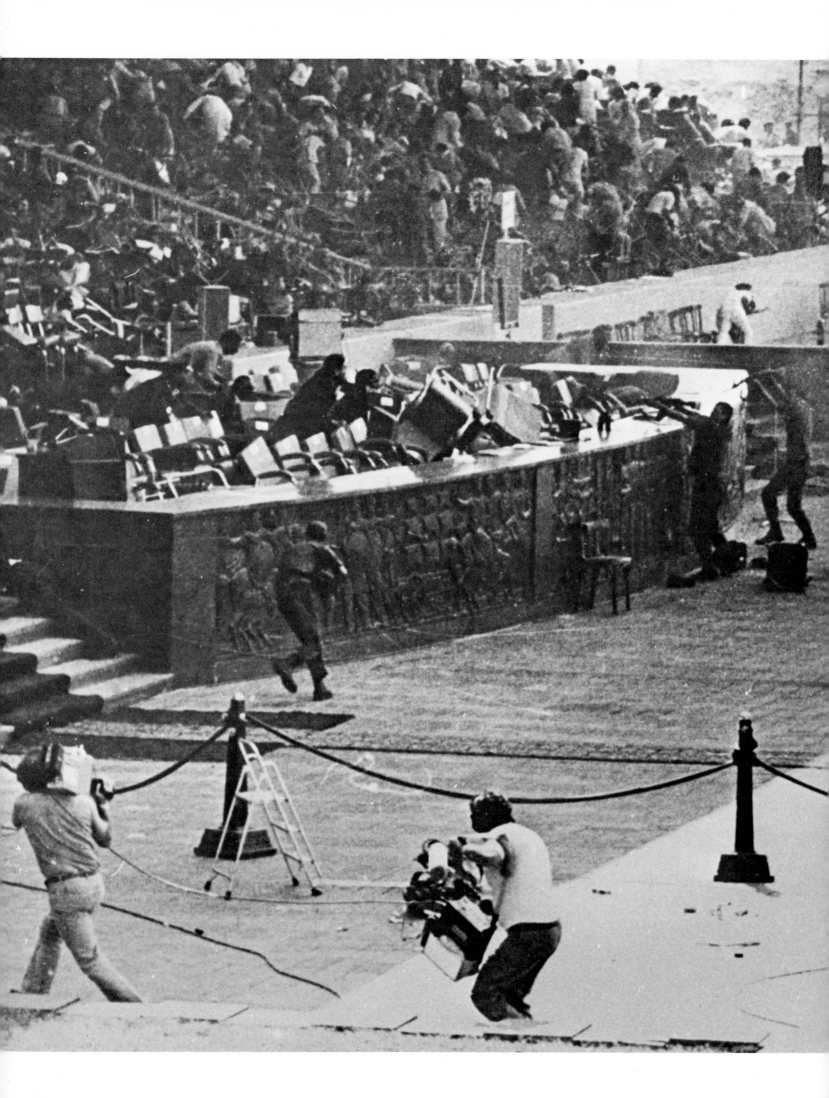

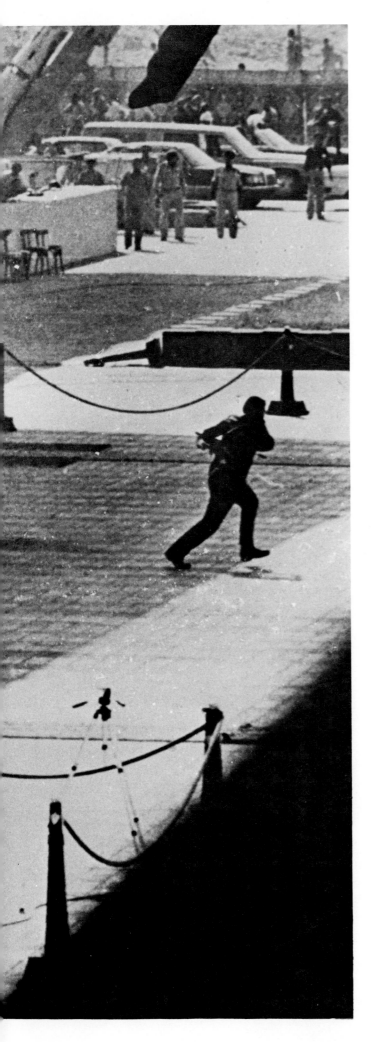

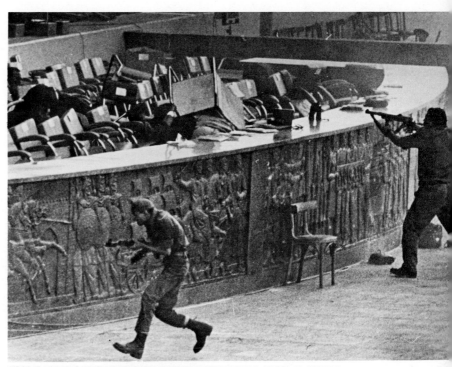

FIRST PLACE MAGAZINE NEWS/DOCUMENTARY, MAKRAM GADEL KARIM, AL AKHBAR
GAMMA LIAISON FOR TIME MAGAZINE (BOTH PHOTOS)

In Cairo, Makram Gadel Karim is known as "the crazy man" for having continued to take pictures during the October, 1973 war between Egypt and Israel when bombs were exploding all around him. In October of 1981, Karim was covering the Egyptian military parade where Sadat was assassinated by four Muslim fanatics who heaved grenades and fired automatic weapons into the reviewing stand. In the bloody jungle of chairs, seven besides Sadat were dead or dying. At least 28 others were wounded.

Karim's pictures were used in both TIME and LIFE magazines, providing readers with one of the most horrifying visual reports recorded of Sadat's assassination. One judge said that Karim's pictures re-emphasized the helplessness felt by witnesses to such events, a feeling punctuated by seeing so many photographers shooting the scene — unable to alter what was occurring before their cameras.

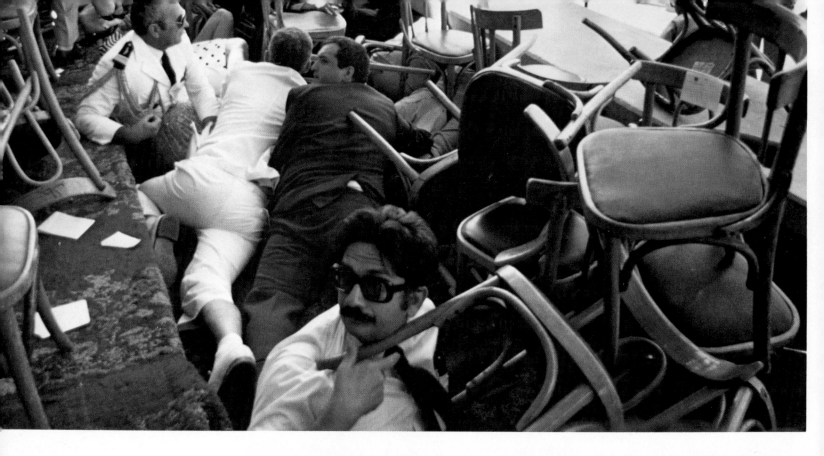

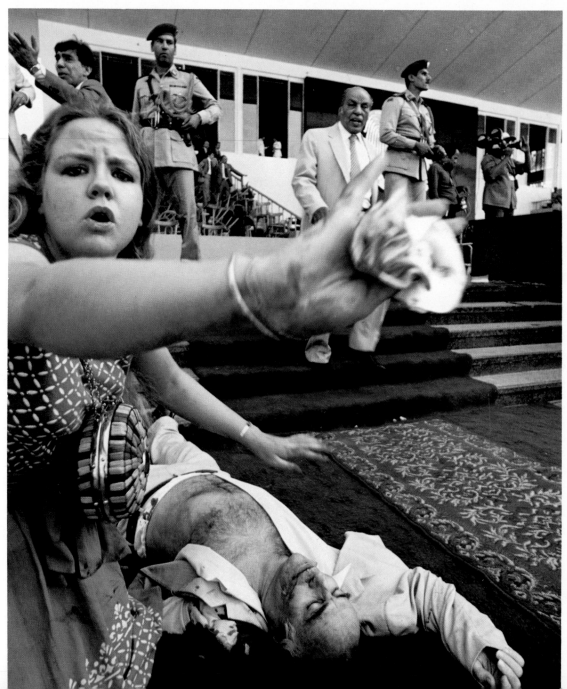

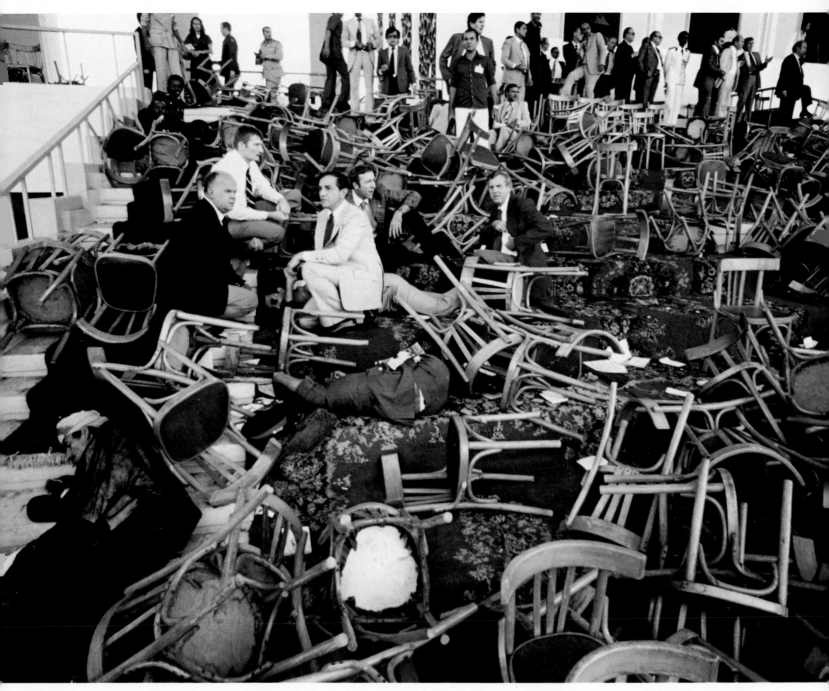

Shielded by an aide, Claude Ruelle, the Belgian Ambassador to Egypt was one of the seriously wounded dignitaries who attended the military parade at which Sadat was assassinated. Many were trapped in the reviewing stand, awaiting medical attention and ambulances among the tumbled chairs after the shootings.

Hundreds of pages of copy were written as to why and how Anwar Sadat was slain. Those who claimed political authority pointed to a group of Islamic fundamentalists led by First Lt. Khaled Ahmed Shawky al Islambouli.

According to Newsweek, the group was outraged by Sadat's admiration of Western ways, his hospitality to the late Shah of Iran and his "entente cordiale" with Israel. A professor at the American University in Cairo said, "Each of the hard-core members is a walking time-bomb, waiting to go off.'

Aware of threats to his life and power, Sadat remained calm. His advisers and the Israelis warned him that he was underestimating those threats. When he attempted to round up his opponents, he did not include any members of his armed forces in the initial crackdown. At the time of the assassination, there was no proof that the lieutenant and the assassins were members of the fanatic society. Nevertheless, they slipped into the ceremonies, stopped a truck in front of the reviewing stand, and killed him.

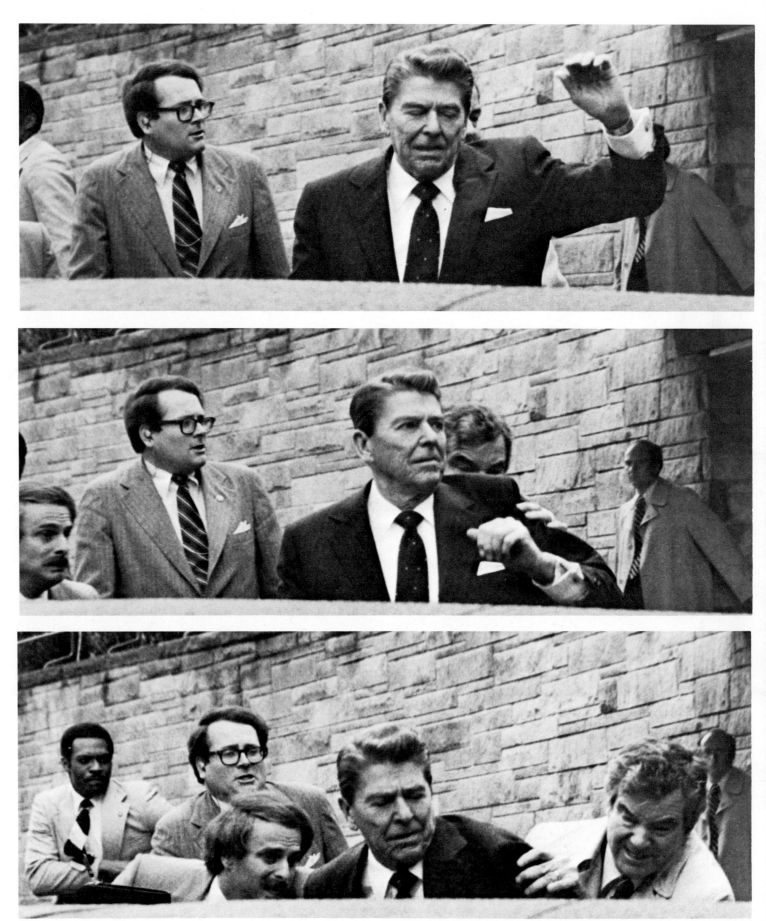

SECOND PLACE NEWS PICTURE STORY, RON EDMONDS, ASSOCIATED PRESS, WASHINGTON D.C.

A day of terrible confusion among editors, writers, photographers and politicians

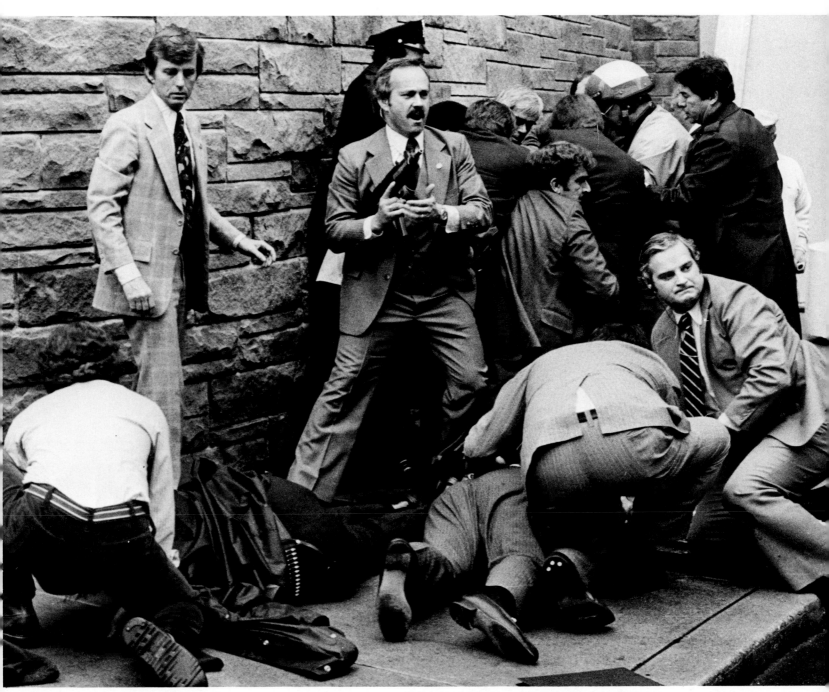

FIRST PLACE SPOT NEWS, DON RYPKA, UNITED PRESS INTERNATIONAL, WASHINGTON, D.C.

The series of photos showing Reagan's reaction to being wounded by gun shots after a routine speech at the Washington Hilton were the only images capturing the President's grimace, a response to what photographer Ron Edmonds and many others thought were merely firecrackers. The pictures were used widely across the nation and in the confusion of the day's events, almost everyone but Edmonds received credit for the series in one fashion or another. Edmonds

had joined AP less than a month before this event and was praised by fellow journalists for his clear thinking and thorough coverage. He said, "you always think it is going to happen someplace else."

Associated Press had about a 30 minute jump on United Press International because a staffer rushed the film back to the bureau. A courier was sent to pick up Don Rypka's film which included the photograph above. Press Secretary James Brady and a

policeman were wounded in the attempt on President Ronald Reagan's life. Both wire services and ABC, CBS and NBC erroneously reported the death of Press Secretary James Brady. Would-be assassin, John Hinckley Jr. was being held by police and agents while the injured awaited assistance. The scene was replayed in print and on television hundreds of times March 30, 1981 and has become permanently etched in the memories of most Americans.

17

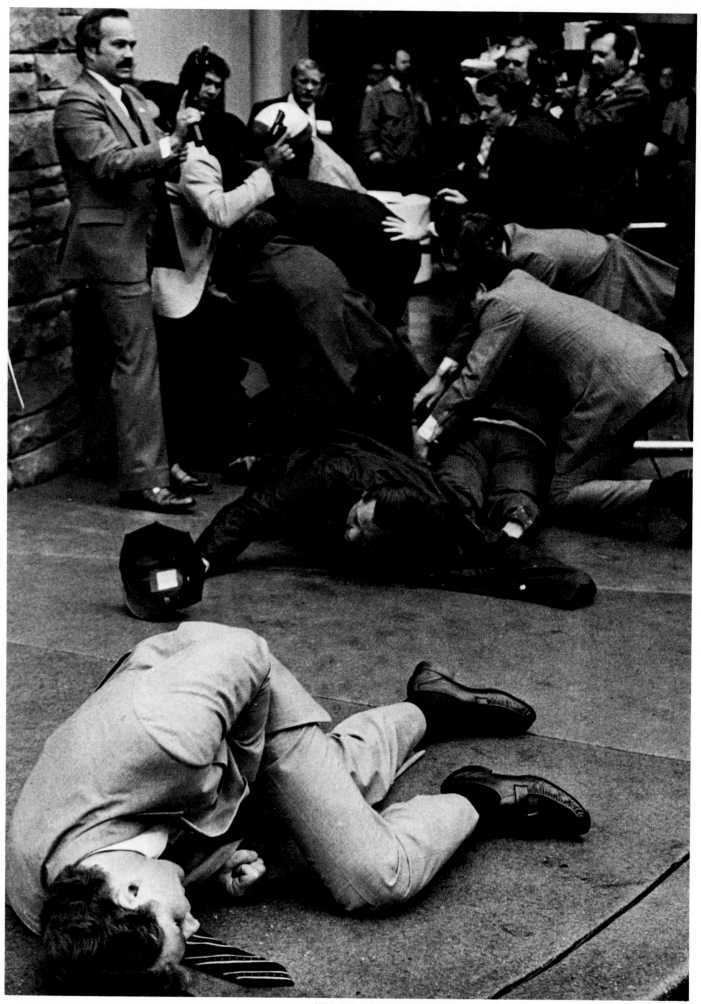

SECOND PLACE NEWS PICTURE STORY, RON EDMONDS, ASSOCIATED PRESS, WASHINGTON, D.C.

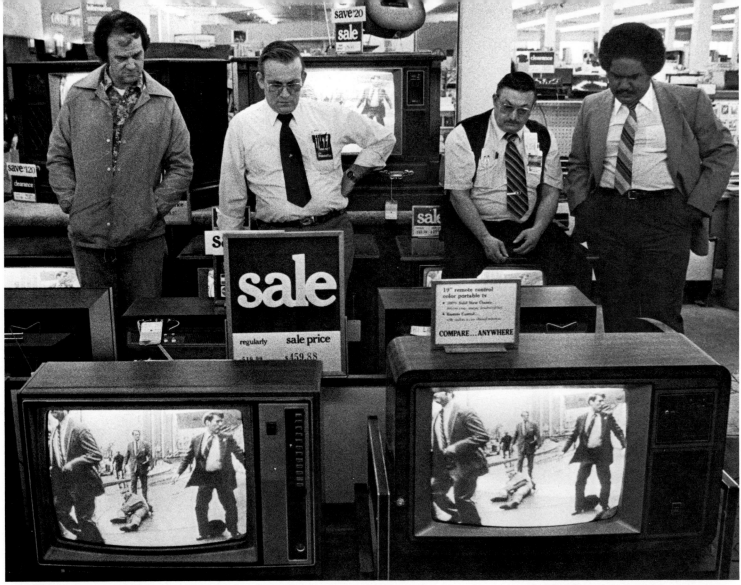

DWIGHT NALE, KANKAKEE (ILL.) DAILY JOURNAL

A secret service agent, a Washington policeman and White House Press Secretary James Brady lay wounded on the sidewalk outside the Washington Hilton March 30, 1981, the day John Hinckley Jr. attempted to assassinate President Ronald Reagan. The August, 1981 News Photographer magazine devoted 11 pages to how news photographers did their jobs that day. It was noted that in this "classic case of coverage," with photographers directly in the line of fire, that the camera became an "invisible shield." The article discussed how photographers deal with unexpected action, danger and stress, elements routine when following a President of the United States.

Employees and customers of a department store in Kankakee, Ill. concentrated on television coverage of the assassination attempt. At least temporarily, the message was more important than the medium.

The picture of the newsboy hawking the message is one of triple irony; John White of the Chicago Sun-Times made the picture of the boy selling the Chicago Tribune.

JOHN H. WHITE, CHICAGO SUN-TIMES

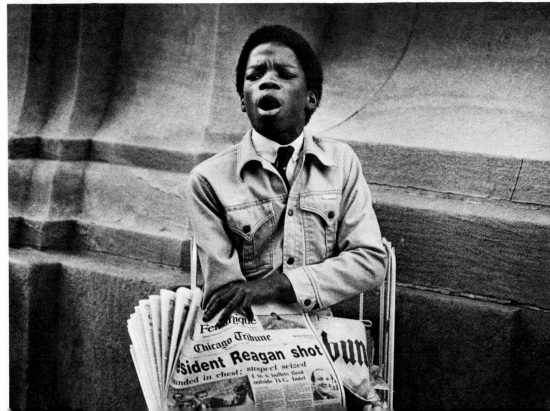

Poland on the brink

First Place
Magazine Published
Picture Story by
Bruno Barbey
LIFE magazine

continued on page 22

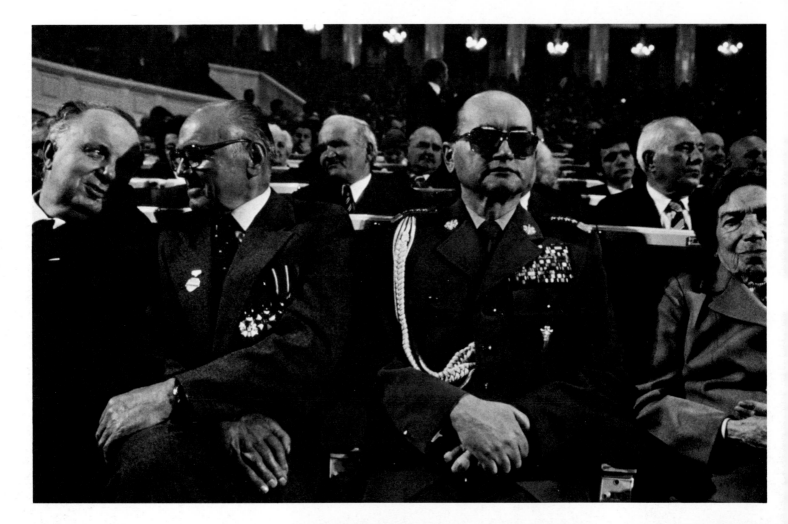

Solidarity in Poland. In spite of the controls of the Communist Party and in support of a better life, the workers' unions in Poland demonstrated the strength of unity in both their appeal for the rights of laborers and their celebration of faith through the Roman Catholic Church. Political tension was high and two half-day shut-downs in March and October added to the turmoil and brought more threats of Soviet aggression. Within the Communist ranks, there was great change as Polish party boss Stanislaw Kania was replaced by General Wojciech Jaruzelski (center, above) who here, was among officials gathered at Warsaw's Cultural Palace. In eight months, he rose from Poland's premier to party head. Wearing both Polish and American flags, as well as the pin of the Black Virgin, Lech Walesa jokes with members of the Solidarity Congress in Gdansk. Shortages of bread, gas, meat, even vodka and toilet paper, were endured by the Polish people in spite of the unusual freedoms and concessions gained by the efforts of the Solidarity movement.

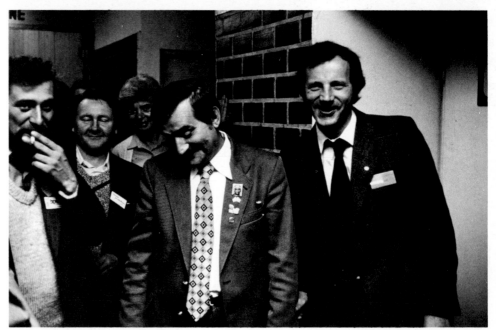

FIRST PLACE MAGAZINE PUBLISHED PICTURE STORY, BRUNO BARBEY/MAGNUM FOR LIFE MAGAZINE (ALL PHOTOS)

Odonowa. The word means renewal. That was the theme of the LIFE coverage on Poland by French photographer, Bruno Barbey, who spent much of the year documenting the situation in Poland. With ten million members, Solidarity had survived under the leadership of Walesa against the Soviet-controlled regime in Warsaw.

The Gdansk monument honors strikers killed in 1970. The Gdansk agreement which created the independent unions in August, 1980, keeps the Soviets nervous because Solidarity has become the third largest power center in Poland. One power is the party; the other is the Roman Catholic Church.

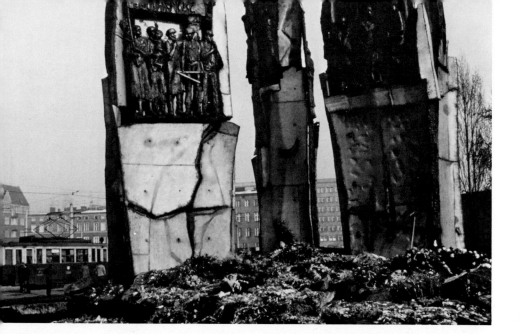

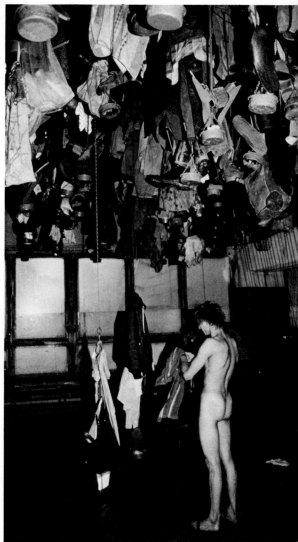

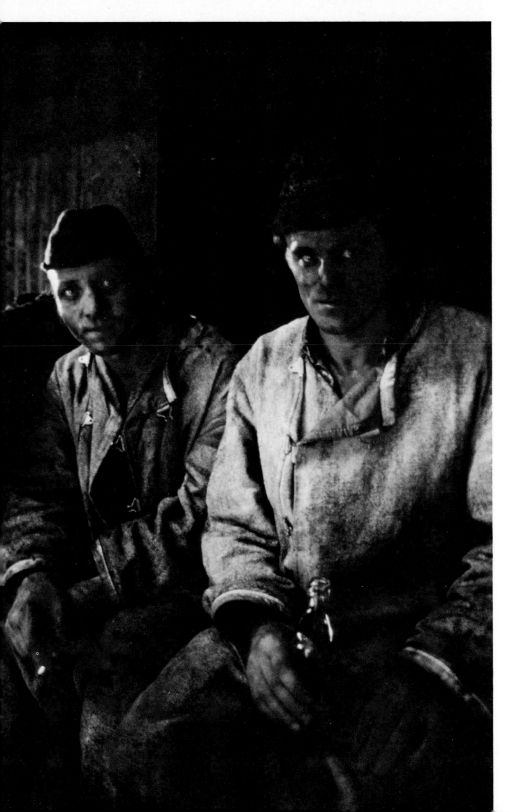

Coal miners, steel workers and farmers are volatile labor forces in Poland's shaky economy. The country has been held at a near, economic standstill by huge debts to the West, the unavailability of parts and fuel, general mismanagement of funds and products, poor weather for farming and, of course, the strife between laborers and the party bigwigs.

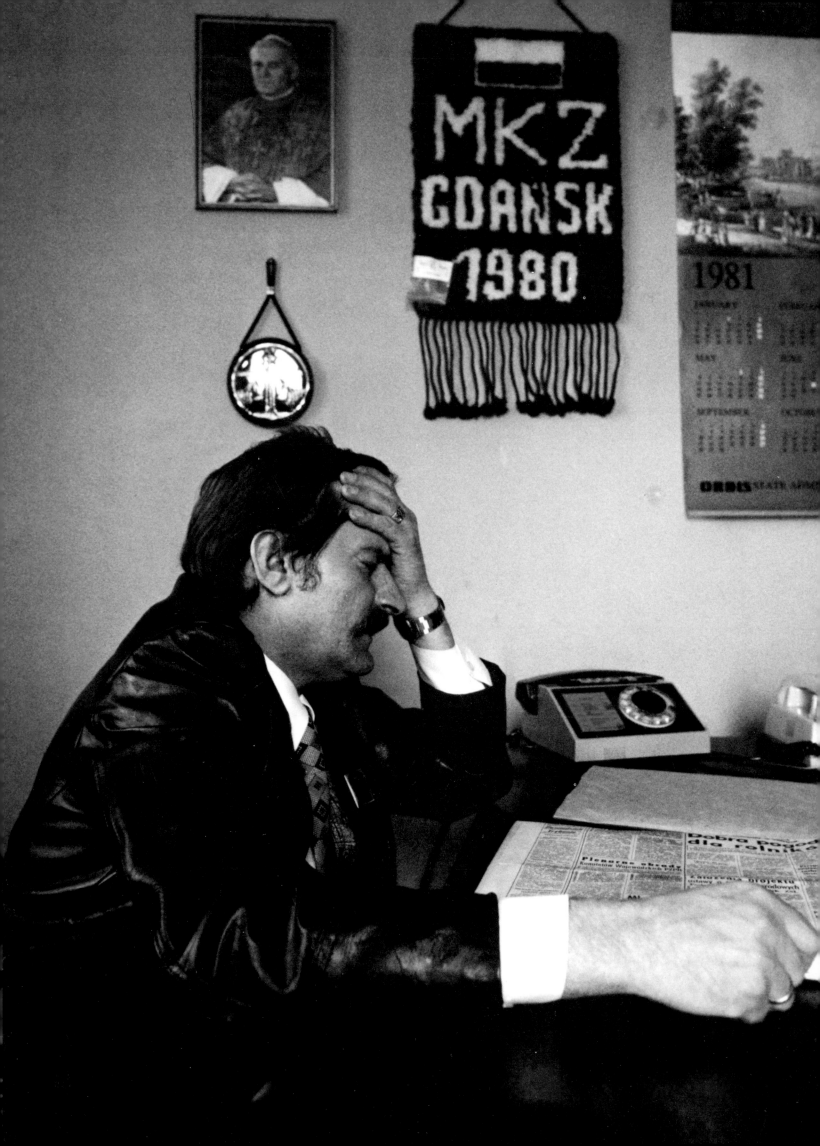

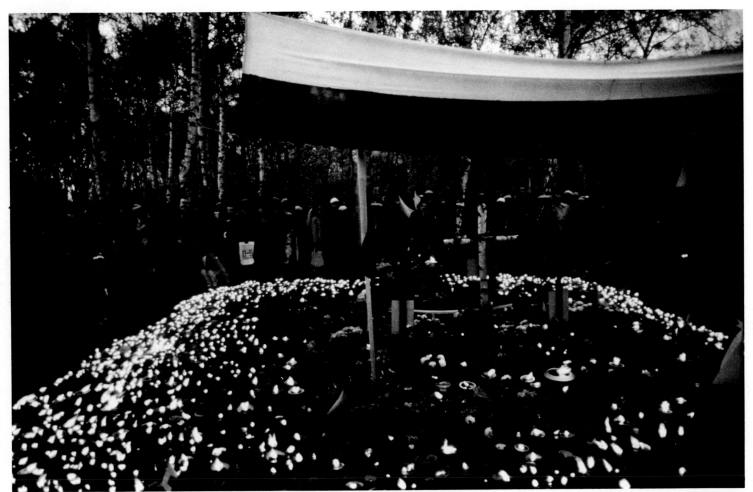

BRUNO BARBEY/MAGNUM FOR LIFE MAGAZINE

An essay by Nobel Laureate Czeslaw Milosz produced for the special supplement to National Geographic on Poland described Lech Walesa as a symbol of things which seem impossible becoming so by the sheer strength of the human spirit. "Nothing is more symbolic than the fact that the Polish working class produced a leader, Lech Walesa, who is recognized as such by both workers and intellectuals." Former electrician, father to six young children, a devout Roman Catholic, the Polish hero sees himself as a peacemaker among Solidarity's moderate and radical factions. In December of 1981, however, the man and his fellow Solidarity leaders were imprisoned by military rule imposed on Poland by General Jaruzelski.

The final picture in the LIFE presentation of Barbey's work was this one of a memorial service to the Katyn dead of 1940 - thousands of Polish officers believed to have been killed by the Soviets. The concrete cross used in the ceremony was removed by state police.

The last few words in the Milosz essay for National Geographic were these, "Gas and tanks were used against the aspirations of a people aware of its glorious past. And, of course, gas and tanks are bound sooner or later to lose."

ARTHUR GRACE FOR TIME MAGAZINE

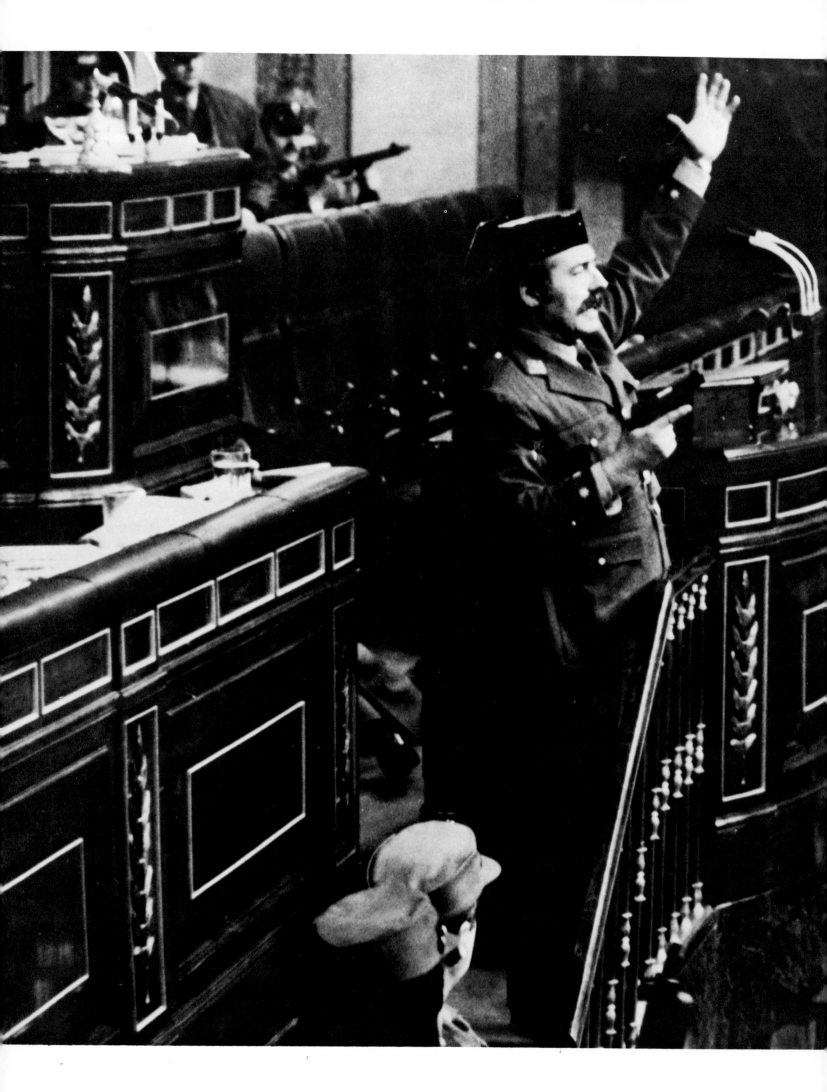

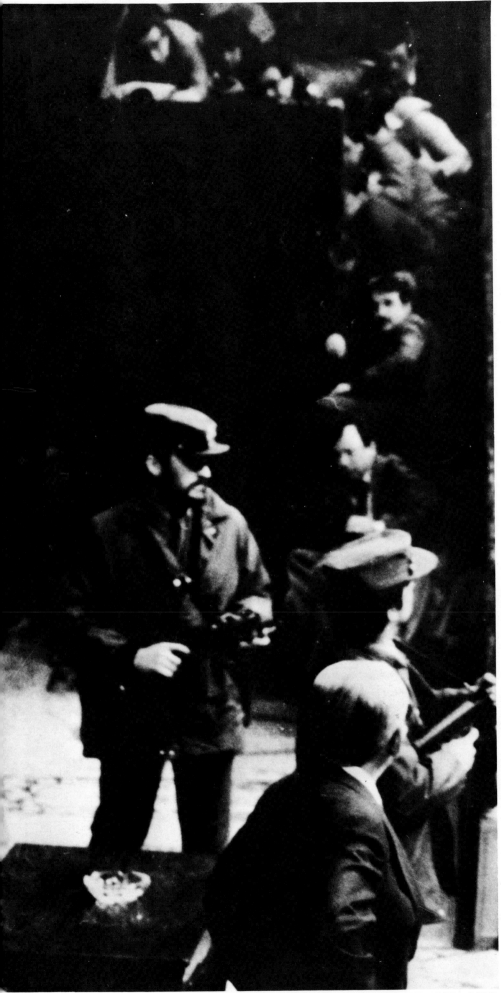

The attempted coup in the Spanish Parliament collapsed 18 hours after it began. The late-November coup failed when King Juan Carlos told the nation he had ordered the Spanish Army to restore constitutional order.

The 200 civil guard members following Lt. Col. Antonio Tejero Molina began jumping from the parliament building windows when it was clear that their brandishment of weapons was going to fail. Although a few politicians were slightly cut from falling debris as Molina and his troops fired at the vaulted ceiling of the parliament building, no one was hurt or killed.

Molina's attempt was to return Spain to a Franco-styled dictatorship which he had plotted once before two years ago. That time he received a seven-month sentence.

"Long live democracy!" the freed government officials were yelling as they left the building.

MANUEL HERNANDEZ AND MANUEL BARRIOPEDRO, UNITED PRESS INTERNATIONAL, MADRID

After 444 days of captivity in Teheran, Iran, 52 American ex-hostages were released and returned to their families. Two of the hostages stepped off an Air Force DC-9 at Frankfort Air Force Base shortly after arriving from Algiers. The ribbon inside the door was a yellow one ... a symbol of hope for a safe return and sympathy for those who waited and prayed. At Andrews Air Force Base, families embraced in tearful reunions. The strain of 14 months of negotiation was released in spirited flag-waving, bell-ringing parades, church services and clinking of champagne glasses. Renewed patriotism coincided with the inauguration of the 40th President, Ronald Reagan. It all happened in a 41 minute time period on January 21, 1981.

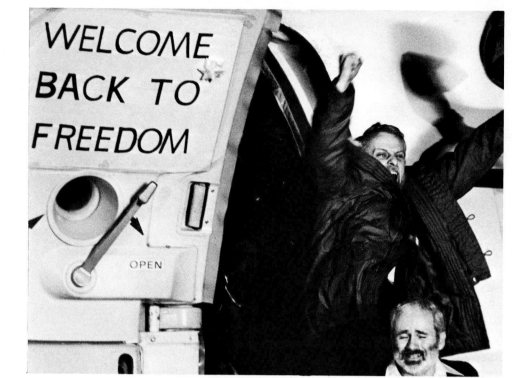

HERIBERT PROEPPER, ASSOCIATED PRESS

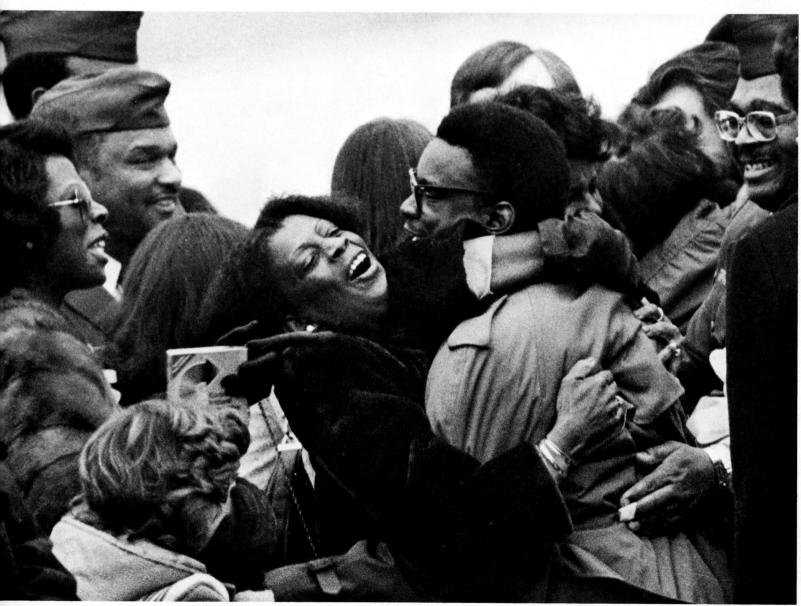

TOMMY PRICE, RICHMOND (VA) NEWSPAPERS TIMES-DISPATCH

JERRY LODRIGUSS, UNITED PRESS INTERNATIONAL

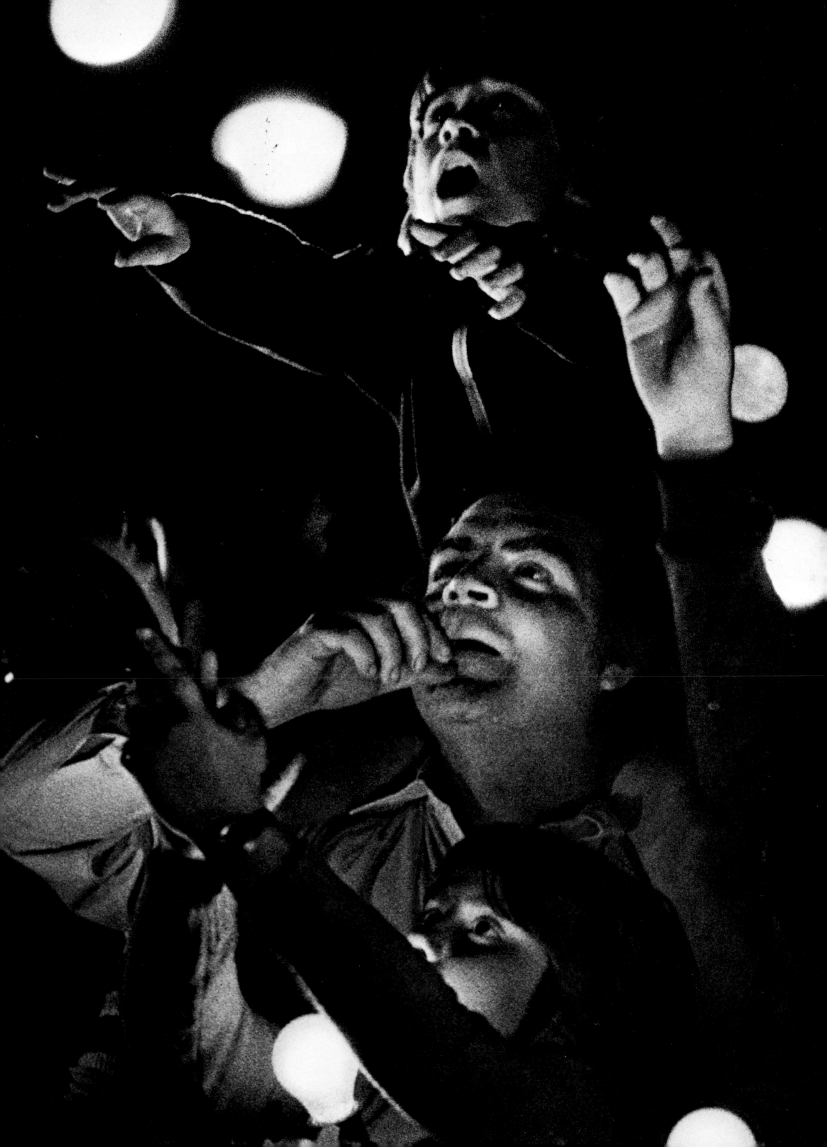

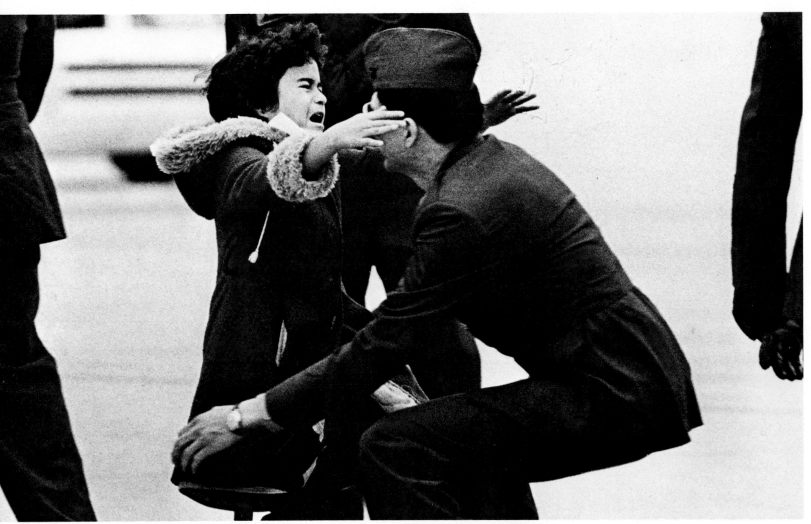

FIRST PLACE GENERAL NEWS, BARBARA LAING, THE POST, ATHENS, OHIO

Seven-year-old Marcie Lopez raced to her brother, Jimmie, as he and the other 51 ex-hostages arrived at Andrews Air Force Base. She had wormed her way past guards to greet Jimmie, an Arizona Marine, as he stepped off the plane.

Donald Cooke was literally carried away by the welcome he received when the freed hostages arrived in Washington for their official homecoming. Cooke is from Memphis, Tenn.

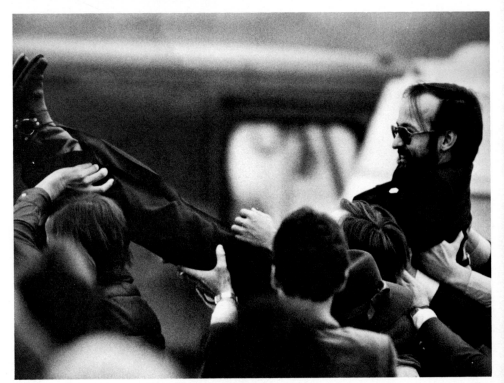

WILLIAM AUTH, ASSOCIATED PRESS

NEWSPAPER PHOTOGRAPHER OF THE YEAR, DAN DRY, COURIER-JOURNAL AND LOUISVILLE TIMES

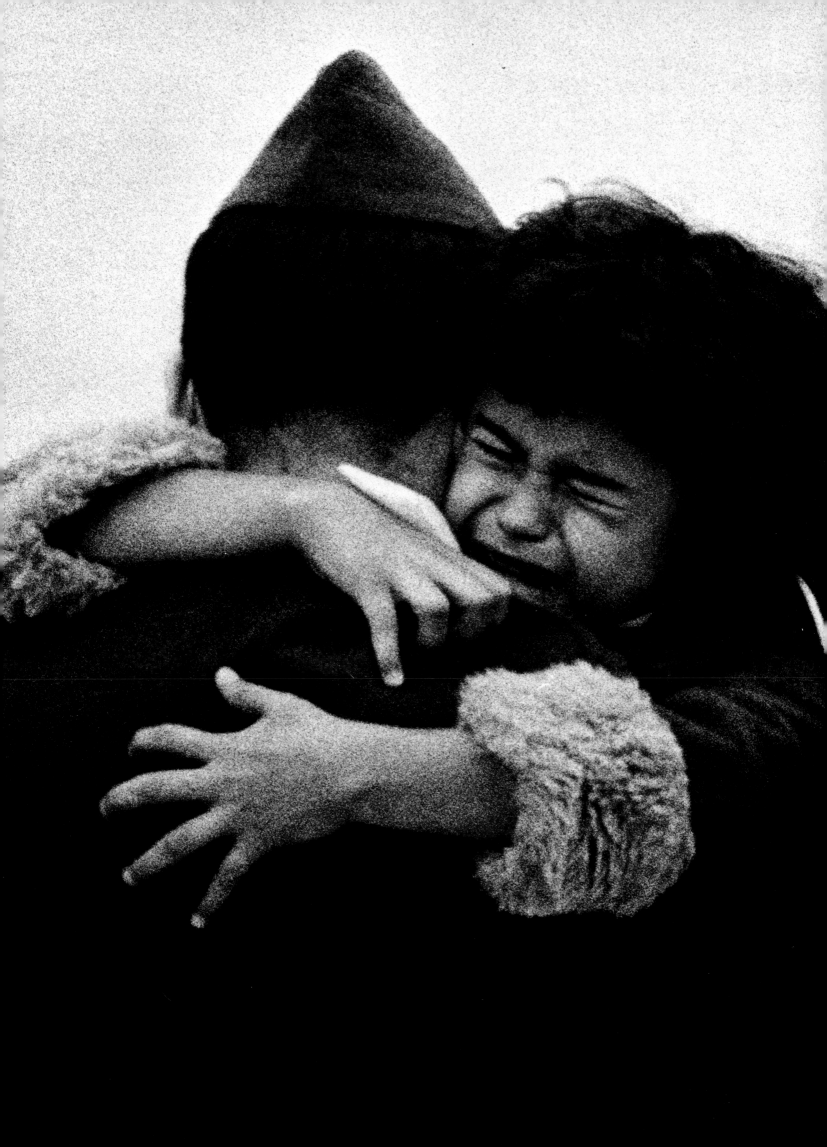

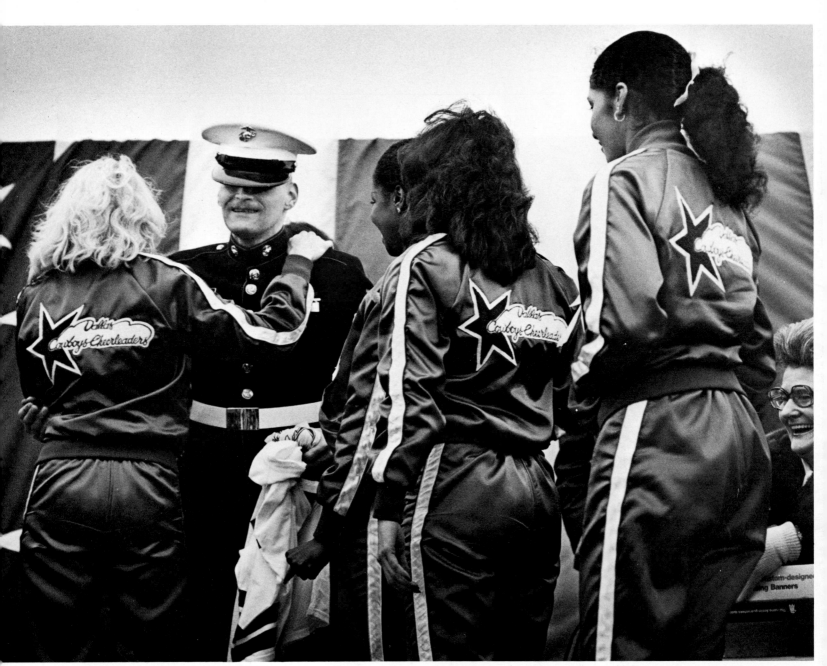

JOHN F. RHODES, THE DALLAS MORNING NEWS

BRIAN SMITH, COLUMBIA MISSOURIAN

Dallas Cowboy Cheerleaders line up for kisses at a homecoming celebration for Johnny McKeel.

Rocky Sickmann joined the flag-waving spirit of the celebration that welcomed him home to Krakow, Missouri.

In the last few days of his presidency, Jimmy Carter reached an agreement with Iran for the release of the hostages, held by the government of the Ayatullah Khomeini since November 4, 1979. That day the U.S. Embassy in Teheran was taken by demonstrators loyal to Khomeini who demanded that the Shah be returned to Iran from the United States where he had been permitted to seek medical treatment.

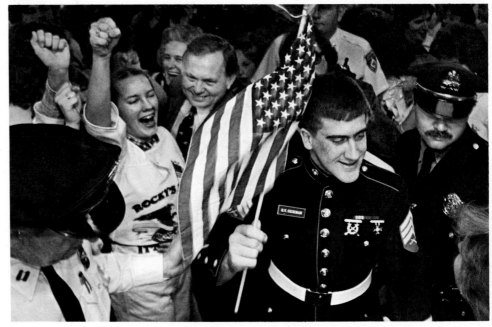

THIRD PLACE MAGAZINE NEWS DOCUMENTARY, JAKE RAJS FOR LIFE MAGAZINE

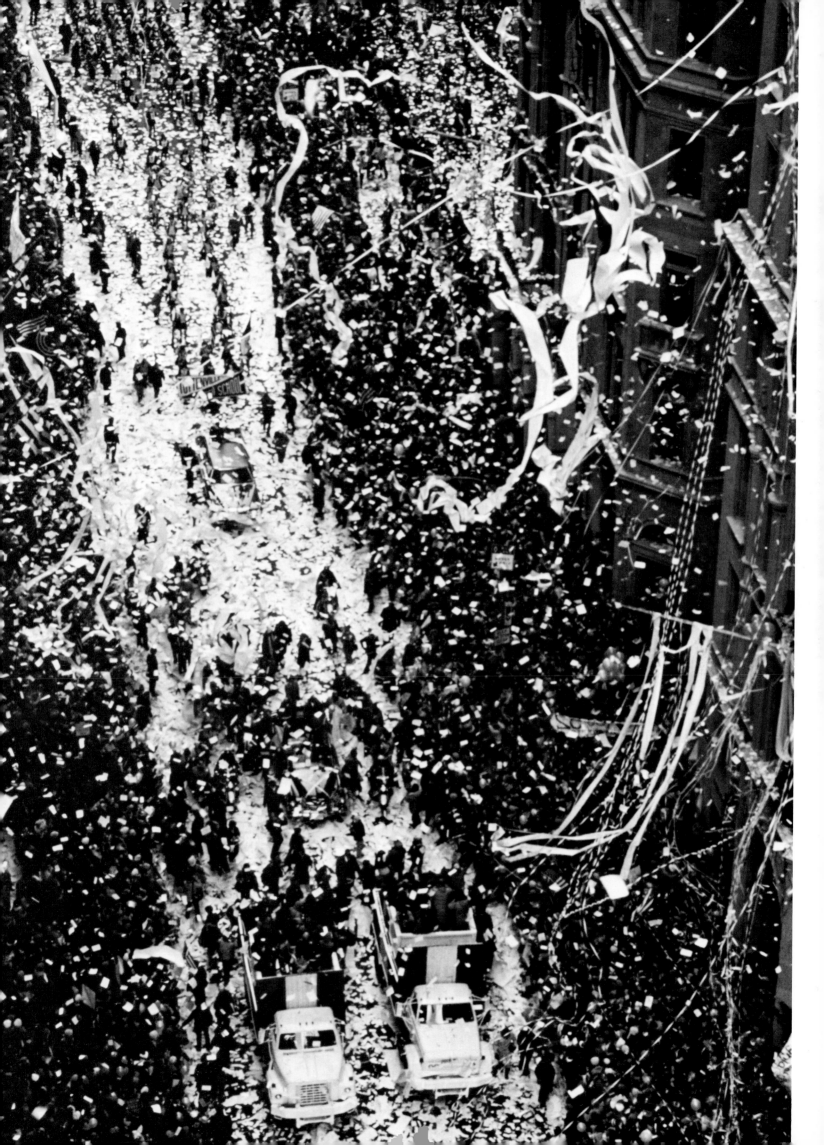

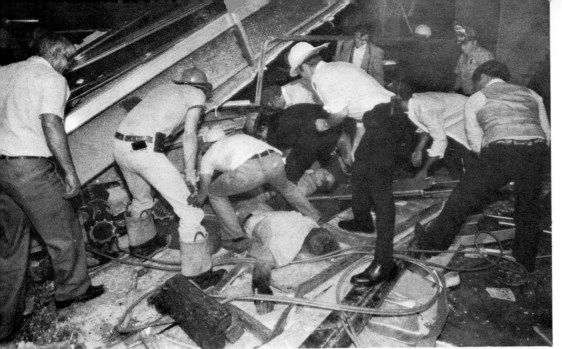

The 8th tea dance at the Hyatt Regency Hotel in Kansas City was on Friday, July 18, 1981, from 5:00 to 8:00 p.m. The crowd spilled onto the three skywalks by 4:30. At 7:04, Steve Miller and the Hyatt Regency Orchestra broke into Duke Ellington's "Satin Doll" — dance contest time. In less than an hour, another tea dance would end. The people on the skywalks bounced and swayed to the music. A minute later — a loud boom. The 4th floor skywalk split in two places near the center, smashed down on the 2nd floor skywalk, which also collapsed. Then, together, wreckage and dancers fell on hundreds of seated guests.

JOHN J. SPINK, KANSAS CITY TIMES

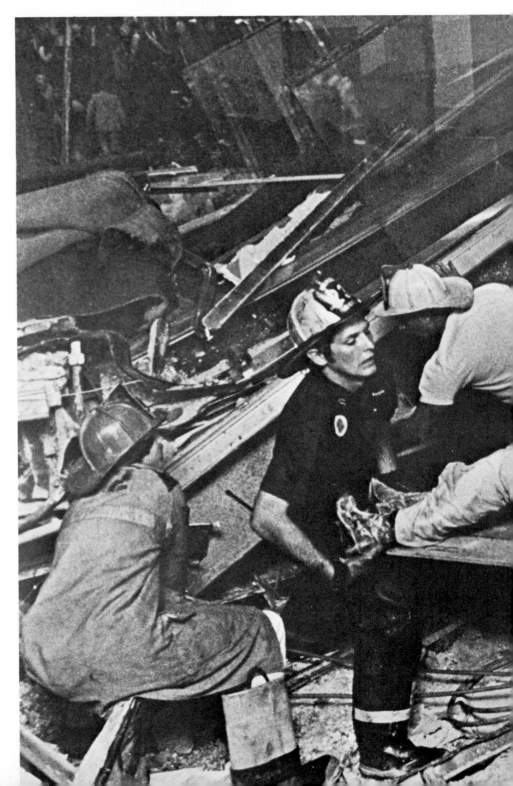

The Kansas City Fire Alarm office was nearby and was immediately notified. Within minutes, paramedics, firefighters and police arrived. Hospitals put on alert called in off-duty staff. Requests for heavy equipment went out. Emergency aid stations were set up inside and outside the hotel.

Broken water pipes flooded the floor of the ballroom. Portable generators powered cutting and prying tools. Jackhammers, saws and hand-held chisels tore through the concrete. Dust and smoke filled the ballroom and windows were broken out. One body freed revealed another trapped.

Rescuers toiled for more than 12 hours. Surgeons performed several on-the-spot amputations. One firefighter found a frightened but unscathed two-year-old girl. Another pulled down the hem of an unconscious woman's skirt. They carried the living to helicopters and ambulances waiting out front on McGee Street. They piled the dead on pallets and tables.

Before police sealed off the hotel within the first hour, photographers Tom Gralish and John Spink were able to get inside. Most of the press relied upon a police spokesman for information.

TOM GRALISH, UNITED PRESS INTERNATIONAL

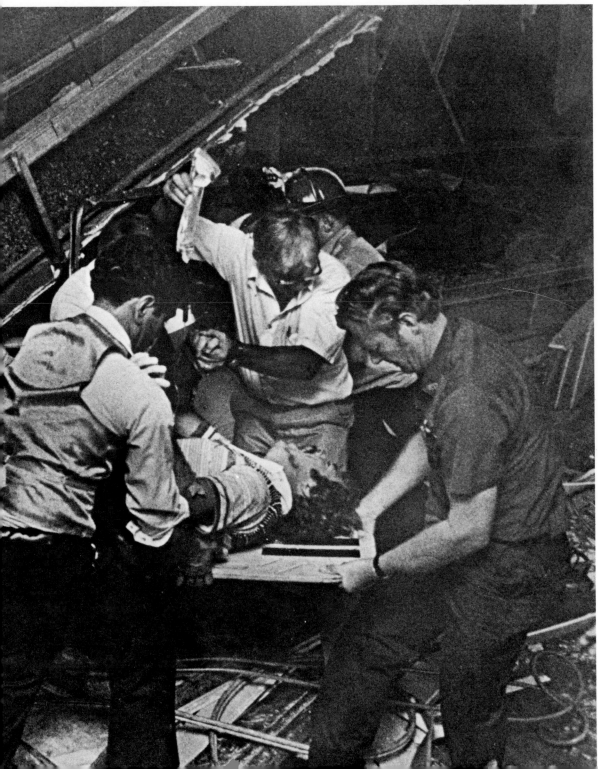

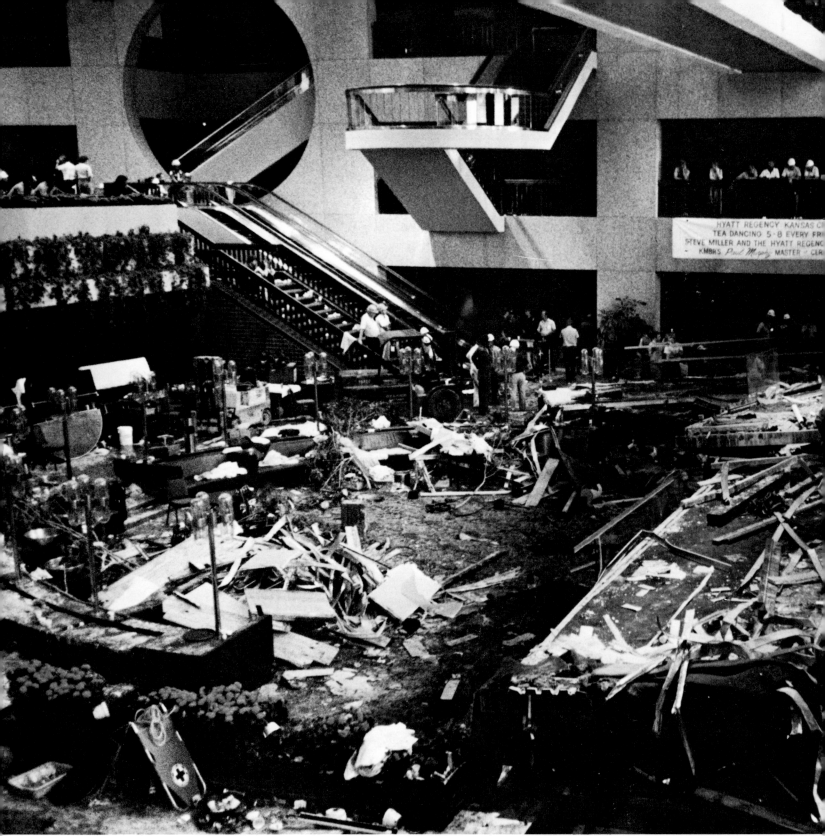

DAN WHITE, KANSAS CITY STAR (ORIGINAL IN COLOR)

Darkslide Magazine: If this was to happen to you again, say a year from now or a similar situation six months from now, could you handle it all right?

John Spink: As long as that camera is between me and what is happening.

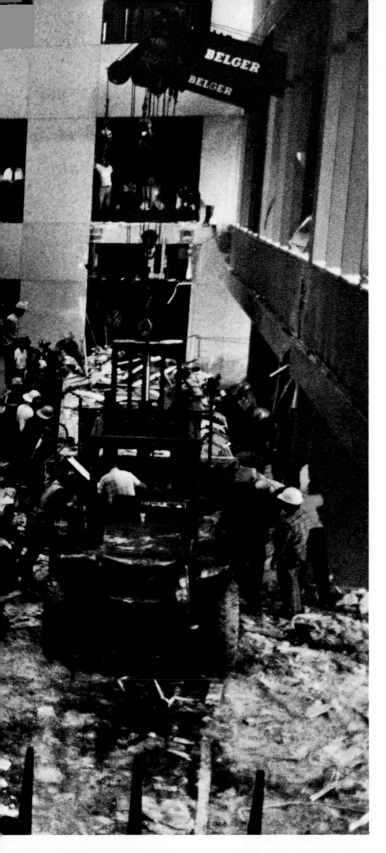

Aided by forklifts, heavy cranes lifted the concrete slabs off the last group of bodies. Outside in the makeshift hospital, those who escaped injury searched for or tended loved ones. Photographer Jan Housewerth concentrated on the triage area in front of the hotel and found Sol and Rosetta Koenigsberg holding hands. (Cyndi Paulson of the hotel staff saw that the couple stayed together while she soothed others.) The last living person was removed from the hotel at 4:30 a.m. Saturday. The last slab was removed three hours later, revealing 31 bodies. Altogether, 114 died and 200 were injured.

The 2nd floor skywalk was supported by steel rods suspended from the 4th floor skywalk which hung by steel rods from the ceiling. The National Bureau of Standards determined that the weight and movement of the crowds on both skywalks put too much stress on the box beams and suspension rods of the 4th floor skywalk, causing the beams and rods to break.

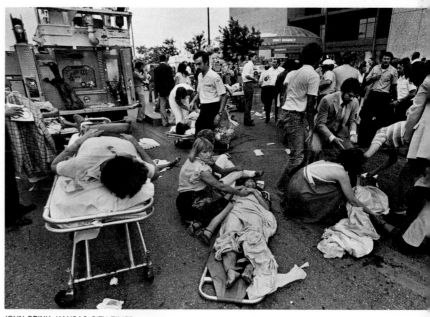

JOHN SPINK, KANSAS CITY TIMES

JAN HOUSEWERTH, KANSAS CITY STAR

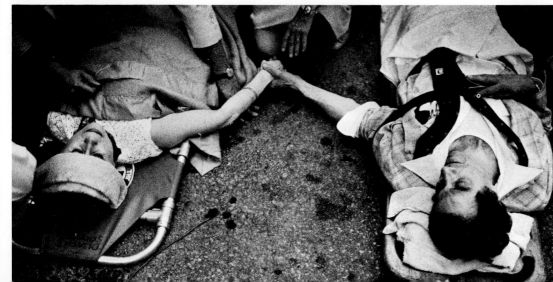

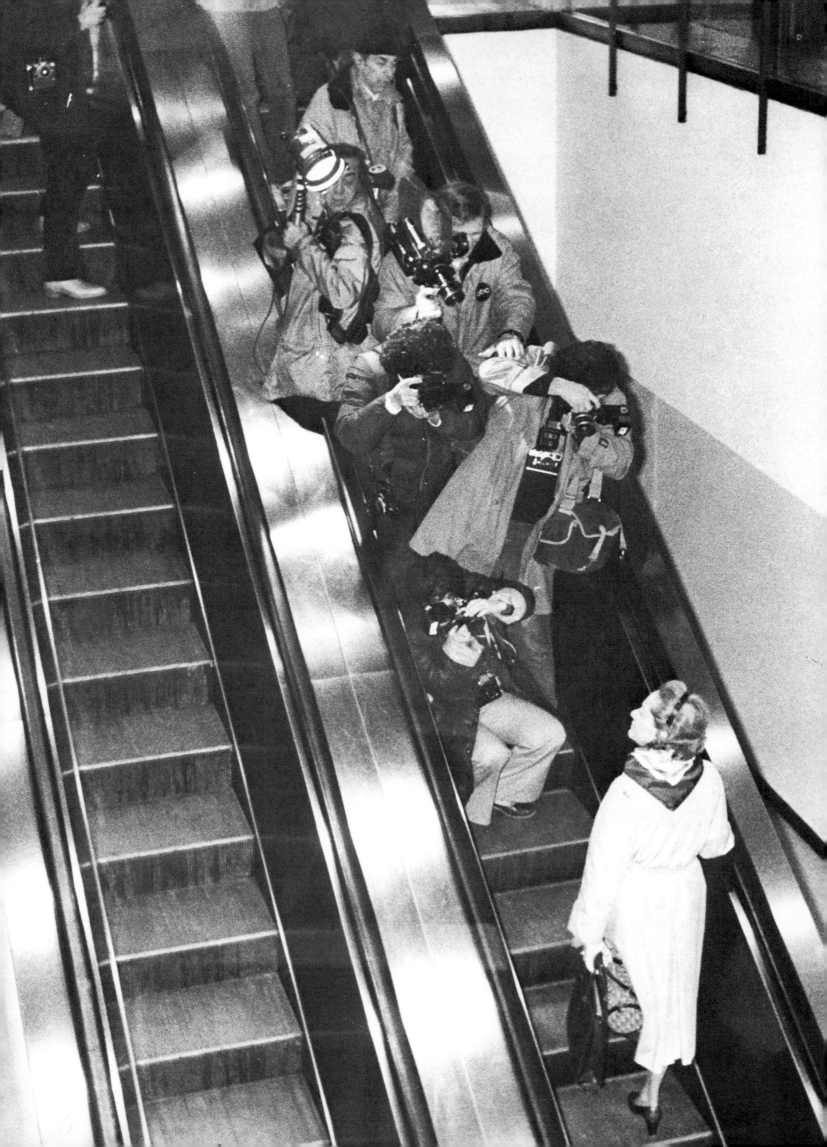

Friday night, May 9, 1981, a woman was feeding her dog in front of her house when she saw a sycamore tree sink into the ground. Saturday morning the ground supporting the house fell away and the house slowly slid into the widening hole. Eventually the 400-foot sink engulfed several Porsches and a camper and the ground supporting the deep end of a municipal swimming pool. The extremely dry weather conditions in Winter Park, Fla., were partly responsible for the destructive drama of nature.

BARBARA VITALIANO, ORLANDO, (FLA.) SENTINEL-STAR

Some quick thinking and arrangements for helicopters to get to the right place at the right time allowed the photographer to get this picture of the exhumation of the body of Lee Harvey Oswald, with ninety seconds to spare before the casket slid into the waiting hearse. The grave was opened to prove, once and for all, that John Kennedy's assassin was actually buried in a Fort Worth cemetery.

Jean Harris, 57, went to trial in White Plains, N.Y., for shooting Scarsdale diet doctor Herman Tarnower. Harris was found guilty of second-degree murder and sentenced to prison for 15 years to life. Press photographers crowded the escalator which Harris took from a parking garage to the trial in the White Plains courthouse.

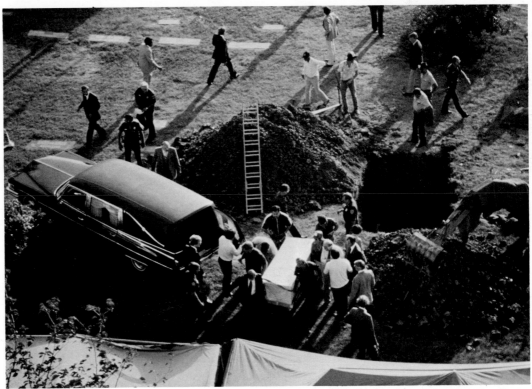

PHIL HUBER, DALLAS, (TEX.) MORNING NEWS (ORIGINAL IN COLOR)

HONORABLE MENTION SPOT NEWS, G. PAUL BURNETT, ASSOCIATED PRESS, NEW YORK

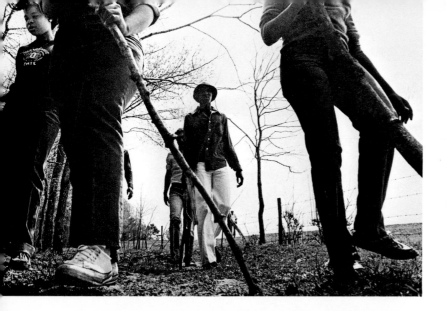

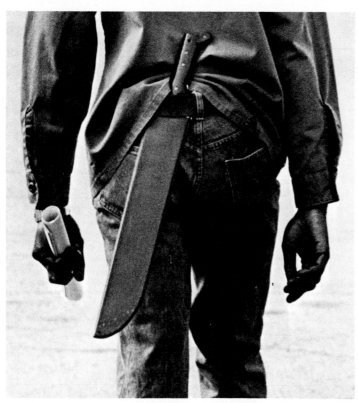

HONORABLE MENTION NEWS PICTURE STORY, DURELL HALL, JR., COURIER-JOURNAL & LOUISVILLE TIMES (BOTH PHOTOS)

In fear and anger, Atlanta mourns

The murders of youth in Atlanta began in July, 1979, and continued well into 1981. The official total reached 27 though two were later dropped from the list. The murders petrified the city and filled the nation with anger and sorrow.

Armed with sticks, Atlanta citizens combed the bottoms of the Chattahoochee River where many of the victims had been found. Armed with pistols, machetes, knives or pipes, they patrolled the black neighborhoods.

At her son Terry's funeral, a stunned Helen Pue receives comfort from a policewoman. Terry, 15, disappeared on January 22, 1981, and was found the next morning off a road 20 miles from Atlanta. He had been strangled.

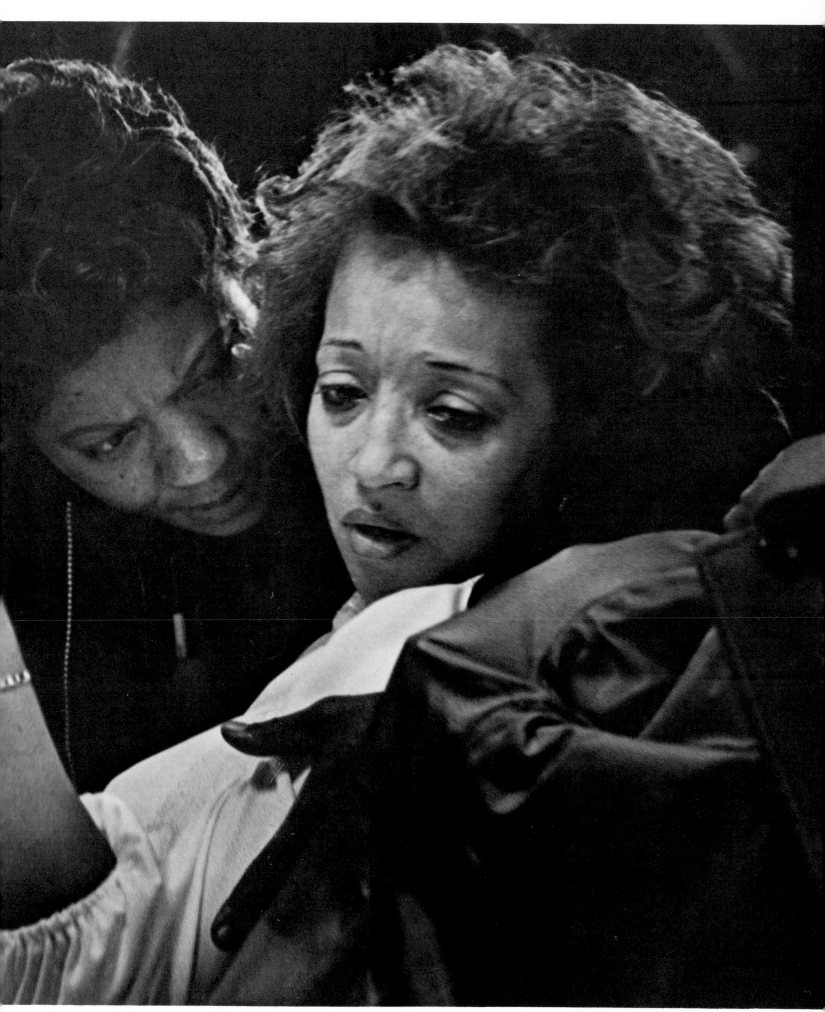

HONORABLE MENTION MAGAZINE NEWS/DOCUMENTARY, GEORGE CLARK, ATLANTA CONSTITUTION/LIFE

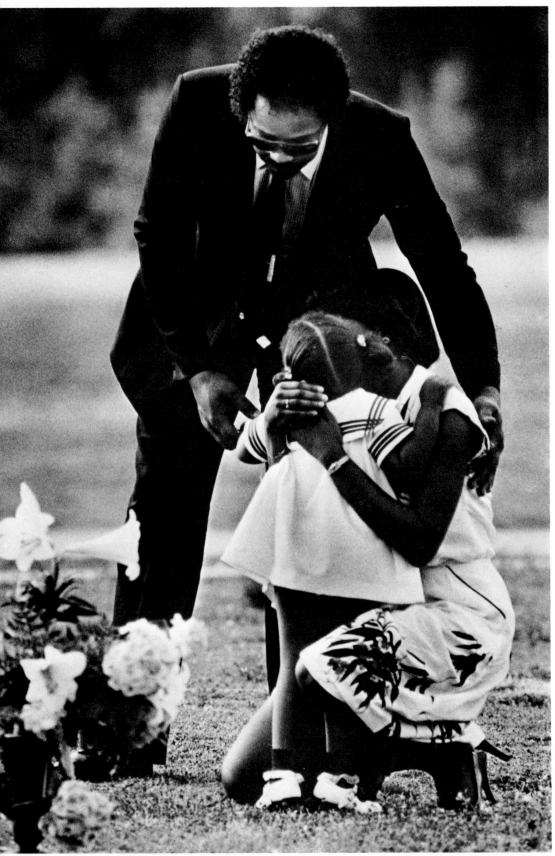

HONORABLE MENTION NEWS PICTURE STORY, DURELL HALL, JR., COURIER-JOURNAL & LOUISVILLE TIMES

A new generation of old troubles in northern Ireland

The Irish refer to the conflict in Ulster as "The Troubles." Its roots lie in hate and anger nearly four centuries old. Since 1969, when the British arrived to quell rioting between Catholics and Protestants, 8,000 have been jailed for terrorist activities and 20,000 have been killed or injured — including 4,000 British soldiers.

Most of Ulster's children have not suffered directly from "The Troubles." They grow up accepting webs of barbed wire, slabs of corrugated iron and patrols of British soldiers. The bombs and gunshots are a street or a hill away. The children hear and absorb the adults' list of real or imagined grievances. They know of one who was shot, perhaps killed, by the "Prods," "Taigs" or "Brits." However close the conflict comes to home, the children grow up fast without realizing it, caged without knowing it.

The child broke out in a loud cry at the Timothy Hill funeral. Her mother attempted to console the girl, then she, too, began to cry. That's when the father moved in to comfort them both.
Then on June 21, 1981, Wayne Williams, a 23-year-old black talent scout, was arrested and charged *with the murders of Nathaniel Cater, 28, and Jimmy Ray Payne, 21. Through comparisons of carpet samples, pieces of clothing, sweepings and animal hairs taken from Williams' home with fibers found on nine of the bodies, Williams was found guilty on February 27, 1982.*

JOHN ROCA, PHILADELPHIA DAILY NEWS

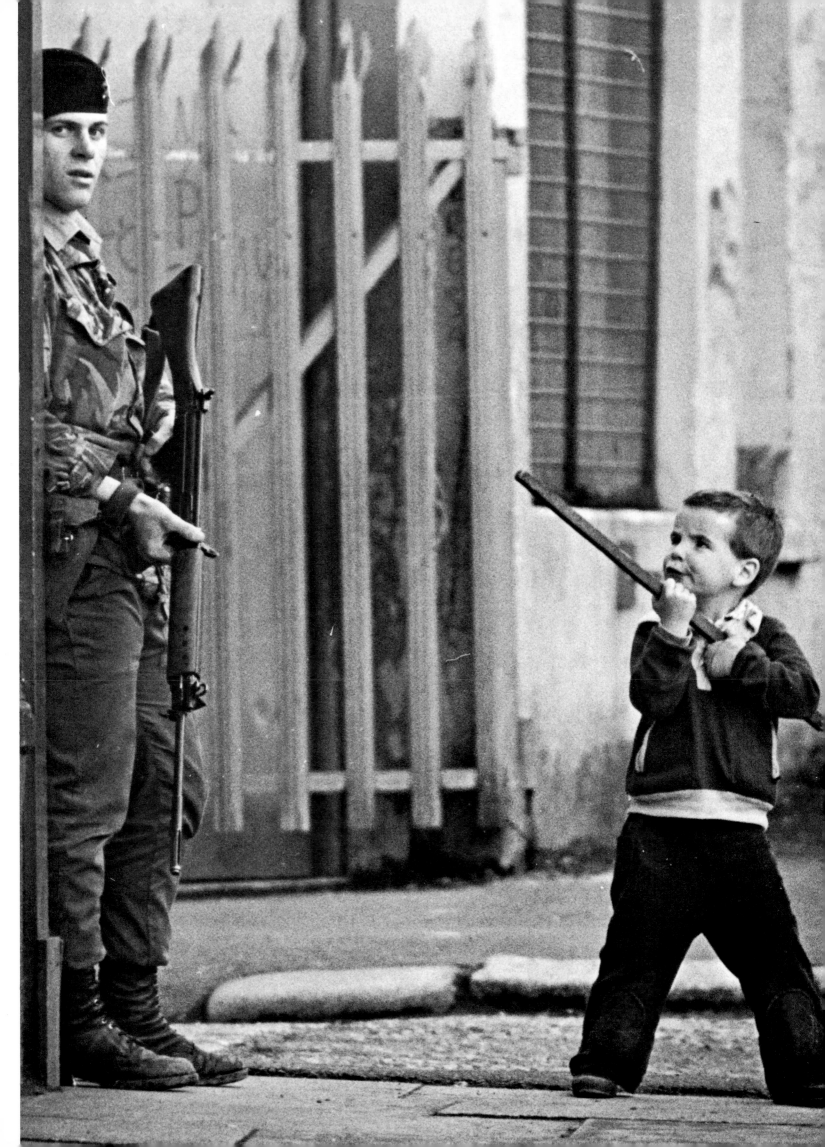

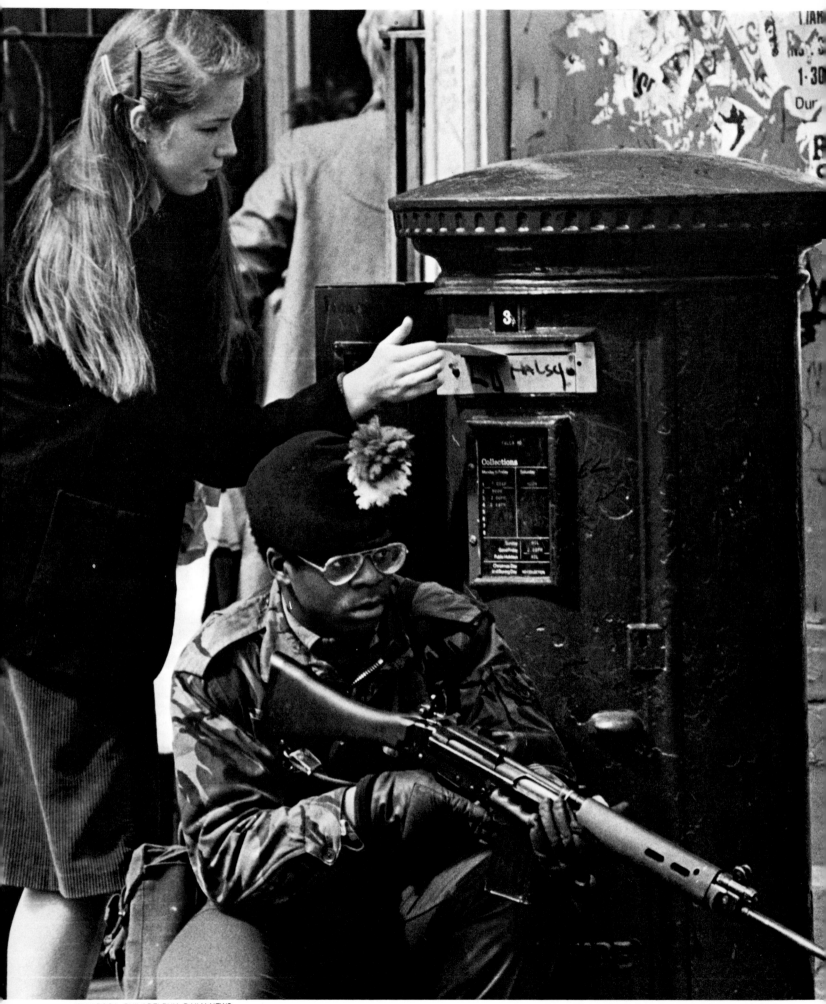

JOHN ROCA, PHILADELPHIA DAILY NEWS

44

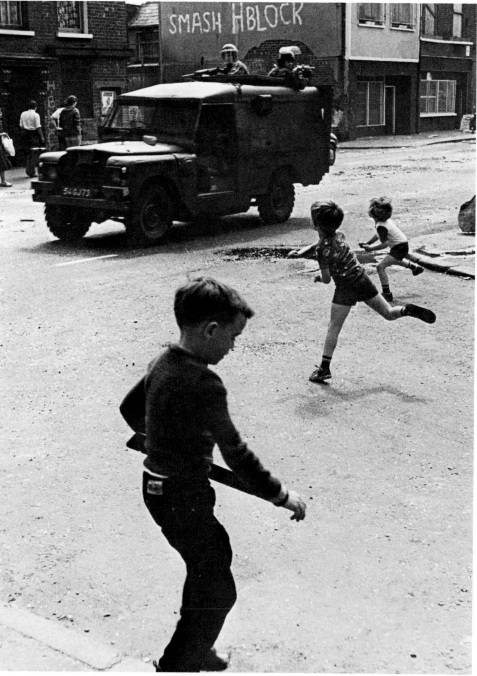

PAUL MARTIN LESTER, UNIVERSITY OF MINNESOTA

The Irish not actively involved try to take the conflict in stride — submitting to brief searches before entering shopping centers, driving around great concrete blocks called "dragon's teeth" in the middle of streets, sitting in parked cars on trips downtown to prove it has no bomb, or mailing a letter above the head of a crouching British soldier.

Children as young as three throw stones at "pigs" — British army troop carriers. Those living in border zones like West Belfast are most affected by the conflict. Either guided by adults or pressured by their peers, the children have had to choose sides. Photographer Paul Lester financed his own two and a half month stay in Belfast to see the conflict firsthand.

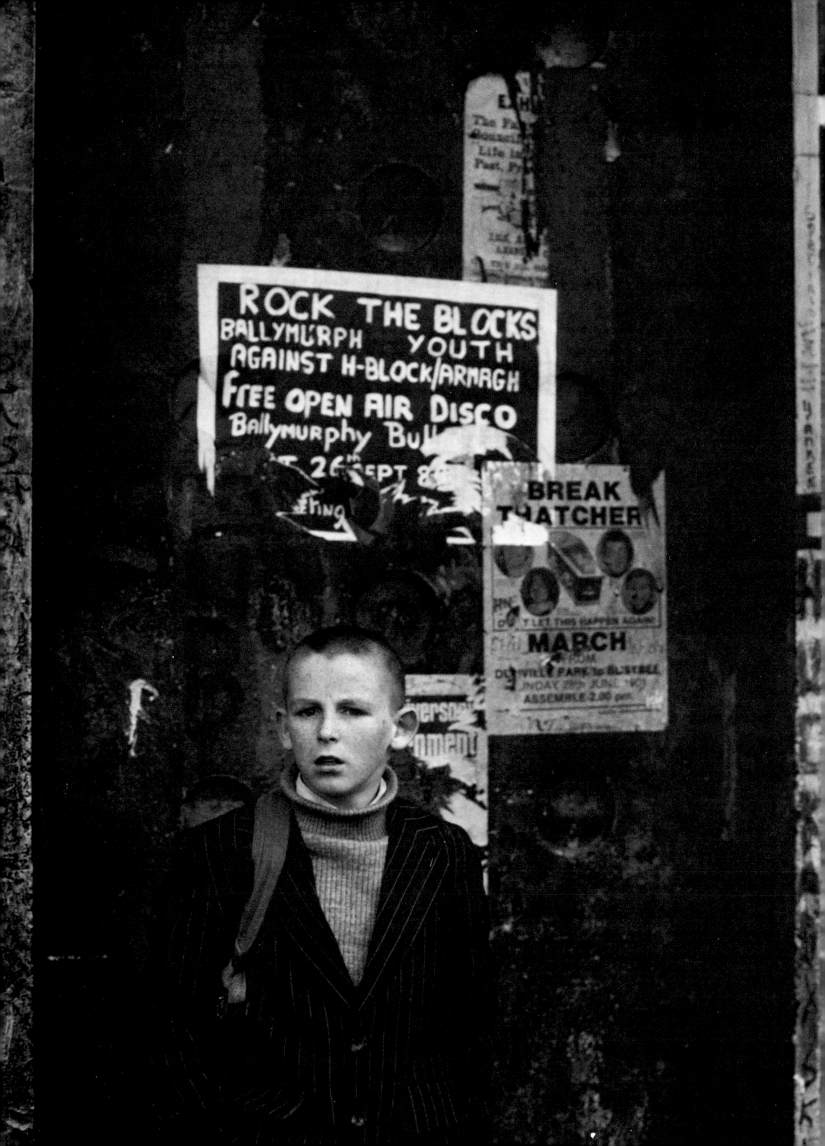

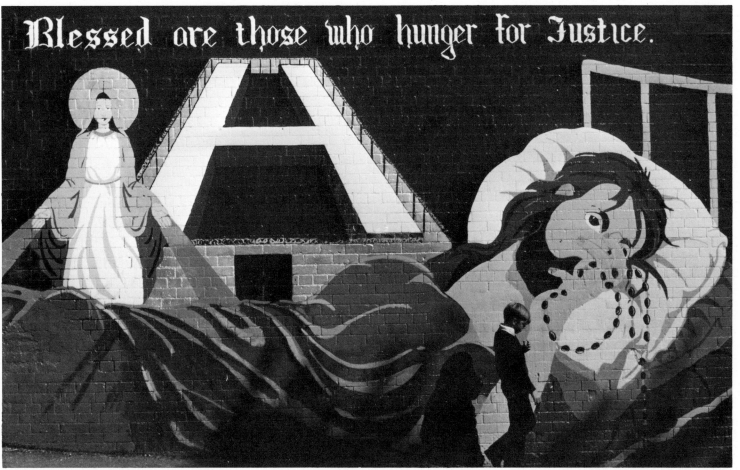

Blessed are those who hunger for Justice.

HONORABLE MENTION SELF-EDITED PICTURE STORY, BILL PIERCE, TIME MAGAZINE (ORIGINALS IN COLOR)

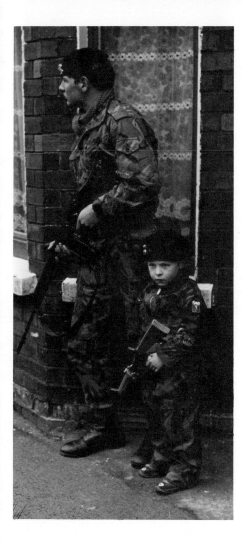

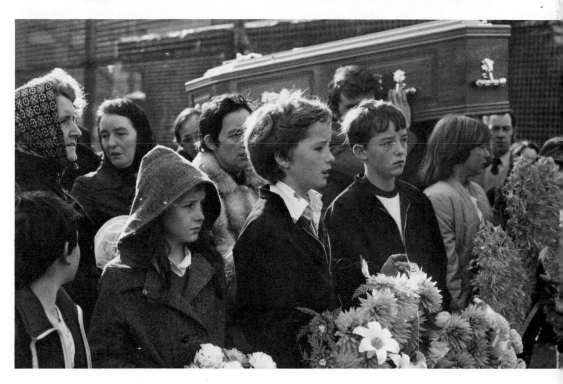

All of Ulster demands more of these children than they can possibly bear — to inherit the hatred or be patient and understanding. It is they whom the terrorists on both sides place at the head of marches, demonstrations and funeral processions to give each cause authority. Bill Pierce's pictures show "the children's inherent goodness, their insanity, and their ugly future." Their purpose is "to teach you one tiny fraction of what the children of North Ireland taught me."

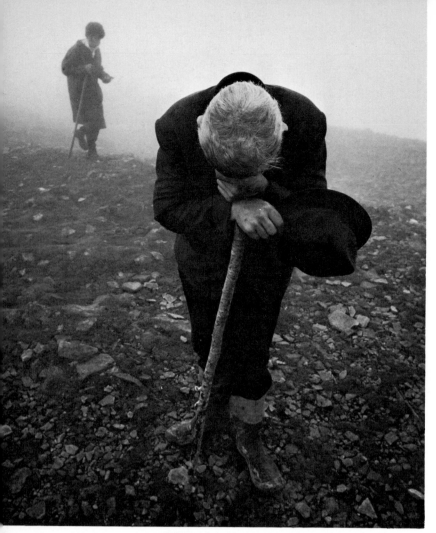

COTTON COULSON, NATIONAL GEOGRAPHIC, (ORIGINAL IN COLOR)

The pilgrim began to climb the holy mount Croagh Patrick before dawn. In noonday fog, he bows for prayer far to the south of Ulster, in Ireland where "The Troubles" are avoided by switching the television channel.

A hooded IRA honor guard keeps watch over the body of Micky Devine as his sister Margaret mourns. Micky Devine was serving a 12-year sentence in the Maze for possessing stolen firearms. (The Maze is the H-block prison the Irish Republican Army calls Long Kesh. Long Kesh was a British prisoner-of-war camp that stood on the sight until it burned in 1974.) Devine went on a hunger strike to force the British to recognize IRA prisoners as captives of war. Devine died on August 20, 1981. The hunger strikes lasted seven months. The IRA called them off after Prime Minister Margaret Thatcher remained unyielding and families of participating prisoners no longer supported the acts of self-starvation. Harry Benson said, "They checked me out very thoroughly. Of course, it always helps to have LIFE credentials. They (the IRA) were well aware that they could use the coverage. There's a price to be paid for that, and I was part of the price. The fasts were a terrible thing — never happened in the history of the world. Even Ghandi, the Indian ascetic, took vitamins when he fasted to protest British rule."

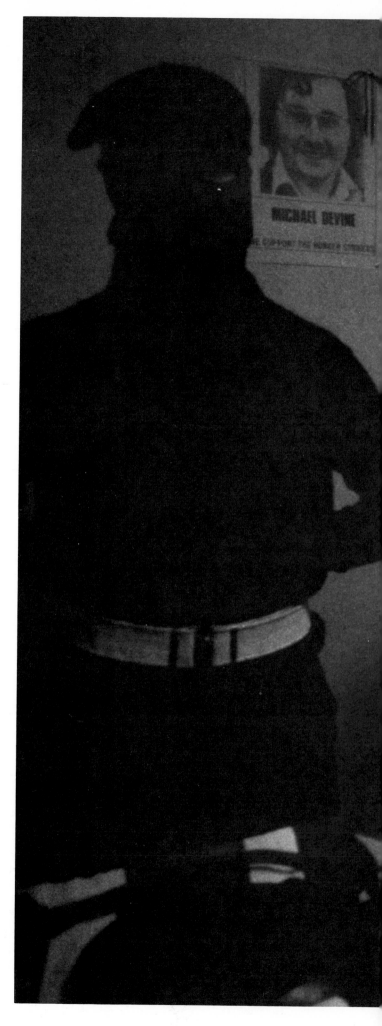

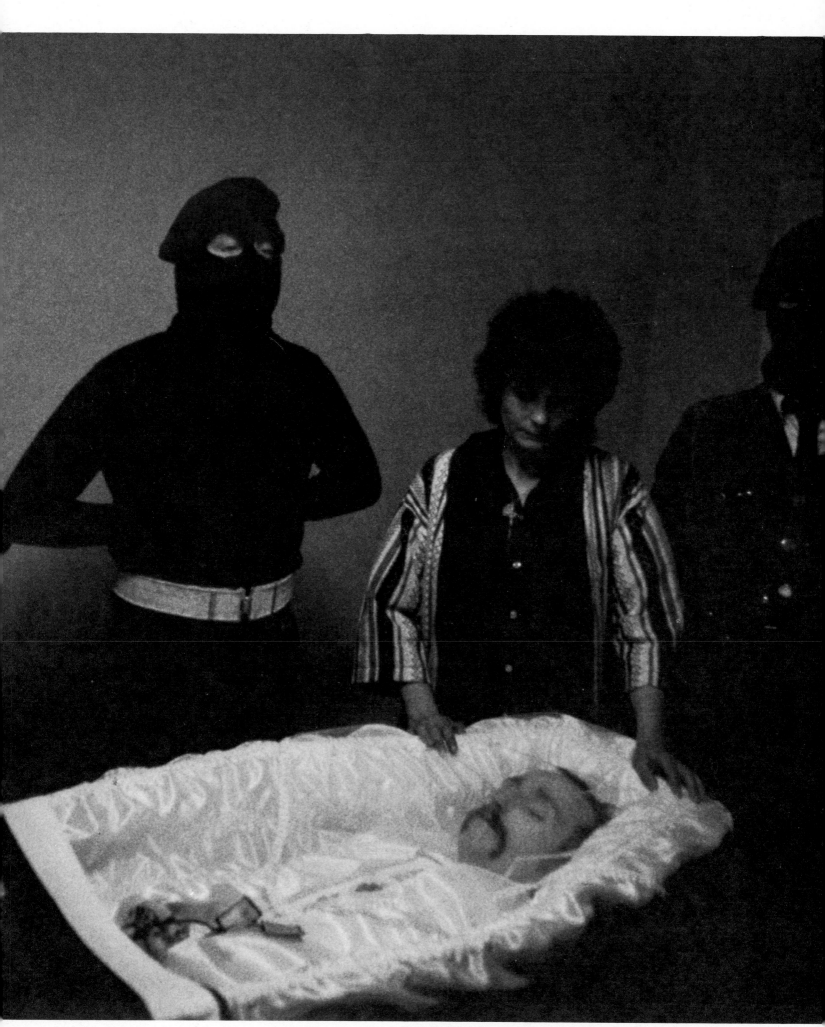

MAGAZINE PHOTOGRAPHER OF THE YEAR, HARRY BENSON FOR LIFE (ORIGINAL IN COLOR)

On the edges of survival — Somalia, Calcutta, Cambodia share the plagues of mankind: poverty, disease, starvation.

Photographed by Harry Benson,
Kevin Fleming, Kent Kobersteen, and
David Alan Harvey.

Desperate thousands flee the border wars from the Ogaden region; goat and camel herding nomads flood into Somalia. The country, barely able to feed its own, cannot accommodate the thousands of starving, disease-ridden refugees. Dr. Eric Avery, chief medical officer and his staff of twelve at the camp of Las Dhure attempt to save lives in spite of the odds. During his rounds through the vast camp of 80,000, Dr. Avery holds up a refugee child in the dusty glow of early dawn. The beauty of the moment hides the horror covered by the brush and animal skin tents where a cup of water and some medicine will be the difference between life or death that day.

MAGAZINE PHOTOGRAPHER OF THE YEAR, HARRY BENSON FOR LIFE MAGAZINE

Two among hundreds of thousands of nomads who crossed the Ogaden region to Somalia were this young girl and her blind grandmother. They walked a month through the desert-like country to reach one of the "transit" camps where daily water consumption was limited to three teaspoons a day and fuel shortages extended the average stay of two or three days to two weeks.

One of Harry Benson's objectives in the LIFE coverage of Somalia and starvation was to show the environment in which the people were trying to survive.

The Somalis and twenty international agencies attempted to provide medical care, food and transportation to the refugees, yet hundreds died from thirst, starvation and disease. Pools of water scratched from the sands were quickly polluted by both people and animals, causing epidemic dysentery and malaria, challenging and frustrating all efforts by the small crews of medical professionals.

One cause of this agony is the continuing conflict over who shall rule the Ogaden region: Ethiopia, with Soviet and Cuban help, or Somalia — a country already ravaged by poverty and disease. Males among the nomadic tribes join the fights along the political borders or shift for themselves in the cities; the women and children move about from camp to camp, chasing dreams of survival.

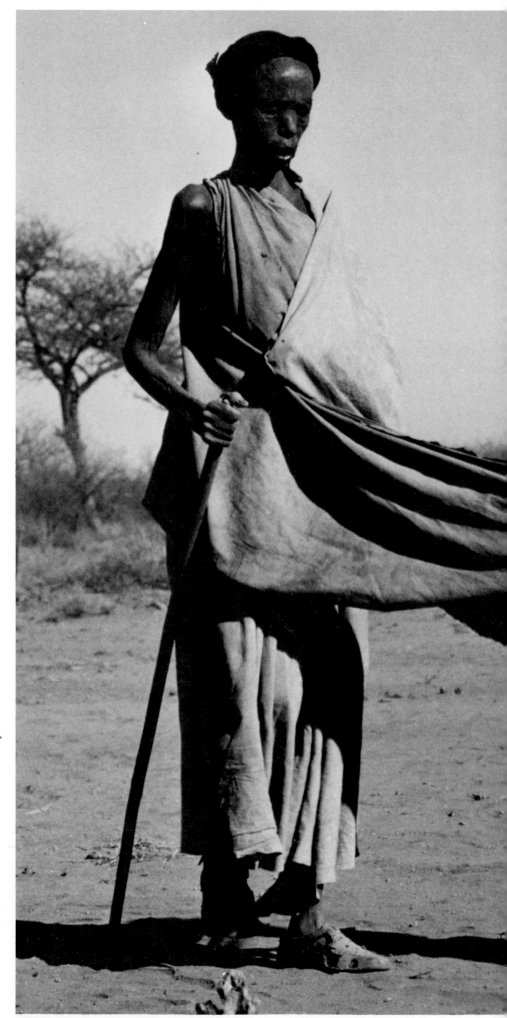

HARRY BENSON FOR LIFE MAGAZINE (ORIGINAL IN COLOR)

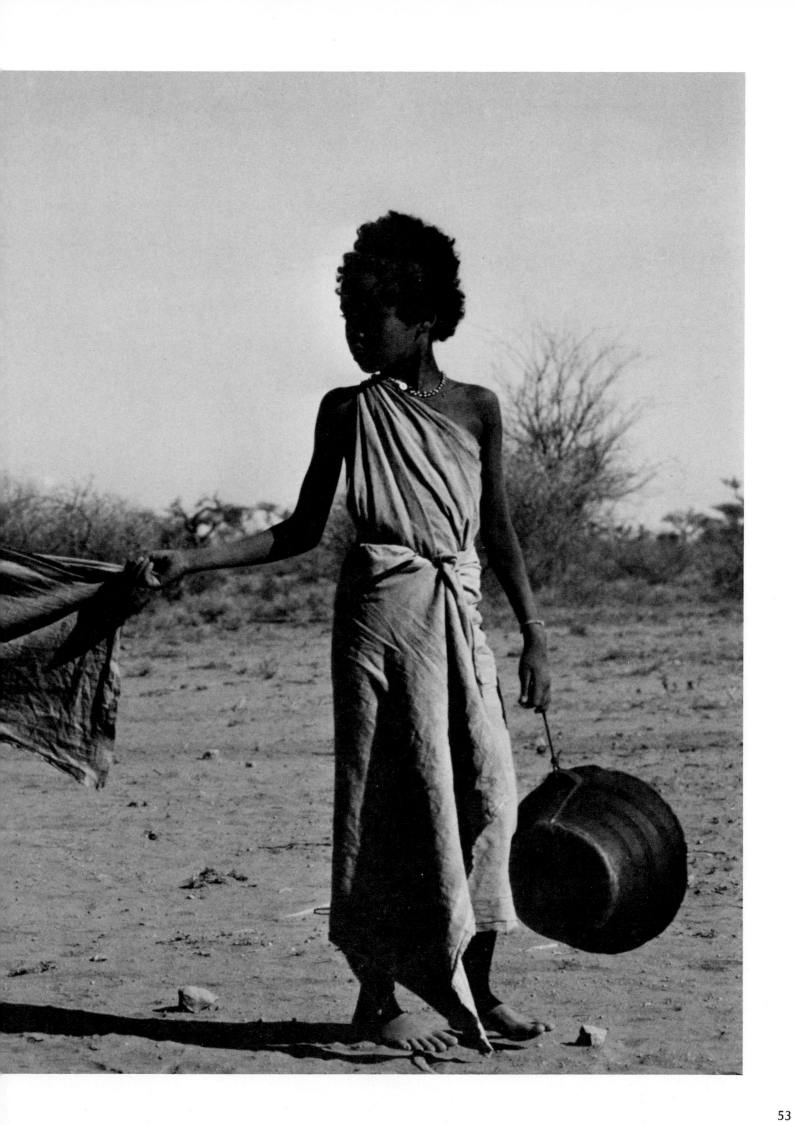

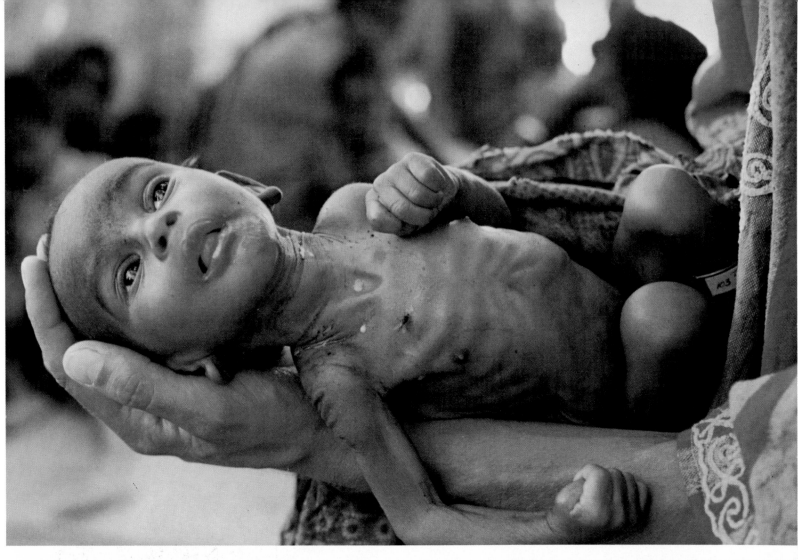

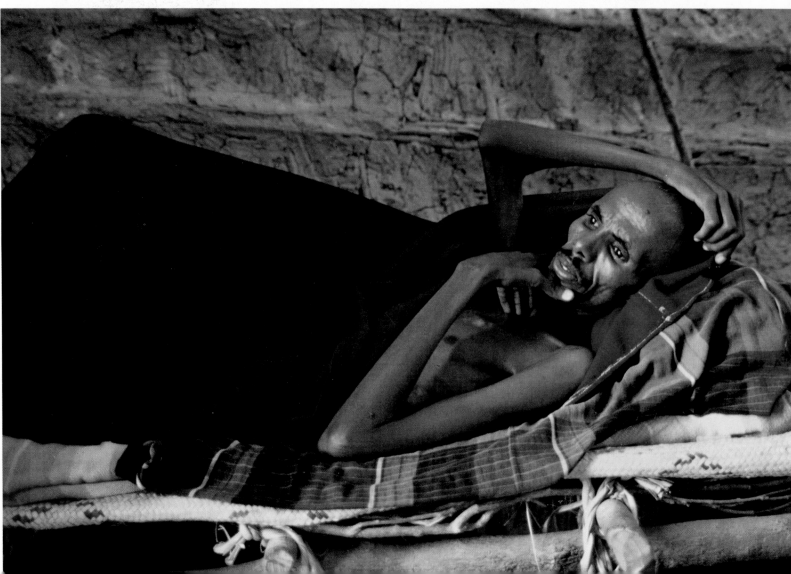

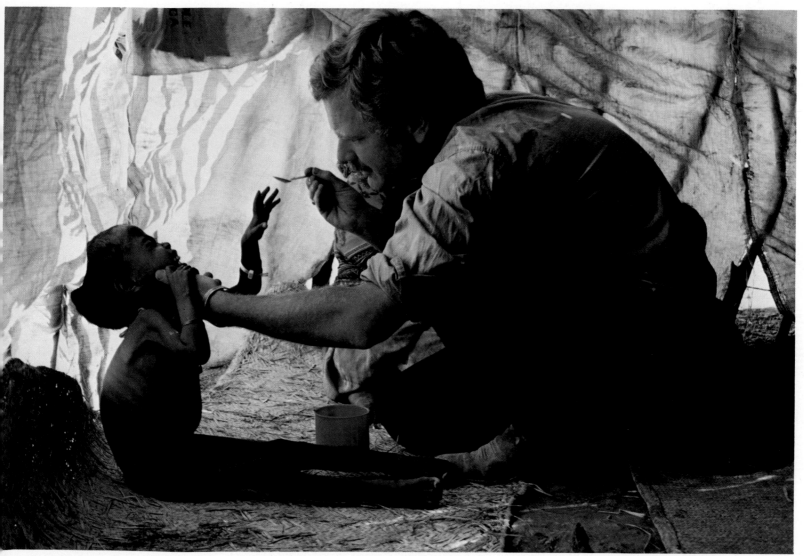

HARRY BENSON FOR LIFE MAGAZINE

A month-old infant is held by a German Red Cross worker at the Las Dhure refugee camp in Somalia. He was kept alive on a diet of sugar and water after his mother died giving birth. By the time he was brought to the clinic for treatment, malnutrition had taken too great a toll and the boy soon died.

An elderly refugee lies weakened by malnutrition and tuberculosis in a quarantined area of the camp. Once a proud desert nomad, he had become another victim of war.

In spite of severe shortages of food, water and medicine, Dr. Eric Avery fights to relieve the starving Somalian children, often forcing nourishment on those too weak to feed themselves. Twice monthly, Dr. Avery sent reports to World Vision headquarters in California, the organization that sponsored his presence at Las Dhure. From the LIFE article is quoted a portion of one of his reports: " . . . we are now out of foodstuffs and are trying to find ways of cooking dust and stones. We received assurances from appropriate authorities, then only chicken and sugar arrived . . . We do not have sufficient needles to use each day, so must each evening boil them again and again . . . The Good News is that, with the Lord's help, we are pulling together. We seem to be moving into a more relaxed form of panic. We are settling in for the long haul."

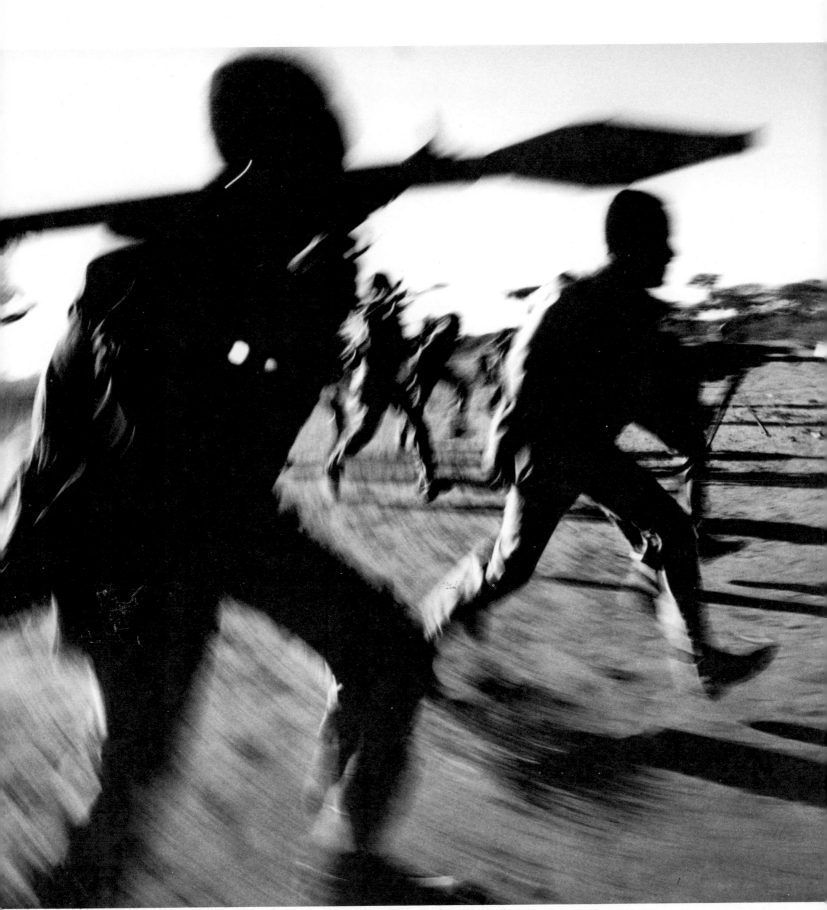

SECOND PLACE MAGAZINE PHOTOGRAPHER OF THE YEAR, KEVIN FLEMING, FOR NATIONAL GEOGRAPHIC (ORIGINAL IN COLOR, BOTH PHOTOS)

Soldiers from the Western Somalia Liberation Front advance toward Ethiopian positions. The soldiers fight a guerilla war to win back their Ogaden desert homeland from Soviet and Cuban-supported Ethiopian troops.

Seven years of drought, a depressed economy and war feed Somalia's problems as her people starve. His head shaved to prevent lice, a Somali boy cradles a baby goat outside his nomad family's hut in a refugee camp.

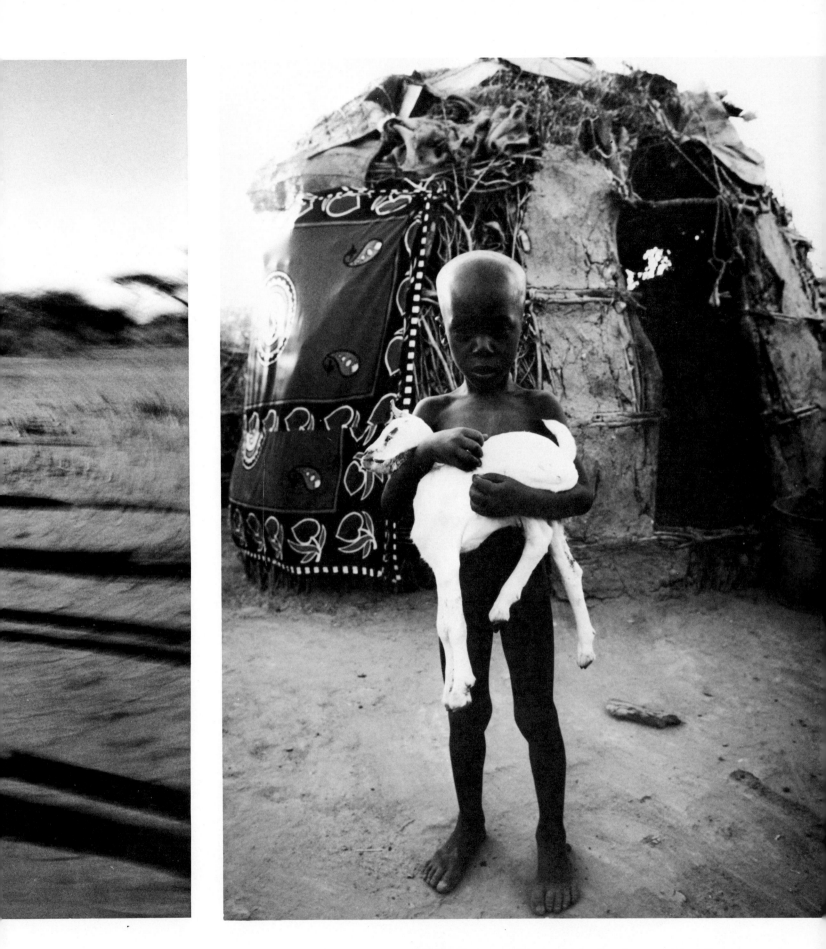

OVERLEAF: *A small boy died of malnutrition and pneumonia. For lack of space near the camp, his grave was shared. Dr. Eric Avery crouches to the left of the man bearing the boy's shrouded corpse. Only males attend the tribal burials.*

HARRY BENSON FOR LIFE

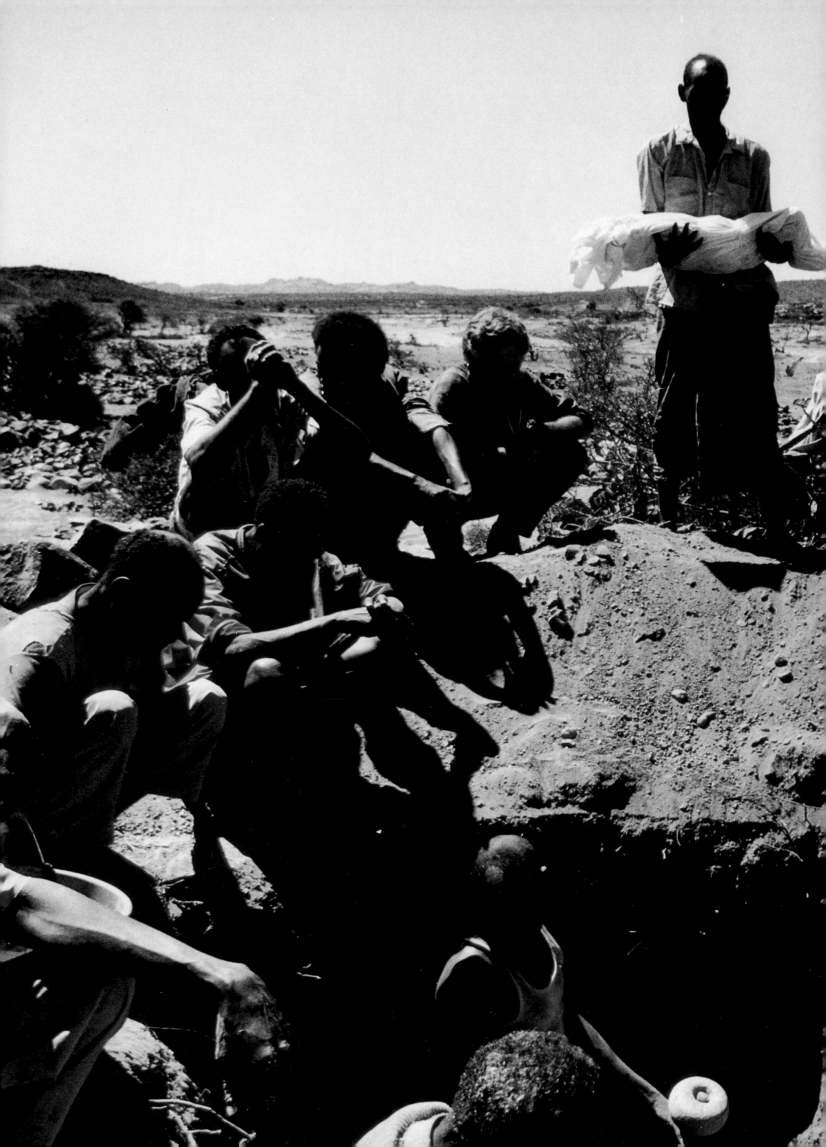

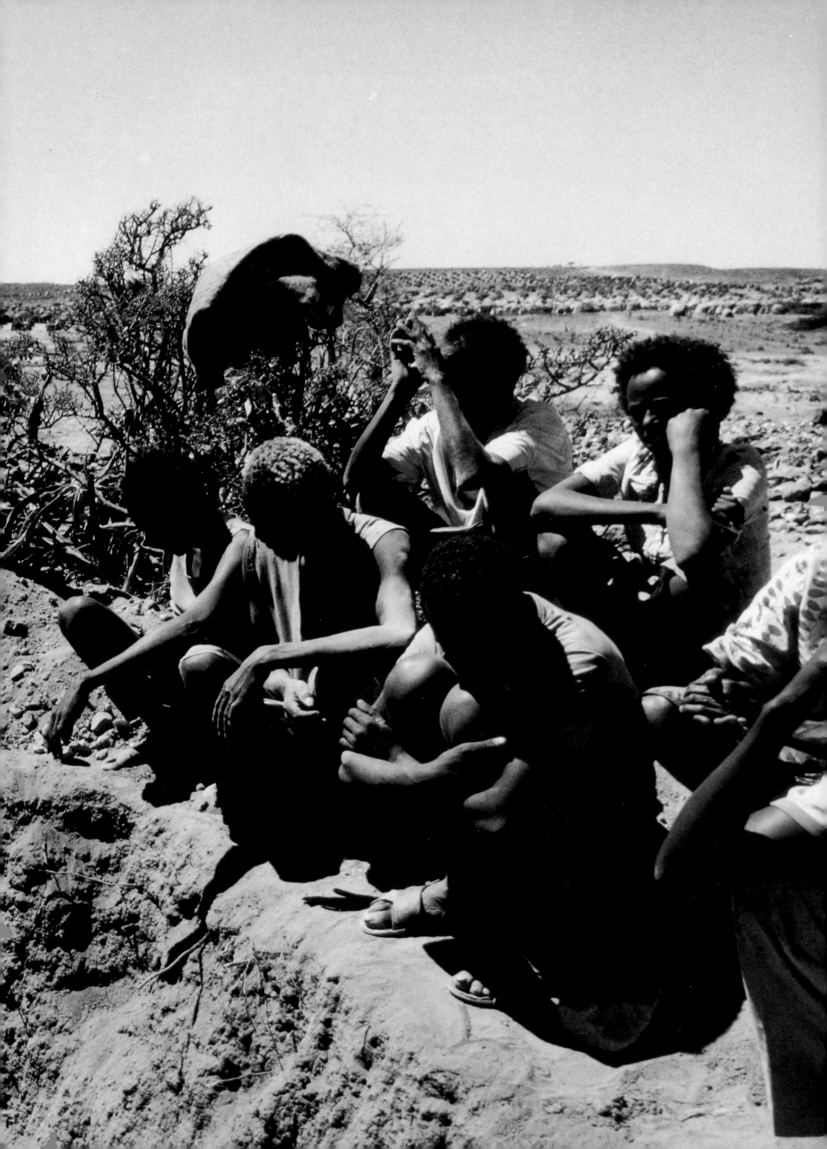

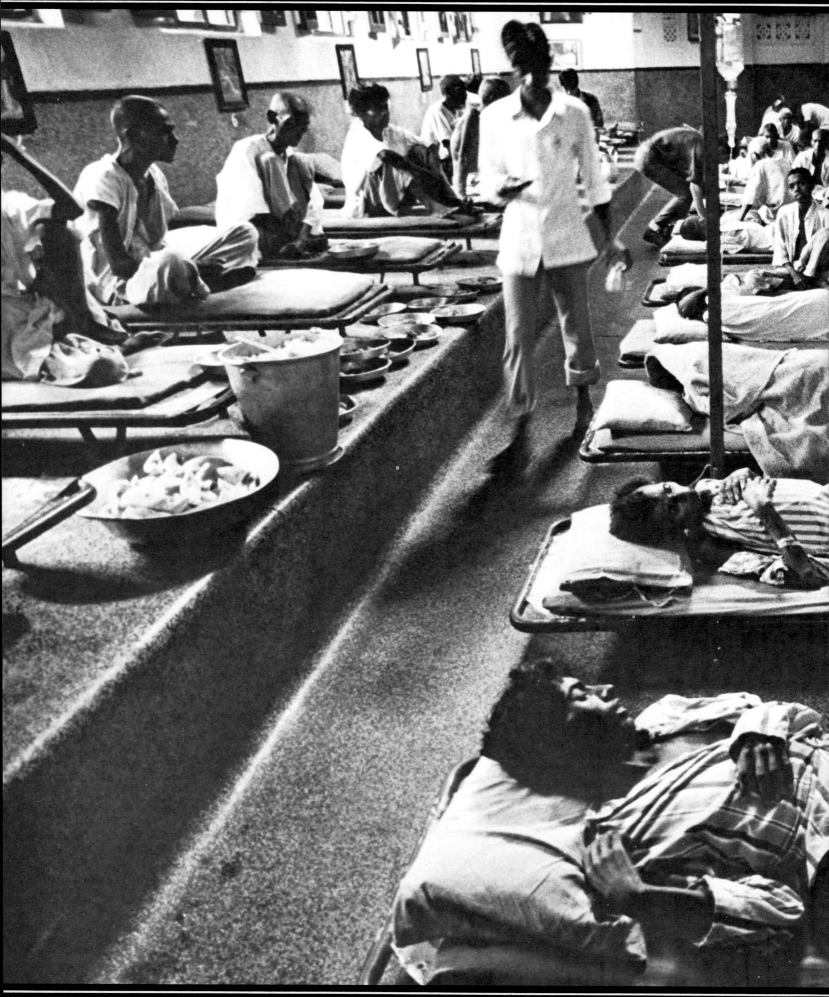

WORLD UNDERSTANDING SPECIAL RECOGNITION, KENT KOBERSTEEN, MINNEAPOLIS TRIBUNE

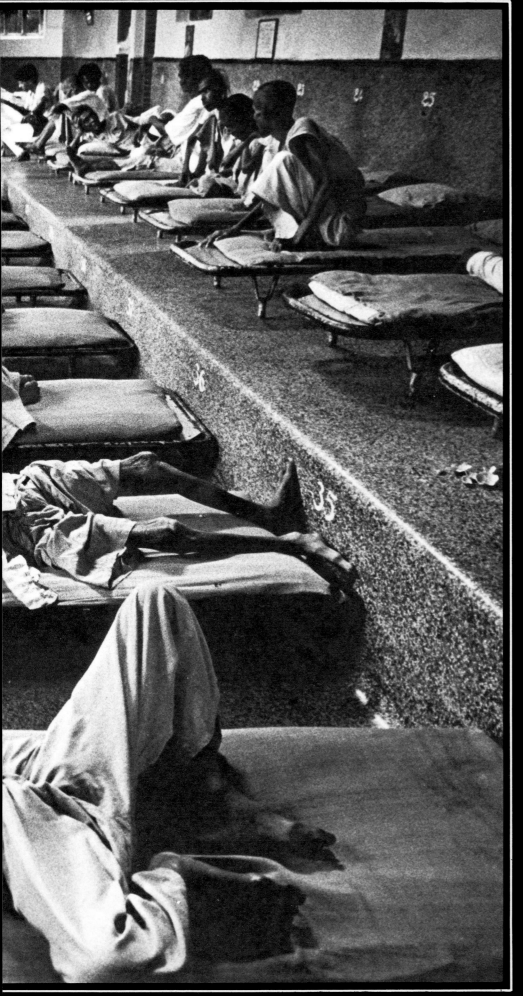

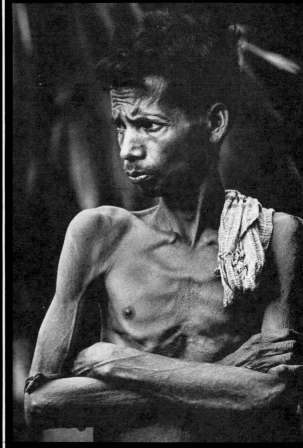

It is gloomily estimated that in the year 2000, four fifths of the world will exist in poverty and environmental chaos and that the world population will exceed six billion. The "Global 2000 Report to the President" challenges world powers to restore and protect Earth's capacity to support life and fill human needs.

The Minneapolis Tribune invested six weeks and $20,000 plus in a two-man team who surveyed poverty in six nations for an extensive series based on the U.S. Government study.

The home for dying destitutes in Calcutta (Nirmal Hriday) and the landless workers of Bangladesh were subjects in the series. Agricultural worker, Yunis Ali earns 49¢ per day when the weather is good enough to work.

OVERLEAF: CAMBODIA
Until two years ago, Phnom Penh was a ghost town after the purges of Pol Pot. Cambodians climb aboard a train headed for the Thailand border where they will pick up black market goods and smuggle them back to Phnom Penh.

HONORABLE MENTION MAGAZINE NEWS/DOCUMENTARY
DAVID ALAN HARVEY FOR NATIONAL GEOGRAPHIC
MAGAZINE

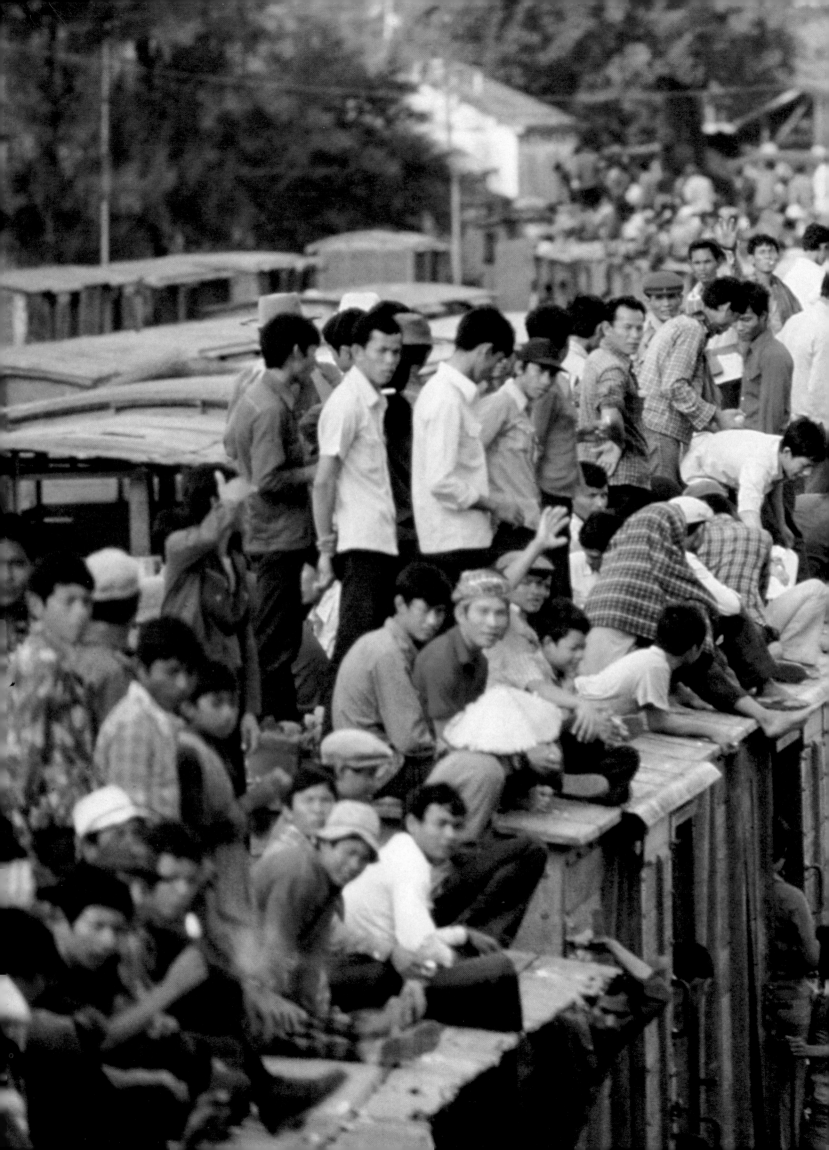

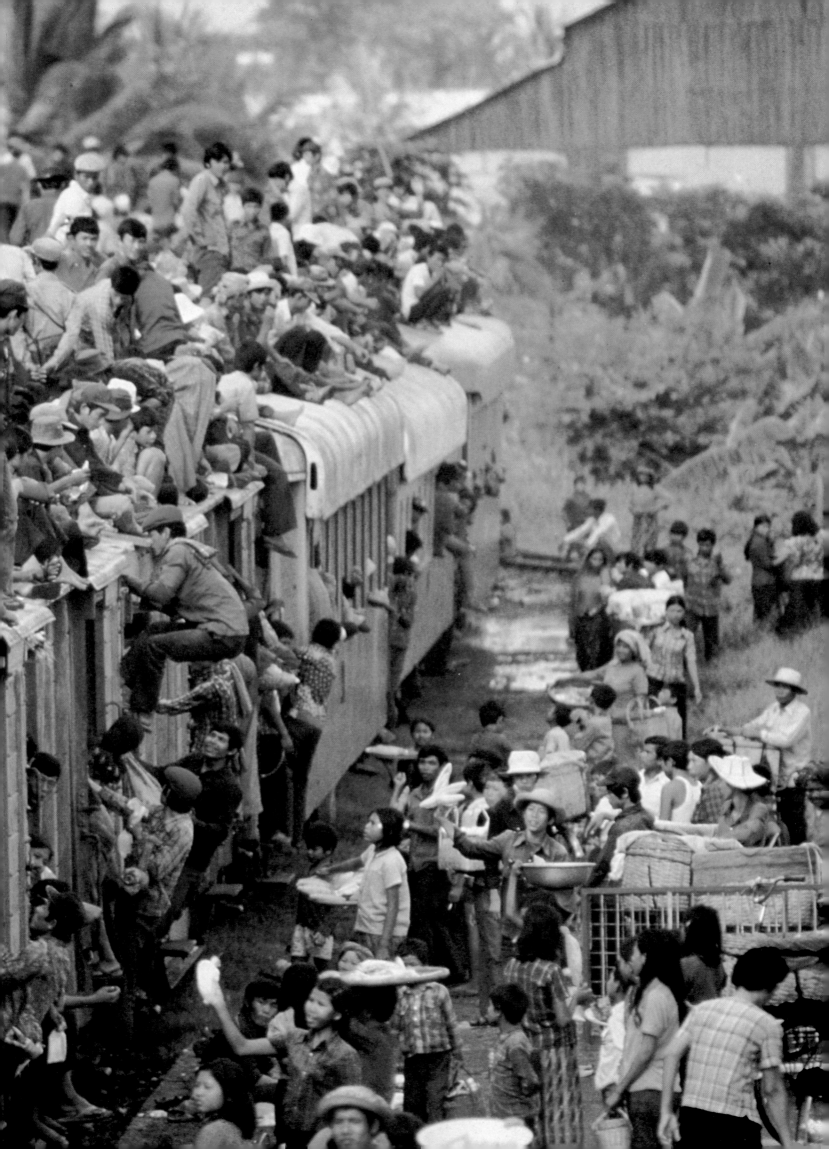

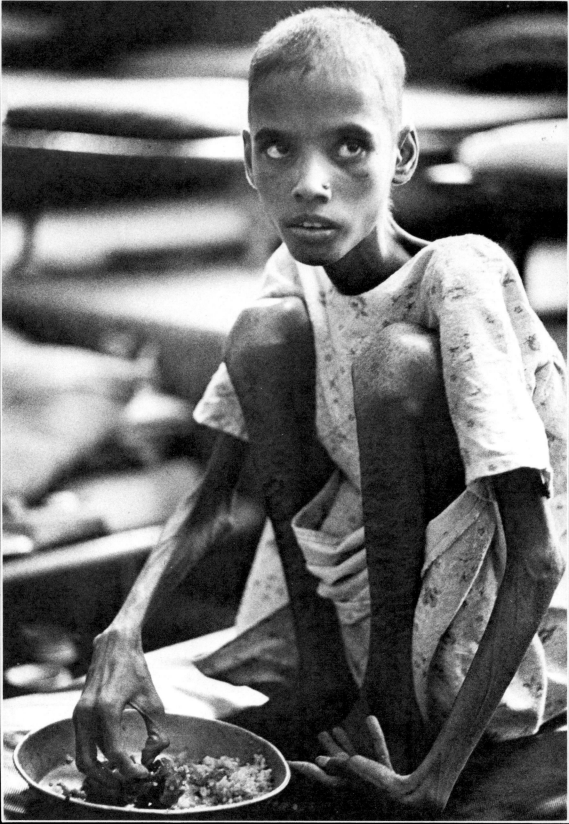

WORLD UNDERSTANDING SPECIAL RECOGNITION KENT KOBERSTEEN, MINNEAPOLIS TRIBUNE, (BOTH PHOTOS)

Writer Al McConagha and photographer Kent Kobersteen visited Mother Teresa's home for the dying and destitute in Calcutta and Al talked with Mother Teresa who said, "It is much harder to work with the poor in the United States because they feel rejected. You cannot make a person feel wanted unless you give a person love . . . we are inclined to talk much about the poor, but do very little for the poor."

In parting, Mother Teresa said, "God Bless you. Pray before you write" And Al's final lines were, "She is a woman whose wishes must be respected

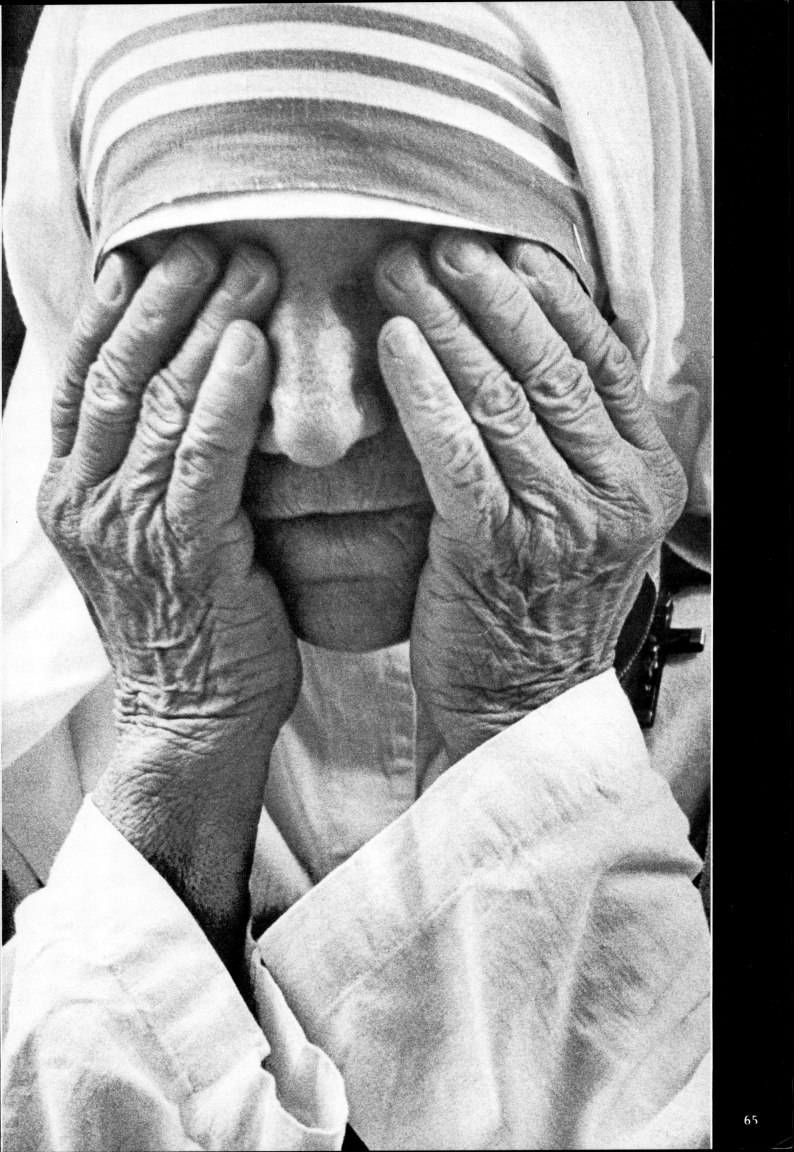

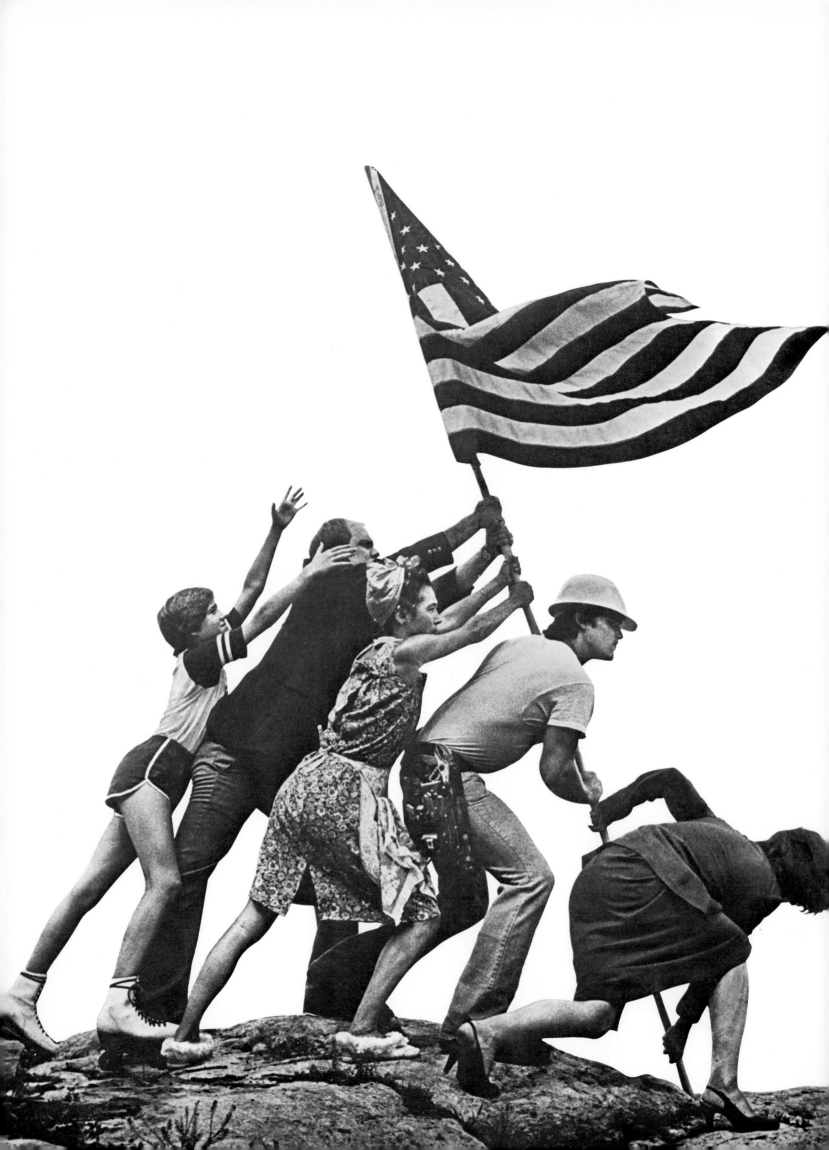

American dreams and heroes

The diverse citizenry of the United States creates a fertile mix of dreams and realities. In recording events from the everyday to the bizarre, from comedy to tragedy, the American photojournalist has one advantage over his foreign colleagues — access to people's public and private lives.

The American photojournalist may be denied access to the Pentagon but may record the birth of a child in a family's home. Recorded, too, are gentlemen who dream of winning a Lincoln look-alike contest or a Miss Gay America Pageant. A judge who waves a gun at an unruly defendant. A child prostitute who survives by his wits. The KKK soliciting donations in a public park. Iranians demonstrating against the United States. Paraplegics tackling a mountain trail. A preacher who sermonizes from the snackbar roof of a drive-in theater.

The American photojournalist is allowed to record the death of a cancer-stricken girl. Nightmares of Vietnam vets. The effects of Agent Orange on human bodies and human lives. A train of elephants and a wagon train of problem teens. The worship of astronauts and the Rolling Stones. The arrest of young black men trapping rabbits in the city. A policeman leering at hookers being booked. A prisoner showing a portrait of himself and his son. Lingerie parties, too, and Civil War reenactments. A girl practicing for a violin solo she will play during a church service.

Intentionally or not, the photojournalist makes family portraits. The Laotian family waiting at the train station. The Hollywood family. The family evicted and living in a car. The family whose breadwinner was laid-off. The logging family whose neighborhood was ruined by a volcano. The young family still in their wedding clothes, eating at a family restaurant.

Access to people's public and private lives gives the American photojournalist the opportunity to show with clarity the dreams and realities of our country.

Simplicity, symbolism and strong graphic appeal are characteristic of successful photo illustrations. The purpose of photo illustration is to render abstract concepts into clear, visual statements. Sarah Leen's picture was produced as a Fourth of July illustration to depict the resurgence of patriotism among the American people.

FIRST PLACE EDITORIAL ILLUSTRATION, SARAH LEEN, COLUMBIA (MO) DAILY TRIBUNE

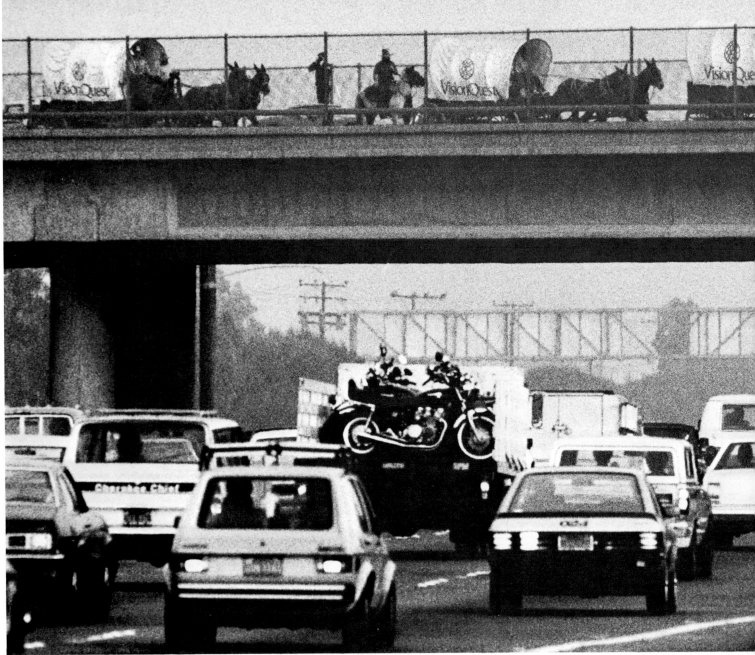

MICHAEL RONDOU, THE PRESS TELEGRAM, LONG BEACH, CALIF.

Wagon-loads of teens, some with arrest records, roll across the country supported by a privately funded rehabilitation program called Vision Quest, headquartered in Tucson, Ariz. Seventeen wagons, 90 animals and 60 staff members travel in a manner reminiscent of earlier days in America. Here, however, the group is trying to maneuver its way across the San Diego Freeway at rush hour. While waiting for the wagons to approach the bridge, Rondou was questioned by highway patrol officers who were suspicious as to why he was on the shoulder of the freeway. They were kind and allowed him to stay, even after he told them he was waiting for a wagon train.

Photographer Bruce Gilbert said that it was an unusually cheery Miami Herald. The hostages in Iran arrived in Weisbaden, Germany, and the Ringling Brothers — Barnum and Bailey Circus came to town. Since the big tent is in Miami Beach and no railroad runs near it, the circus train stops at the end of this causeway in Miami. The animals are led across it with a police escort. The fisherman ignored much of the public relations event.

BRUCE GILBERT, MIAMI HERALD

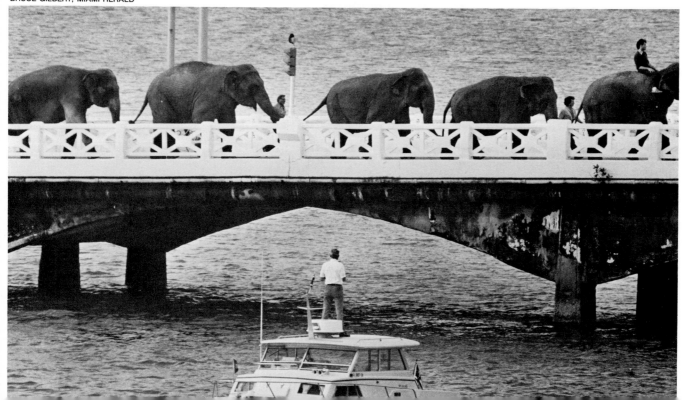

SECOND PLACE FEATURE PICTURE, RACHEL RITCHIE, PROVIDENCE (R.I.) JOURNAL

The Rev. Walter Wnek of the Centenary Methodist Church of Attleboro preached from the snackbar rooftop of the Seekonk Twin Drive-In in Seekonk, Mass. Sixteen cars showed up for the "GG" rated (God's Guidance) service that featured recorded hymns and a prison medical coordinator as guest speaker. The drive-in services were in addition to those at the minister's church in Attleboro, Mass. Rev. Wnek hoped to reach the beach crowd, the handicapped and those who associate church with the loss of a loved one.

On the first Sunday following Easter, Melissa Greenlaw practiced a flute solo she would play during the service that morning. Accompanying at the piano was Mary K. Longstreth, the deaconal minister of the United Methodist Church in Rocheport, Mo.

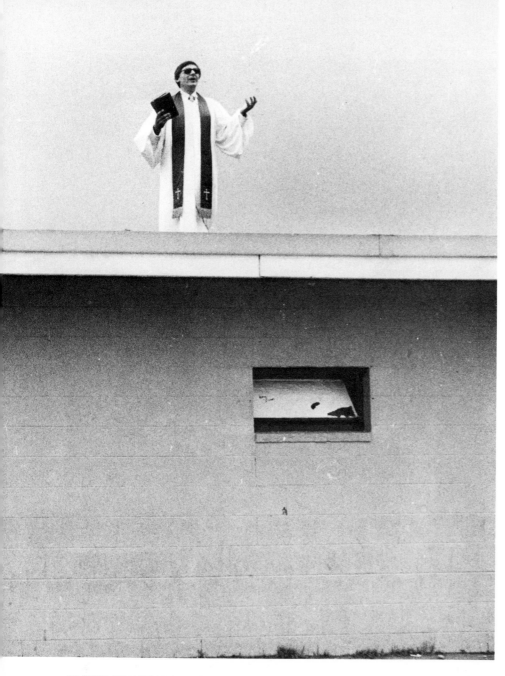

JOE EDENS, COLUMBIA MISSOURIAN, COLUMBIA, MO

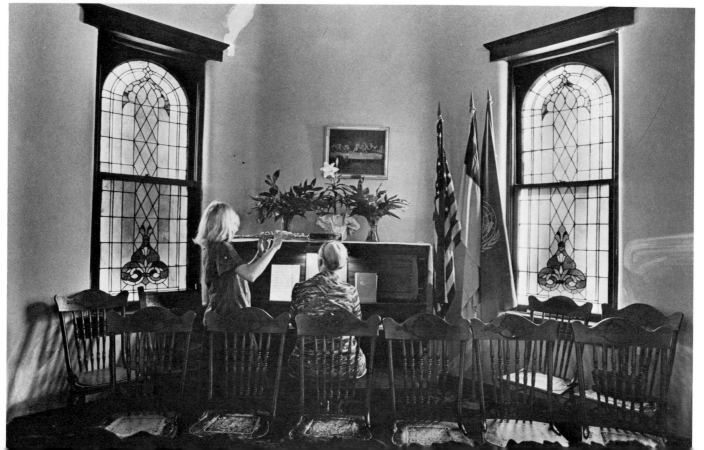

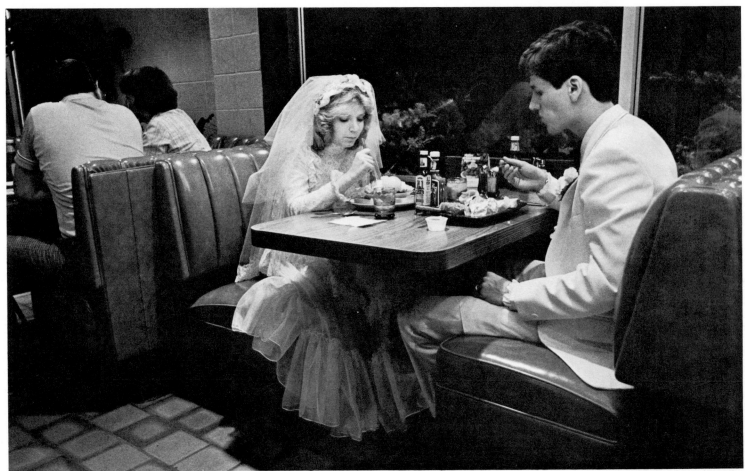

FIRST PLACE FEATURE PICTURE, OWEN STAYNER, HERALD JOURNAL, LOGAN, UTAH

After husband Doug cut the cans loose, wife Roseann insisted they do something bizarre. The Hutchins were famished after their reception, so they went to J.B.'s Big Boy in Logan, Utah, where Owen Stayner had stopped for a snack after working late at the Herald Journal. Stayner asked for a photograph. The couple clowned around until their food arrived. Several weeks later, the Hutchins asked the paper to take a picture of them smiling in regular clothes because everybody thought they looked depressed. Theirs was one of 30 weddings that week in a town of 30,000, Stayner said.

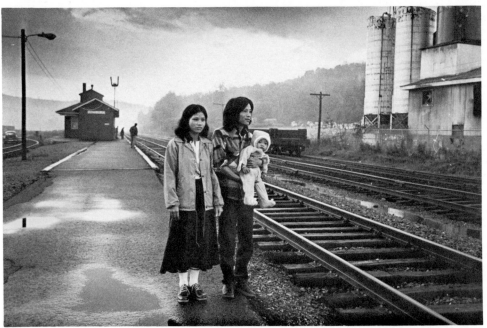

ELAINE ISAACSON, THE BURLINGTON FREE PRESS, BURLINGTON, VT.

A Laotian couple awaits family members who arrive on an early morning train at the Montpelier station in Vermont. The Migna family, husband Khansevanh, his wife Oudephone and their baby boy, Vichitpanh received church sponsorship in Vermont.

The Allen Gould, Jr., family gathered in front of their woodpile for a family portrait. Gould is a "gypo," an independent logger, who works the area around Mount St. Helens. Chris Johns was doing a story on the stress of living and working near the volcano.

CHRIS JOHNS, SEATTLE TIMES

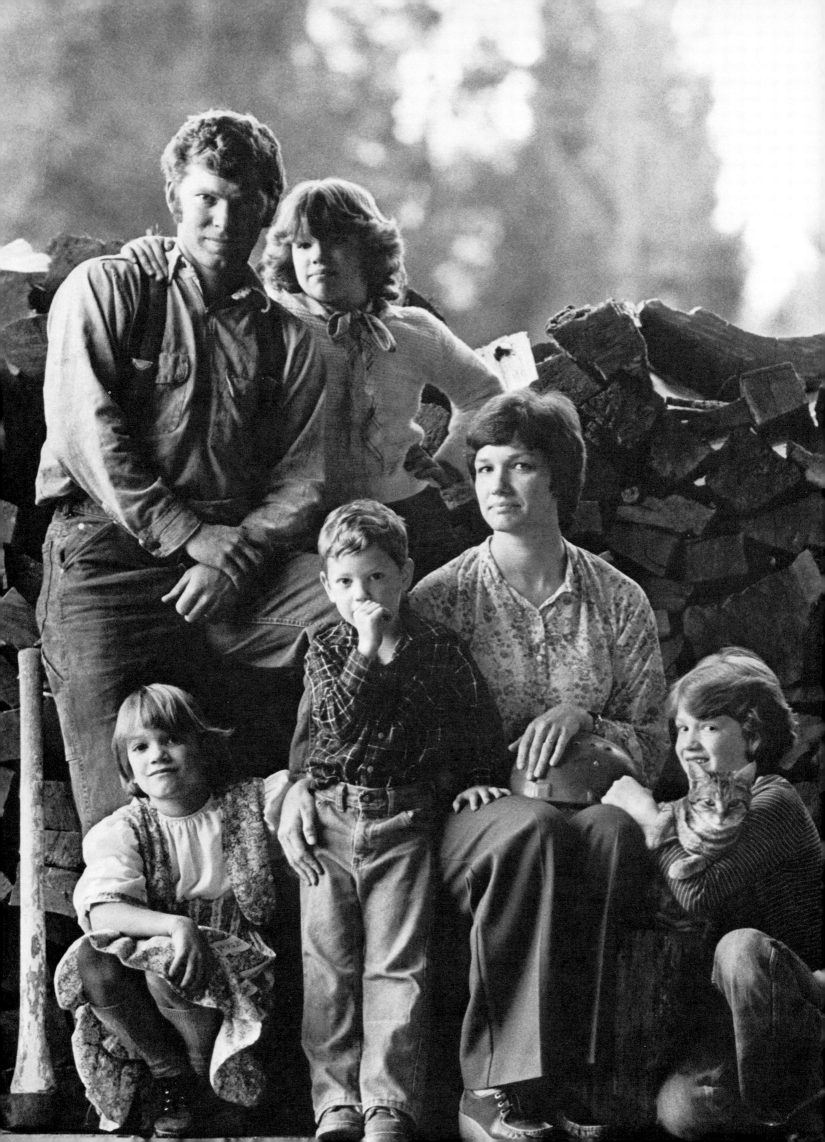

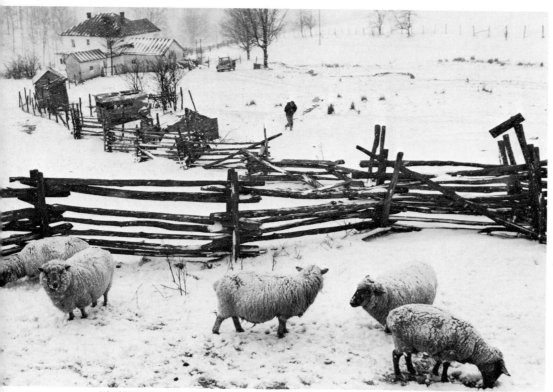

HONORABLE MENTION MAGAZINE PICTORIAL DAVID ALAN HARVEY, NATIONAL GEOGRAPHIC (ORIGINAL IN COLOR)

A Virginia farmer comes to check his flock of sheep during a mountain snowstorm. The picture is from a personal work on Virginia by David Alan Harvey.

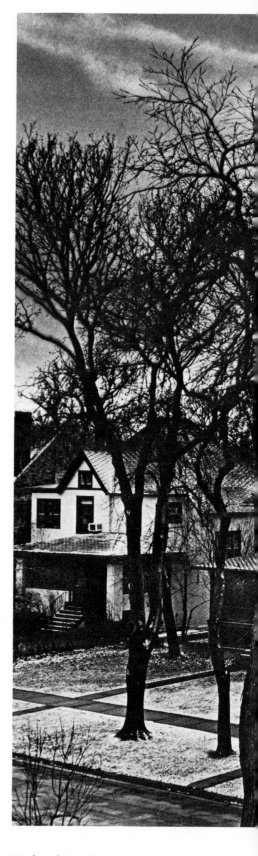

Richard Derk was checking the sunset every so often while working on prints at his home on Scoville Street in Oak Park, Ill. In a period of 40 minutes, three people walked down the block before a fourth stepped into the right place. Derk used a little dodging and bleach to highlight the snow.

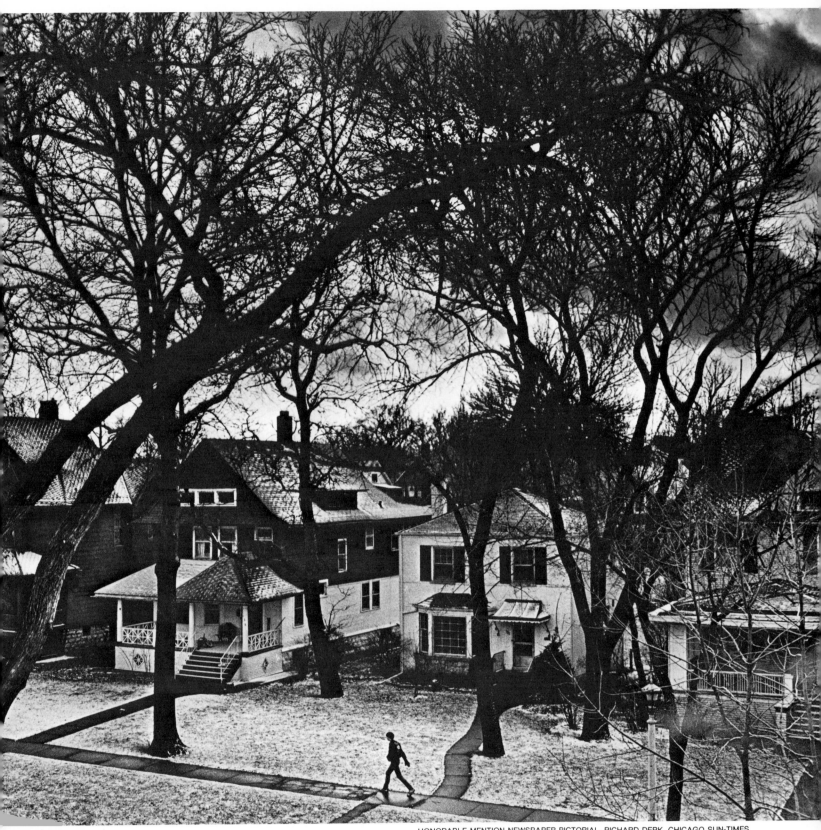

HONORABLE MENTION NEWSPAPER PICTORIAL, RICHARD DERK, CHICAGO SUN-TIMES

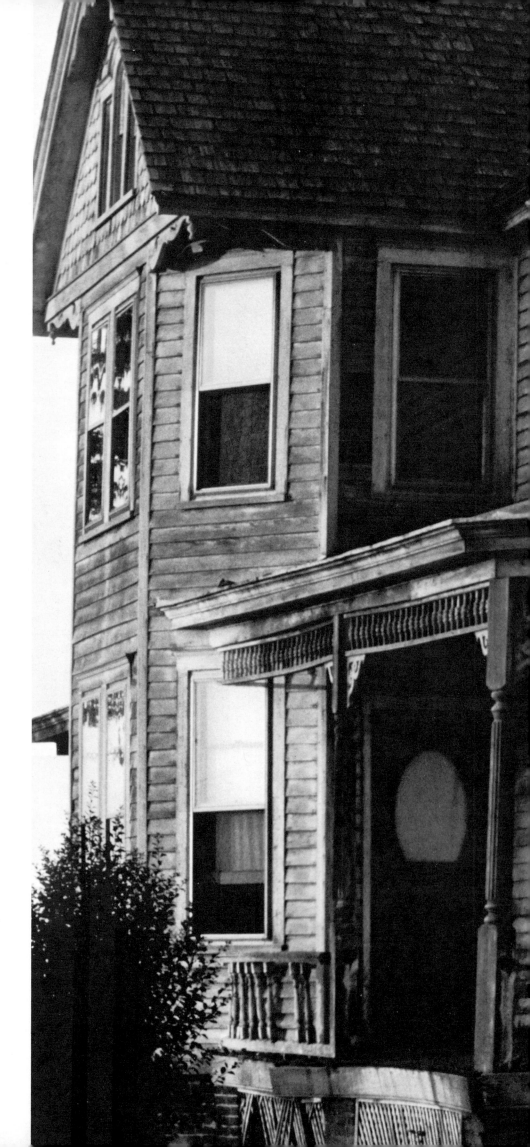

A Delaware farmer watches the sunset from the porch of his house which he says hasn't been painted in more than 40 years. "I'll get to it one day," he says. Meanwhile, the old house is painted with light every day the sun shines.

RUNNER UP MAGAZINE PHOTOGRAPHER OF THE YEAR, KEVIN FLEMING, NATIONAL GEOGRAPHIC (ORIGINAL IN COLOR)

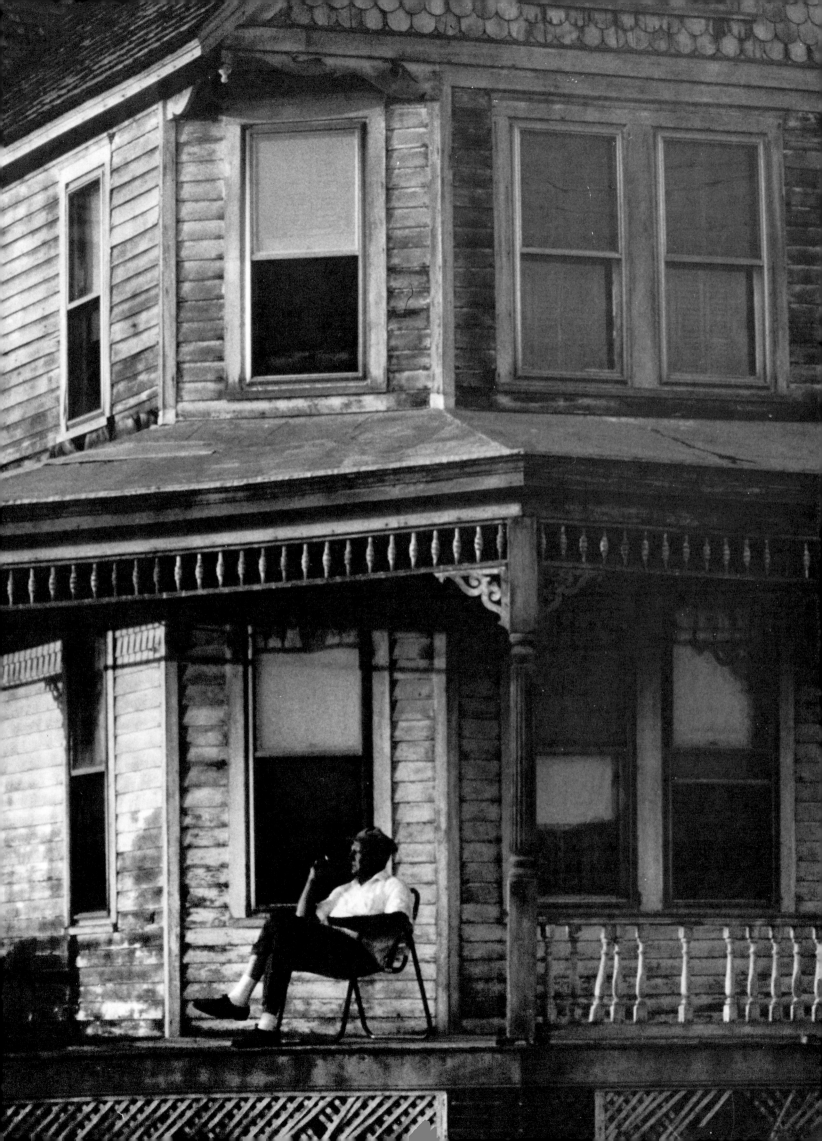

RUNNER-UP NEWSPAPER PHOTOGRAPHER OF THE YEAR, BRAD GRAVERSON, DAILY BREEZE, TORRANCE, CALIF.

JIM BYE, VIRGINIAN-PILOT/LEDGER-STAR, NORFOLK, VA

Said to be more fun than parties where women buy plastic jugs, jewelry or cosmetics, this gathering is one of many where women model lingerie and "exotic" undergarments. Products labeled "Pleasure Balm" and "Taste of Love" are popular, along with electric vibrators and edible panties. The Los Angeles based group sponsoring the events may be saving marriages. One participant said, "Lingerie parties are destined to save marriages by putting emphasis in the proper place."

This portrait of a woman preparing a 19th-century-styled meal of cabbage and potatoes is one of several pictures made at a Civil War reenactment near Smithfield, Va. Both writer and photographer were to perform as Civil War correspondents and their story appeared as a full page in the Virginian-Pilot/Ledger Star; the photos were a sepia-tone tint. The woman is Dale Cronce; her husband, Michael, was taking part in a skirmish with other "soldiers" in the historical drama.

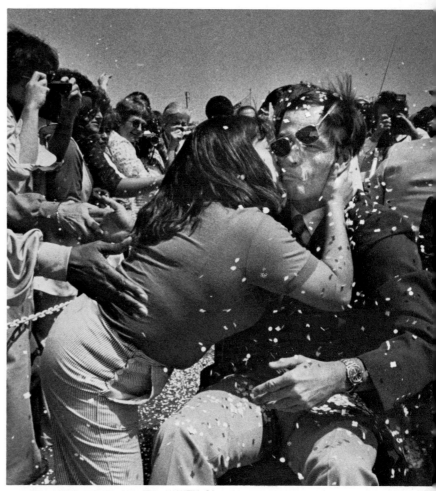

MICHAEL PILGRIM, ANAHEIM BULLETIN, ANAHEIM, CA.

The American public has affectionately welcomed and congratulated their real-life space heroes since the first moonwalk of July, 1969. An exuberant woman hopped a chain barrier to plant a big kiss on astronaut Robert Crippen when he and fellow-astronaut John Young visited Rockwell International to thank the personnel there for the "perfect" space craft, the space shuttle, Columbia.

American heroes historically include stars of stage and screen. The success of Star Wars brought actor Mark Hamill to fame. Benson photographed the Hamill family, Mark, wife Marilou and their two-year-old son Nathan in New York's Central Park.

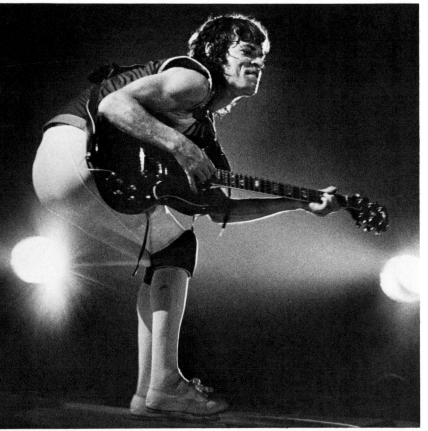

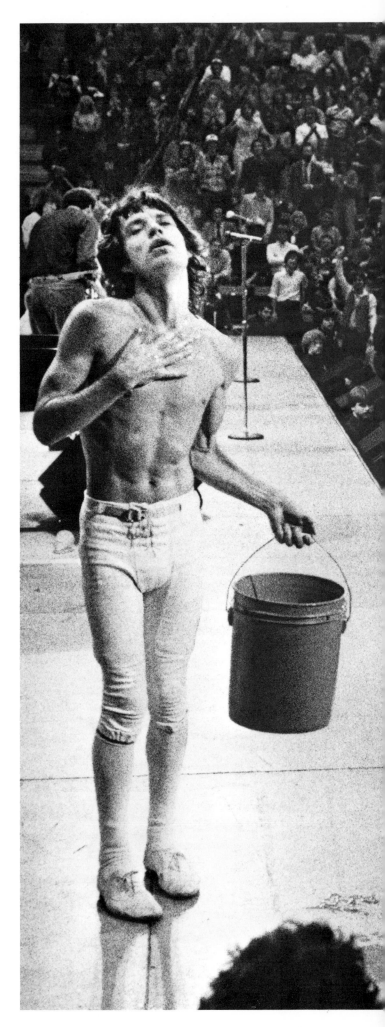

PERRY C. RIDDLE, CHICAGO SUN-TIMES

In Chicago, Mick Jagger, 38, leader of the Rolling Stones, grinds out a lick on a wireless guitar. On their first U.S. tour since 1978, the Rolling Stones pranced and strutted before sellout crowds. Wireless microphones and guitars allowed greater freedom of movement. The tour grossed $30 to $40 million.

At concert's end in the Rockford Metro Centre in Rockford, Ill., Mick Jagger cools himself with a touch of water. Jagger threw several bucketfuls at the fans who had petitioned the Rolling Stones to come to Rockford. Richard Derk said that Jagger establishes a greater rapport with audiences by letting them see through his stage persona. The stage set-up was a throwback to the Sixties . It was also the only Rolling Stones concert Derk covered where he had access to the stage.

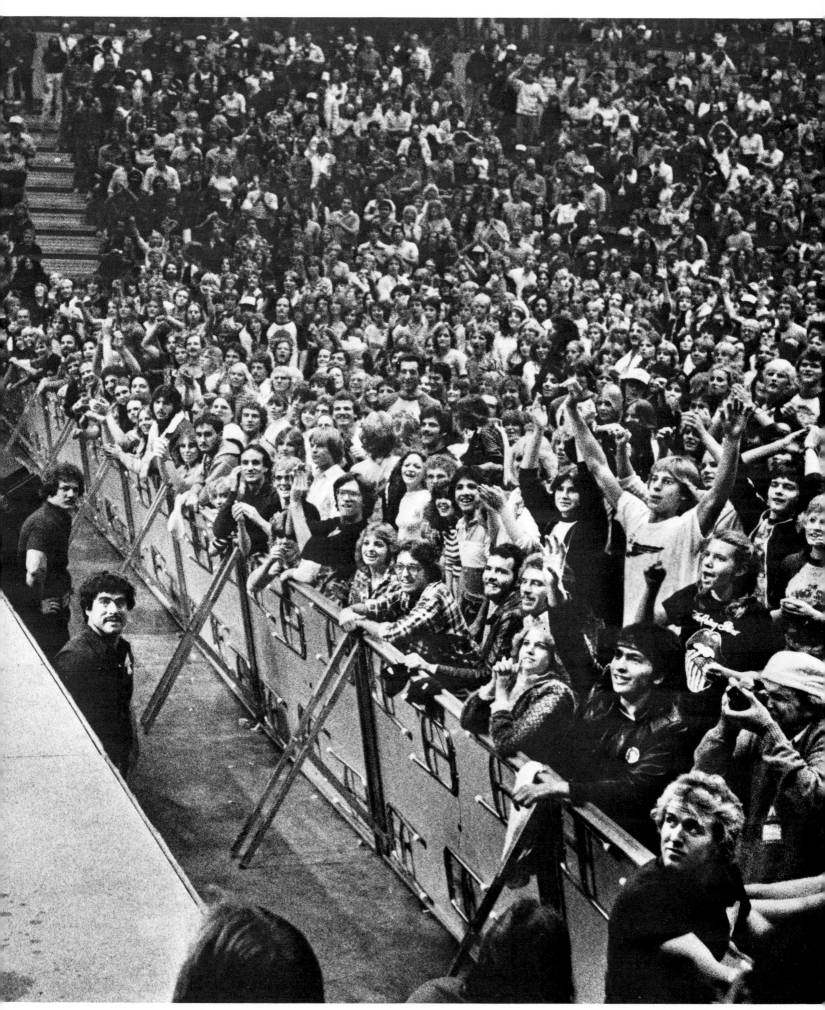

RICHARD DERK, CHICAGO SUN-TIMES

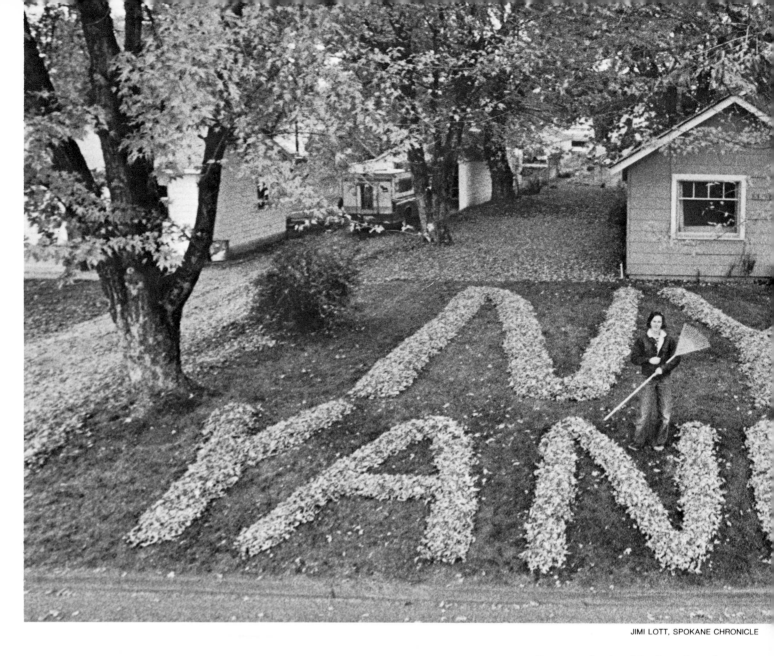

Born and raised in Los Angeles, Jodi Malan might have grown up as a fan of the L.A. Dodgers. The fact is that she is a Yankee fan and created a leafy testimony in front of her home in Yamika, Wash. The photographer's title for this picture; "a true be-leaf-er."

Lincoln look-alike contestants await the judges final decision at the Springfield, Ill. first annual Lincoln Fest.

LINDA SMOGOR, ILLINOIS TIMES

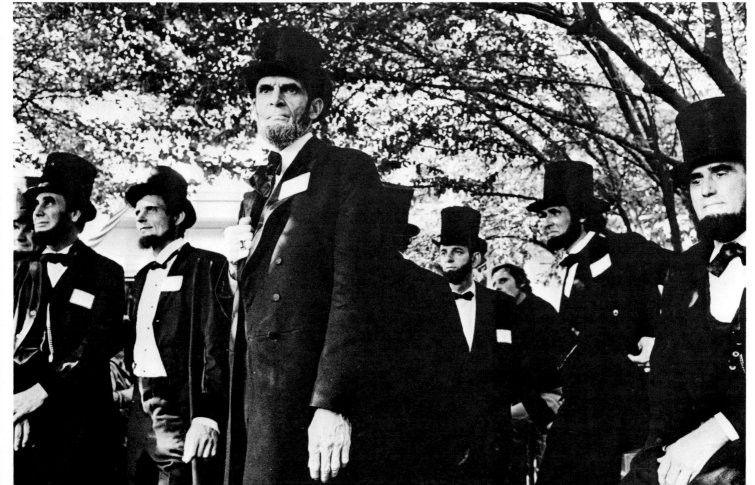

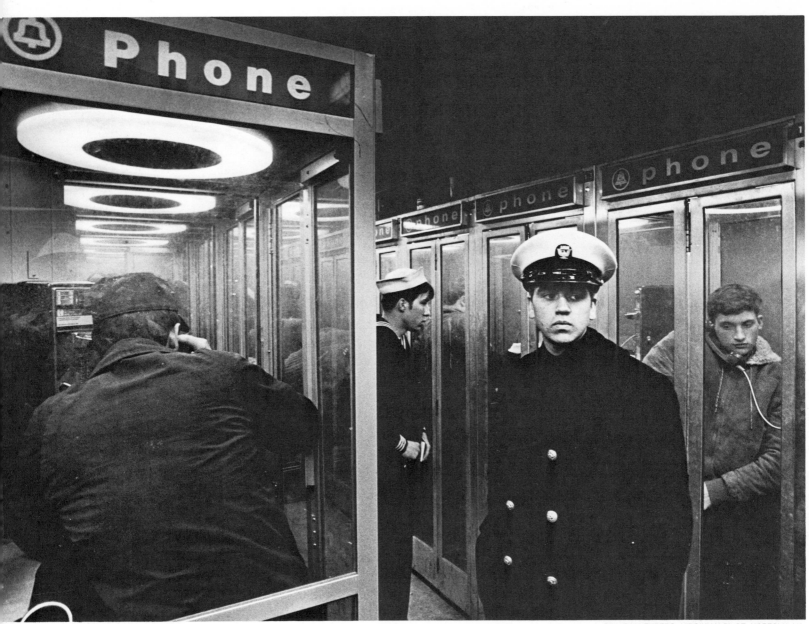

BILL BALLENBERG, VIRGINIAN-PILOT, NORFOLK, VA.

On the night before Thanksgiving, the nuclear aircraft carrier, Eisenhower, was delayed by bad weather for nine hours. The reporter and photographer expected a mad dash to the telephones once the carrier docked in Norfolk. What they found instead was a mood of quiet exasperation. Seaman Lawerence Hager of Cincinnati was among those who waited for a telephone to schedule his route out of Norfolk.

Pvt. Matthew Mittelstadt was one of 43 members of a Marine platoon who passed all the tests for the "making of a Marine" and graduated on time. There were 28 others who were either dropped from the platoon or graduated later. Some dropped out of the Marine Corps altogether, adding credibility to the Marines advertising for only "a few good men."

THIRD PLACE FEATURE PICTURE STORY, JAMES BAIRD, TIMES-ADVOCATE, ESCONDIDO, CALIF.

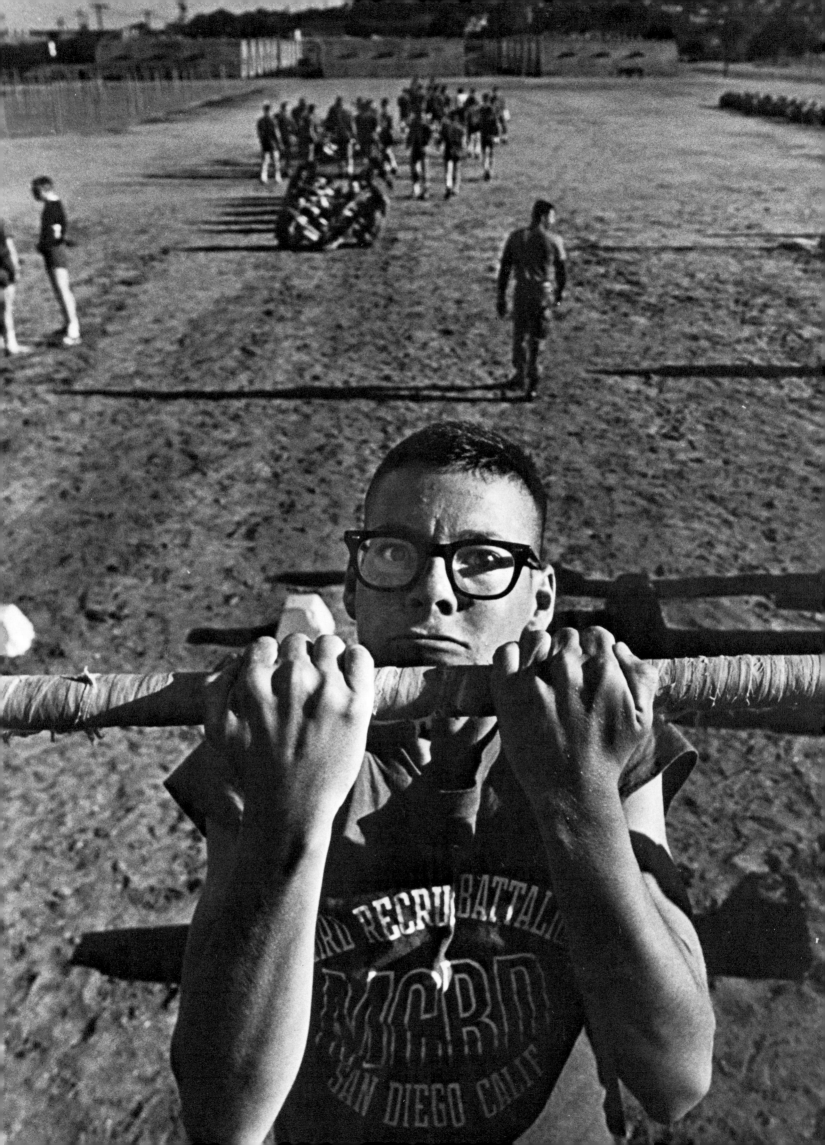

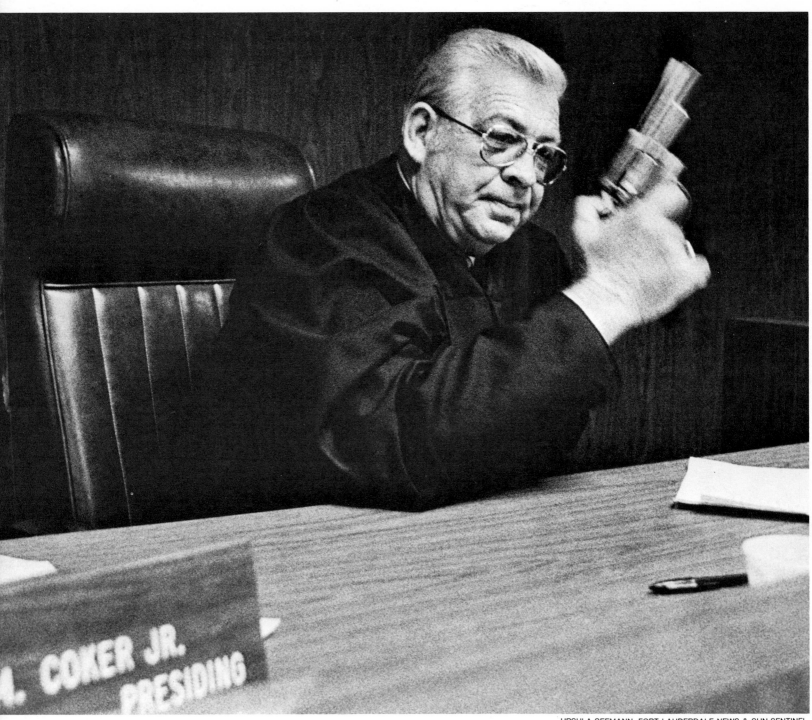

In a Florida courtroom, a dozen security persons were needed to subdue an unruly defendant who threatened the judge. He rushed to his chambers and brought back a gun which he kept on his bench for the remainder of the proceedings.

After a near-riot situation forced a "lock-up" at the Bristol County House of Corrections in New Bedford, Mass., prisoners requested that the Standard Times view the poor living conditions. John Scheckler found a prisoner who crafted string art around a computer-graph of his son.

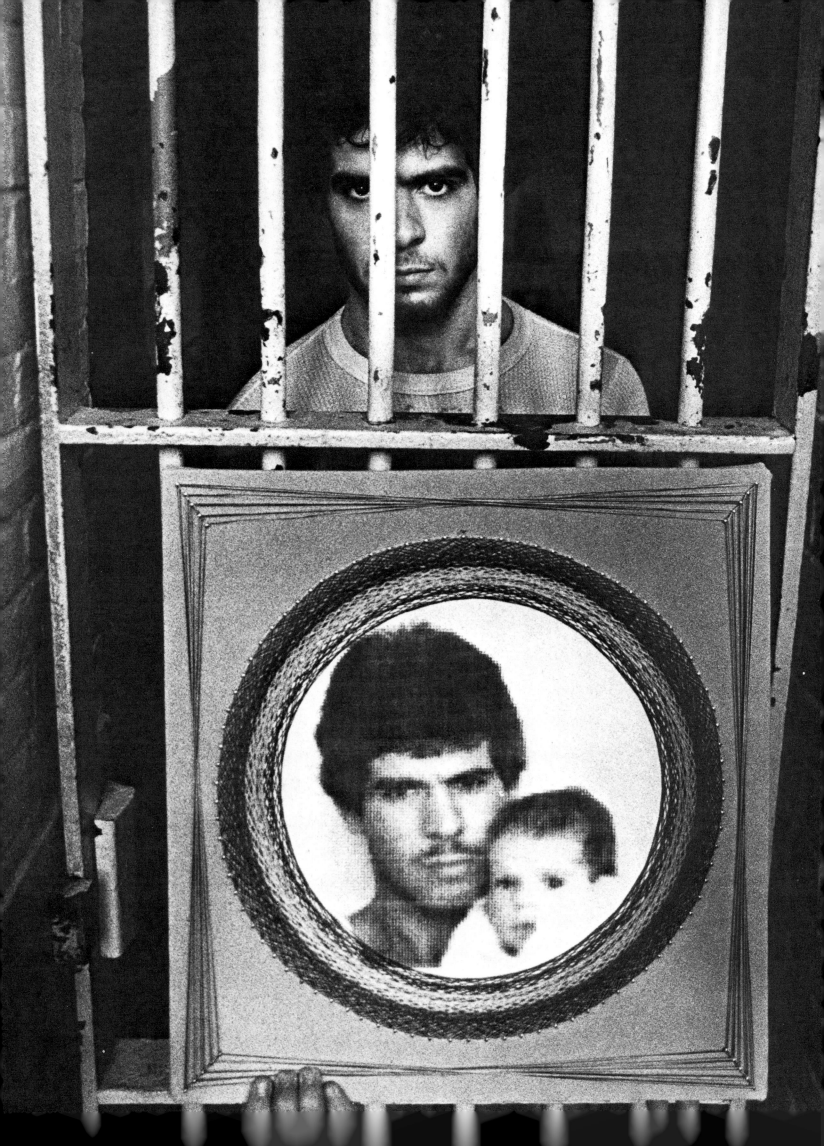

THIRD PLACE NEWSPAPER PHOTOGRAPHER OF THE YEAR, GARY PARKER,
FLORIDA TIMES-UNION & JACKSONVILLE JOURNAL

*Victorian fashions were the subject
for this photo illustration which
capitalizes on atmosphere to sell
ruffles and lace. Doll and model
are dressed similarly, suggesting
girlish innocence. The original
photograph is in color.*

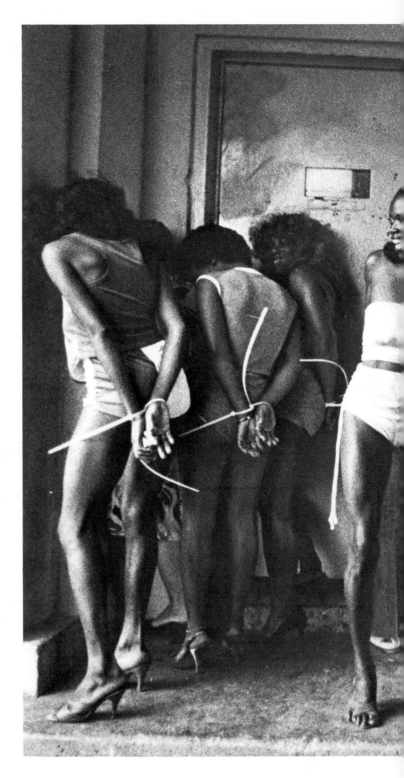

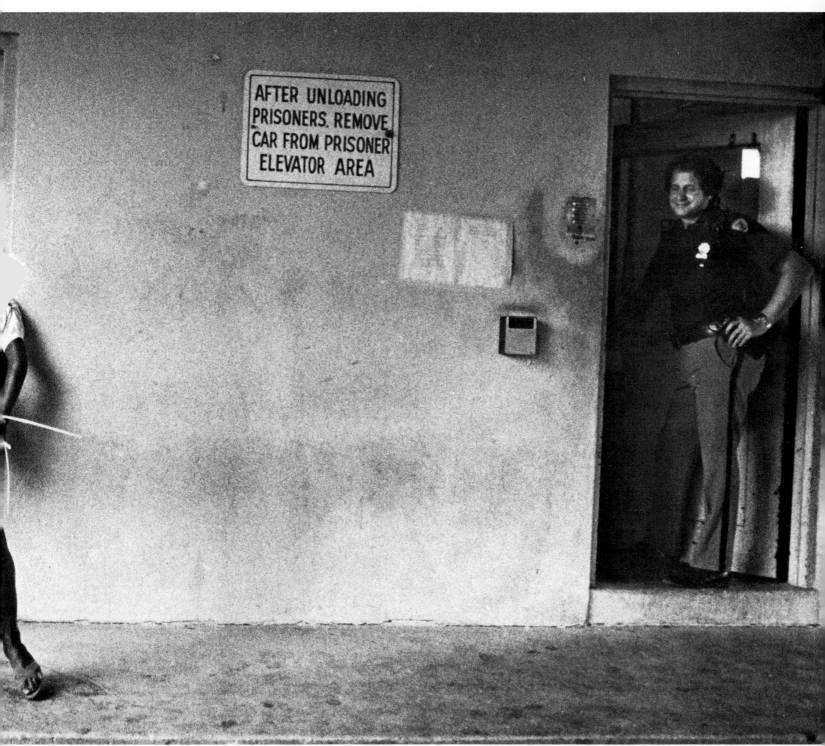

Police officer Alan Stone kept a watchful eye on a group of women arrested for prostitution in Ft. Lauderdale, Fla. Since 1978, Broward County has taken on the pressure of a rising rate of prostitution because of Miami and Dade County efforts to crack down with mandatory jail terms and fines — even for first time offenders. The women are bound with plastic handcuffs. Trainor's picture was printed across five columns of a Broward News section front in the Miami Herald. The picture and story lead to an inside double-truck on the issue of prostitution with a headline suggesting that Dade's harsh law was turning Broward into a hooker's haven.

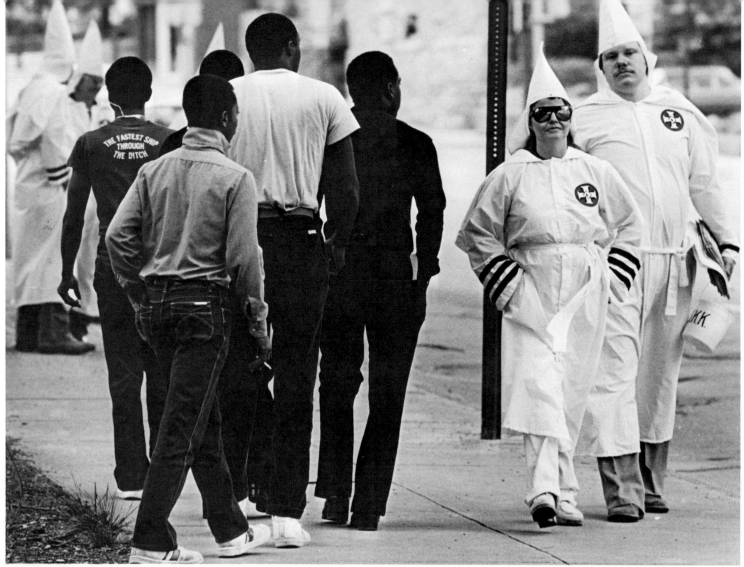

SECOND PLACE GENERAL NEWS, WAYNE SCARBERRY, ROANOKE, (VA) TIMES & WORLD NEWS

PAUL CHINN, LOS ANGELES (CALIF.) HERALD EXAMINER

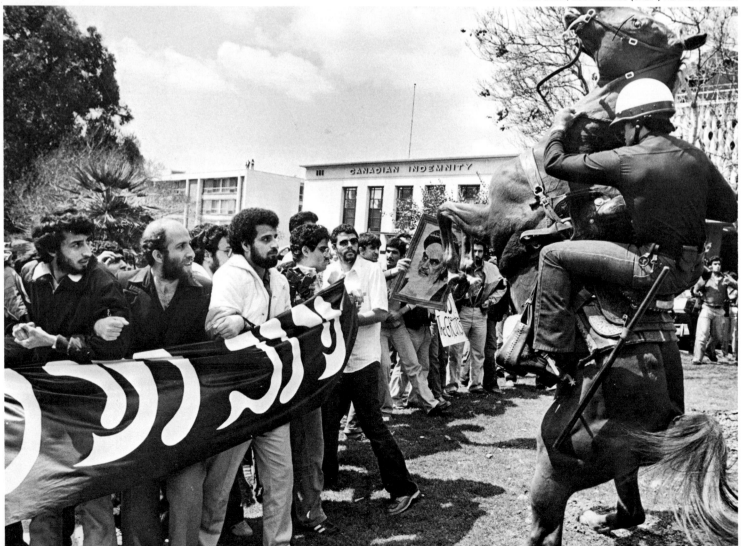

Members of the KKK were soliciting donations in a public park and ignored a group of young black men who were walking the opposite direction. Wayne Scarberry said sharp words were exchanged, but there was no trouble between the men and the KKK solicitors.

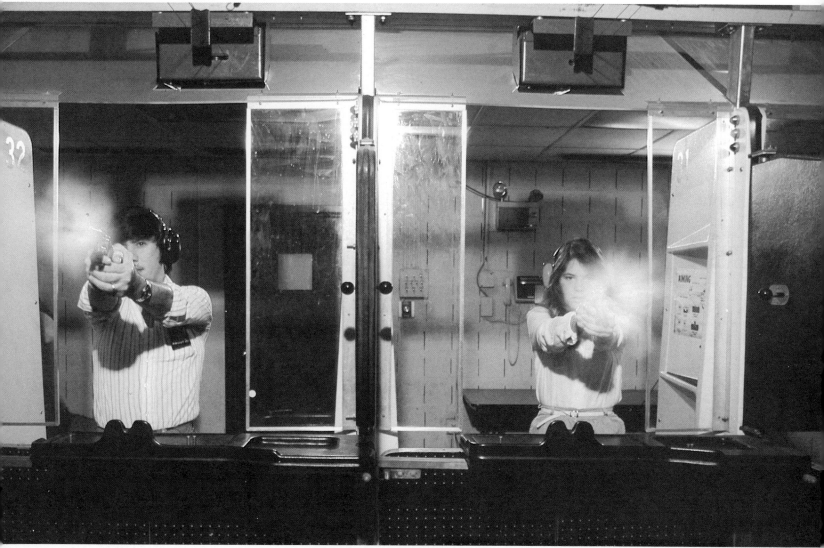

SECOND PLACE MAGAZINE PUBLISHED PICTURE STORY, JOSE AZEL, FREELANCE FOR GEO (ORIGINAL IN COLOR)

The Los Angeles Police Department sponsored this unofficial mounted patrol in their effort to control a group of pro-Khomeini Iranian demonstrators who were throwing rocks and bottles. The L.A.P.D. recently recognized the volunteer patrol as an official department unit.

Freelancer Jose Azel produced pictures for a lengthy story on Dade County, "The Melting Pot Boils," in GEO magazine. This picture was the lead spread in color and visually emphasized that street crime in Miami is sending more and more people to gun shops and practice ranges like this one. The opening copy stated that "Miami and its environs are a laboratory for a social experiment whose elements include racial discord, skyrocketing real estate values, galloping unemployment, a booming drug smuggling industry and torrents of unassimilated refugees. The laboratory may blow up."

NEWSPAPER PHOTOGRAPHER OF THE YEAR, DAN DRY,
COURIER-JOURNAL & LOUISVILLE TIMES
(BOTH PHOTOS FROM DRY'S PORTFOLIO)

Recession:
a loss of jobs
a loss of dreams

*Faced with no job, David Tierny
had time on his hands. He drinks
coffee at the United Auto Workers
Union Hall. "I think I would just
dry up and die if it weren't for the
Union," he said. "When the layoffs
hit, it took everything we saved
just to keep some of the bills
paid." He and his wife, Nancy,
study statements to decide which
bills must be paid immediately and
which they can let slide for awhile.*

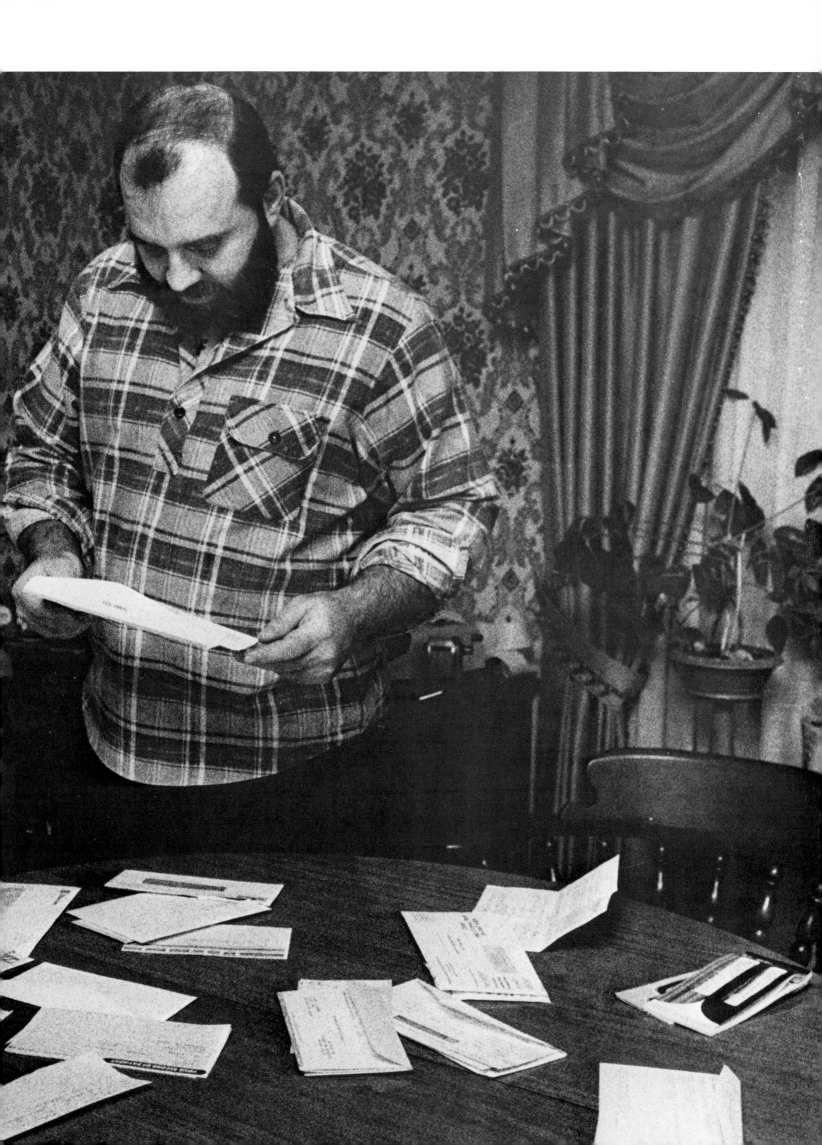

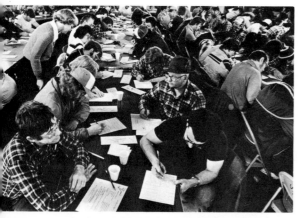

CHUCK KNEYSE, THE IDAHO STATESMAN, BOISE, IDAHO

Every chair was filled as more than 150 laid-off employees of the Bunker Hill Company filed insurance claims. Department of Employment officials added an afternoon session at the United Steelworkers' Union Hall to handle those who had to be turned away from the morning session. The firm's parent company had announced that due to depressed metals prices they were closing down the company.

The Mullins family portrait might easily symbolize the number of families who cannot pay rent, are evicted from their apartment and for awhile live out of their car. Help came to the Mullins family from a woman in the community. Many other families still seek relief from hard times.

WALTER STRICKLIN, FLORIDA TIMES-UNION,
JACKSONVILLE, FLA.

96

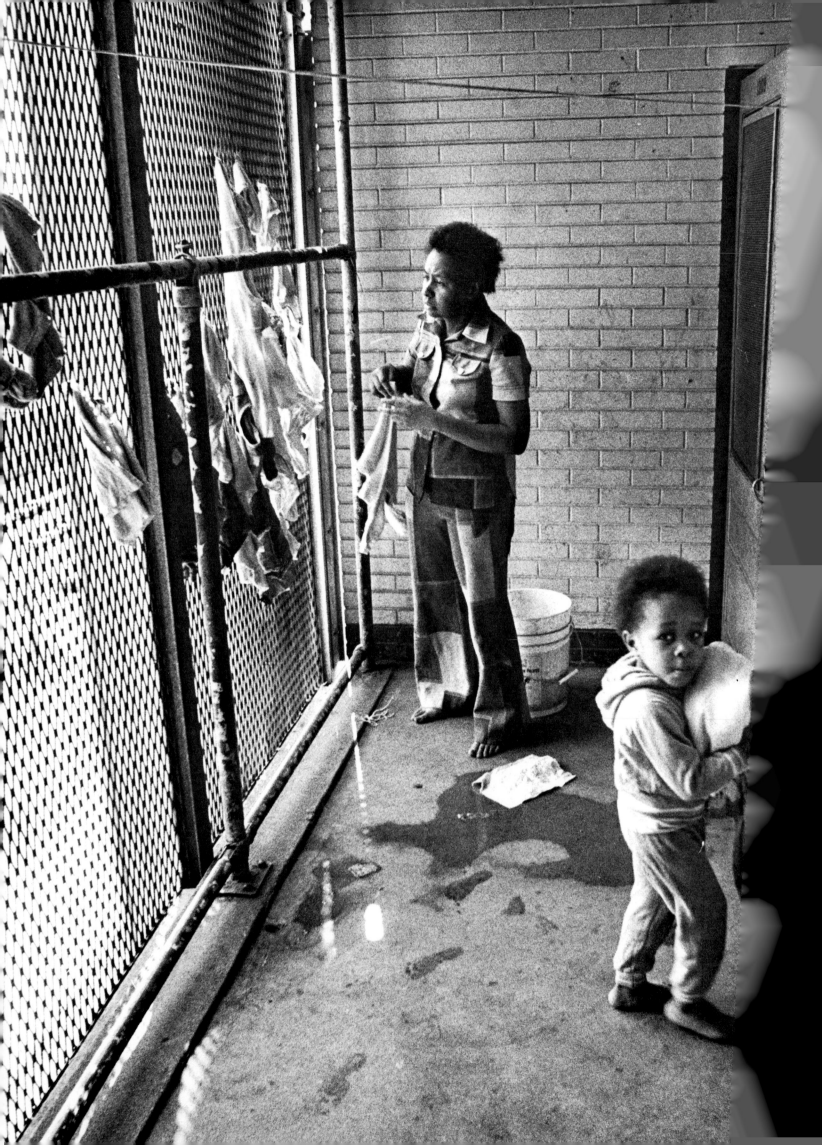

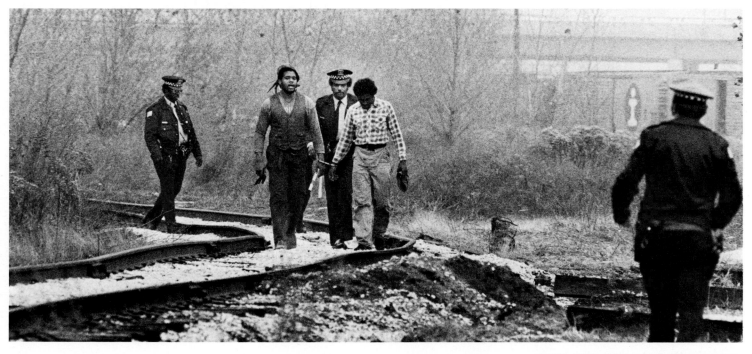

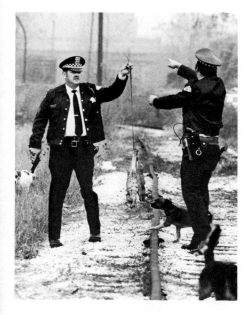

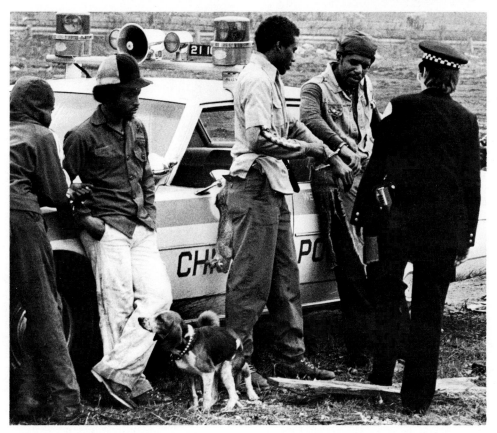

Cabrini Green is a highrise housing project in Chicago that has been taken over by gangs. Many have been killed and fear is a way of life. Some people pay to ride the elevators. Children could not attend school. Chicago mayor Jane Byrne moved into the project to get a first-hand look. And much progress was made for Cabrini and the more than 135,000 persons living in other Chicago housing authority buildings. Shown here is an eleventh floor hallway used to hang laundry by some residents.

Charged in Chicago for hunting without licenses, hunting out of season, trespassing on railroad property and using illegal methods to kill animals, 11 hunters were arrested. They were also charged with cruelty to animals. Some of those arrested had been laid off; others had not found work.

Rabbits in the city go for about $3.00. One police officer said, "Between you and me, it is better than stealing." An angry father said, "What can the kids do? There's no jobs. They've hurt nobody. They weren't sticking anybody. It's all they can do."

Five tough days for Texans on Utah mountain trails

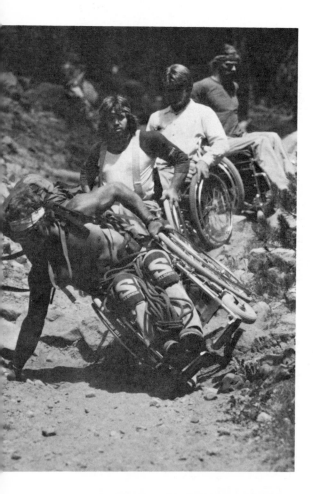

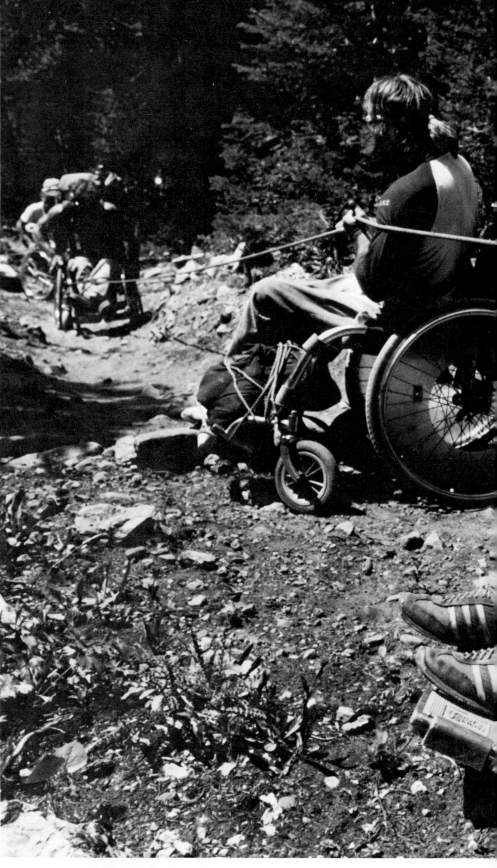

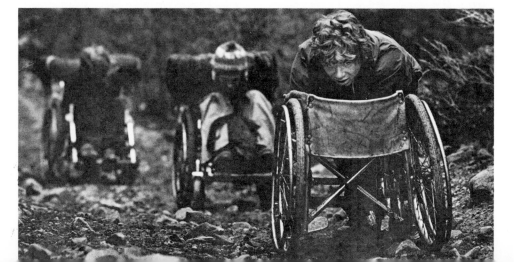

After using kayaks to help clean up a lake, members of POINT — Paraplegics On Independent Nature Trips — set out to maneuver a trail in the Uinta Mountains in eastern Utah. It was their first camping trip, and the Dallas-based group wheeled and hauled themselves across the rugged slopes.

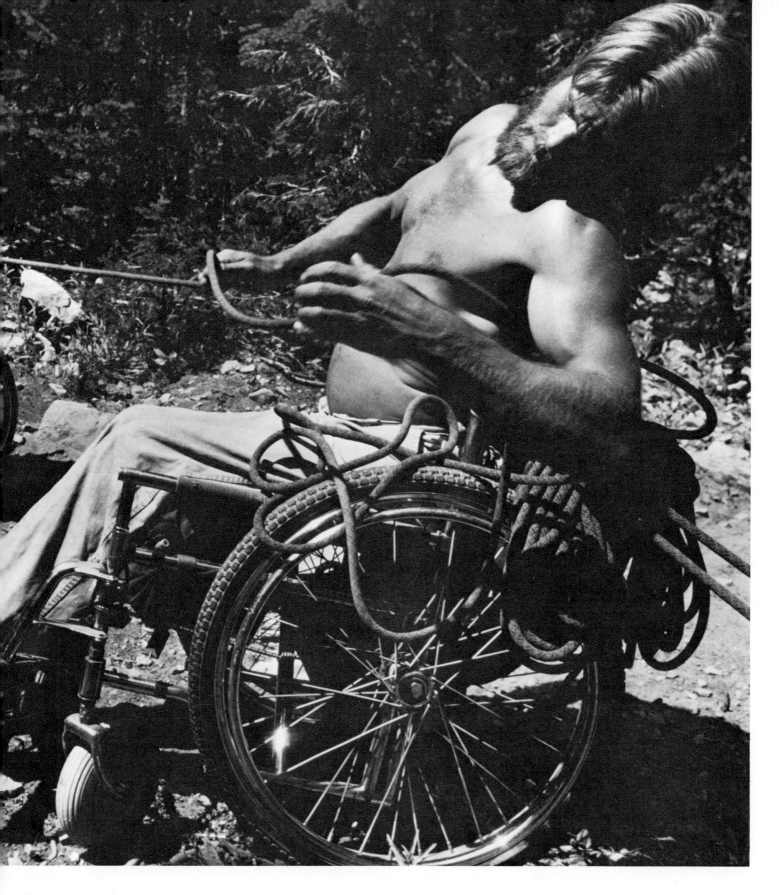

Photographer Rebecca Skelton and reporter Thom Marshall, aided by a pack hinny named Ruby, spent five days with the group. (A pack hinny is the product of a male horse and a female donkey.)

Before the trip, the group told the journalists not to assist in any way.

But, during the trek, POINT needed and requested the help of Skelton, Marshall and Ruby.

It rained the last three nights — hardest on the third. It became colder, one wheelchair broke and some passing horsemen carried the paraplegic back to the cars. On the last slope, the mud, the cold and their fatigue stopped the group. Ruby carried their gear the rest of the way.

As a result of the story, POINT has received greater support — both moral and financial. The group plans to try it again.

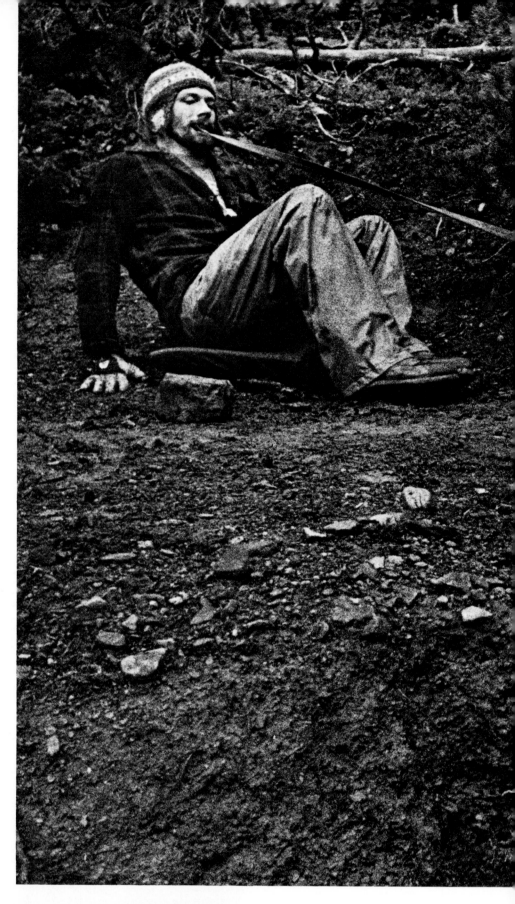

Dan Rogers, POINT member, uses his teeth to retrieve his fallen wheelchair.

Shorty Powers rests in his homemade sauna by the fire.

Members celebrate the ascent of one trail.

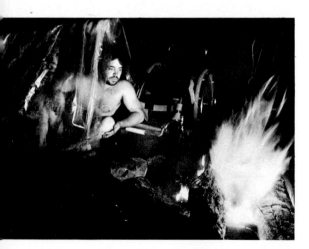

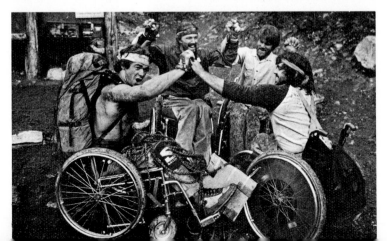

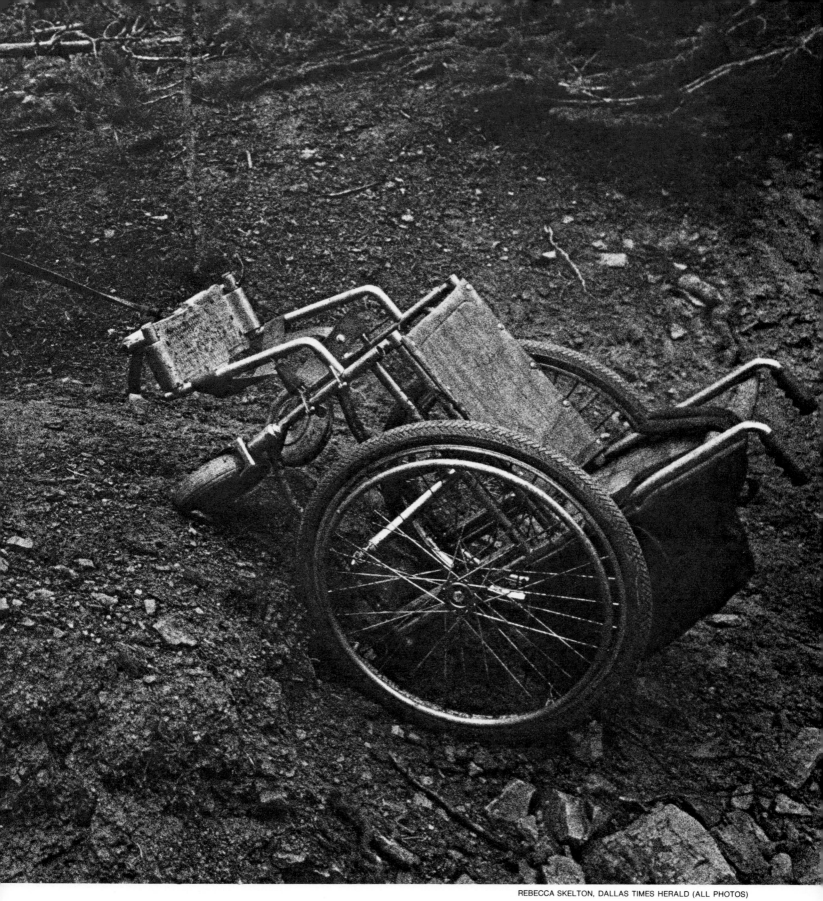

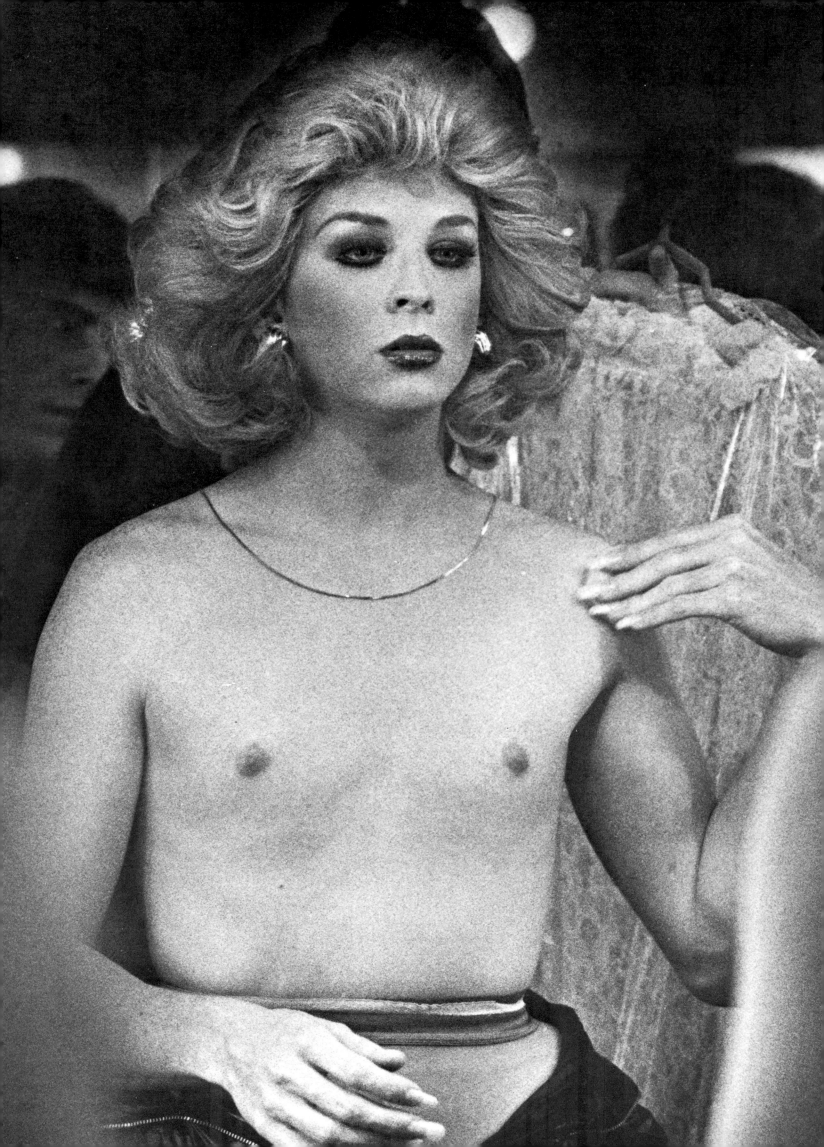

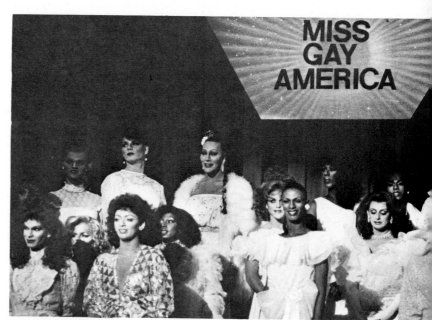

MISS GAY AMERICA

HOWARD CASTLEBERRY, DALLAS MORNING NEWS (ALL PHOTOS)

Female impersonators compete for beauty queen title, "Miss Gay America"

Each year, the Miss Gay America Pageant is held at a major U. S. city to determine which female impersonator will hold that title. Being gay is not a requirement, although most entrants are. This year the competition was held in Dallas and the contestants received several standing ovations. The impersonators, who use female stage names, don't reveal their own names for various personal reasons. There are no women in this entire story except the mother of one of the contestants who won the title.

One contestant finalizes his transformation to female impersonator and applies powder to his chest before getting dressed. Prior to the competition, all the entrants line up on stage for audience review.

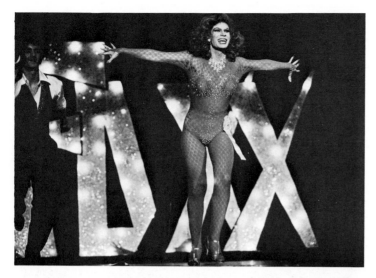

HOWARD CASTLEBERRY, DALLAS MORNING NEWS (ALL PHOTOS)

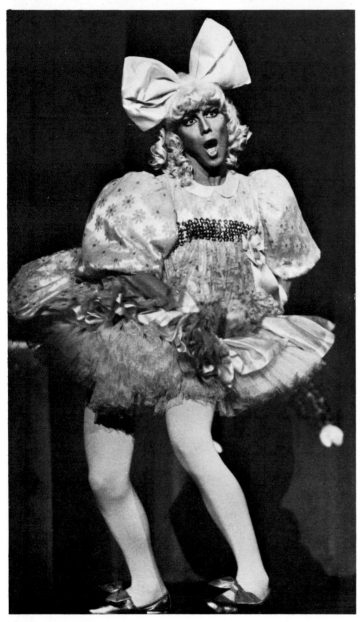

Jennifer Foxx (stage name) goes through her dance routine with her name in lights as background. With social pressure upon these people, acceptance, especially from family members, is difficult to find. "Jennifer Foxx" however, finds that his biggest fan is his mother who jumped on stage with a great big hug after he'd been awarded the title of Miss Gay America.

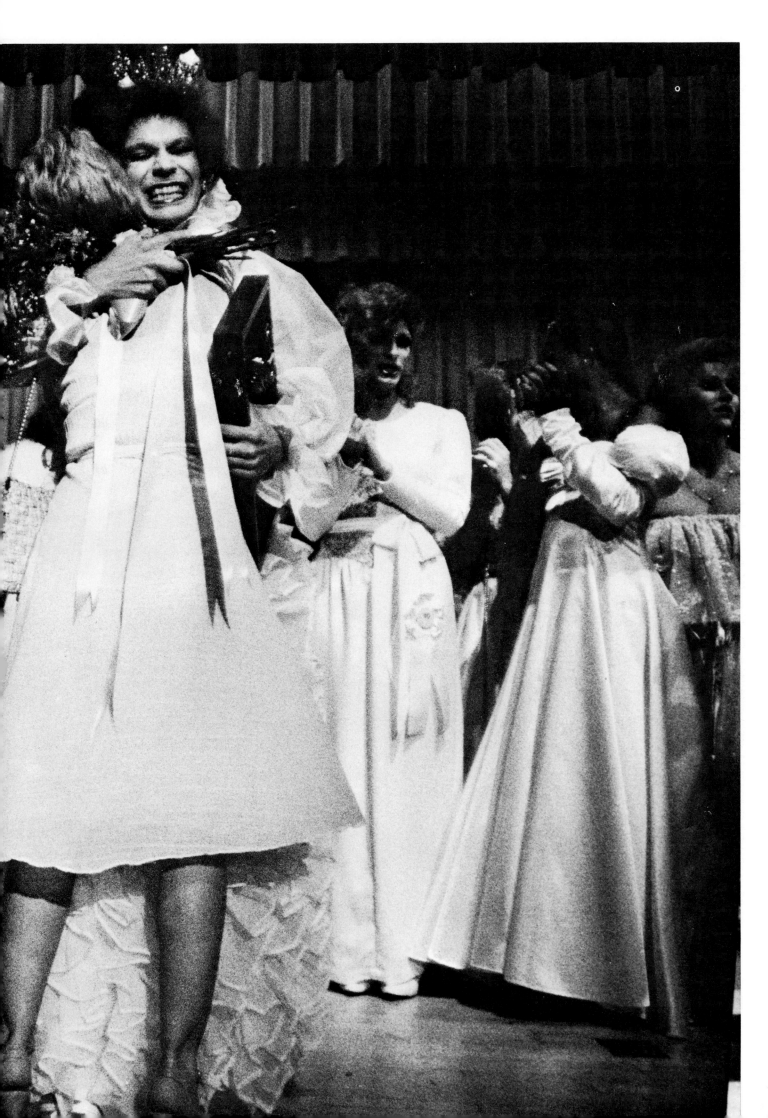

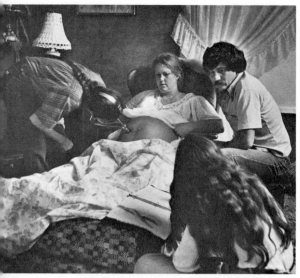

Home birth — a popular alternative in California

Home birth grows in popularity in California. Training in special classes and awareness of the alternatives to hospital birth and care has prepared many couples for assuming more responsibility for their lives and families. Graverson's story is one segment of a long-range project on midwives in California. Now, the midwives of California work without legal sanction, and the maternal care/child-health issue increases in intensity.

Near midnight, the midwife checked Jeanie Anderson and the heartbeat of her baby. Jeanie rested between contractions while John and the family dog, Simon, kept her company.

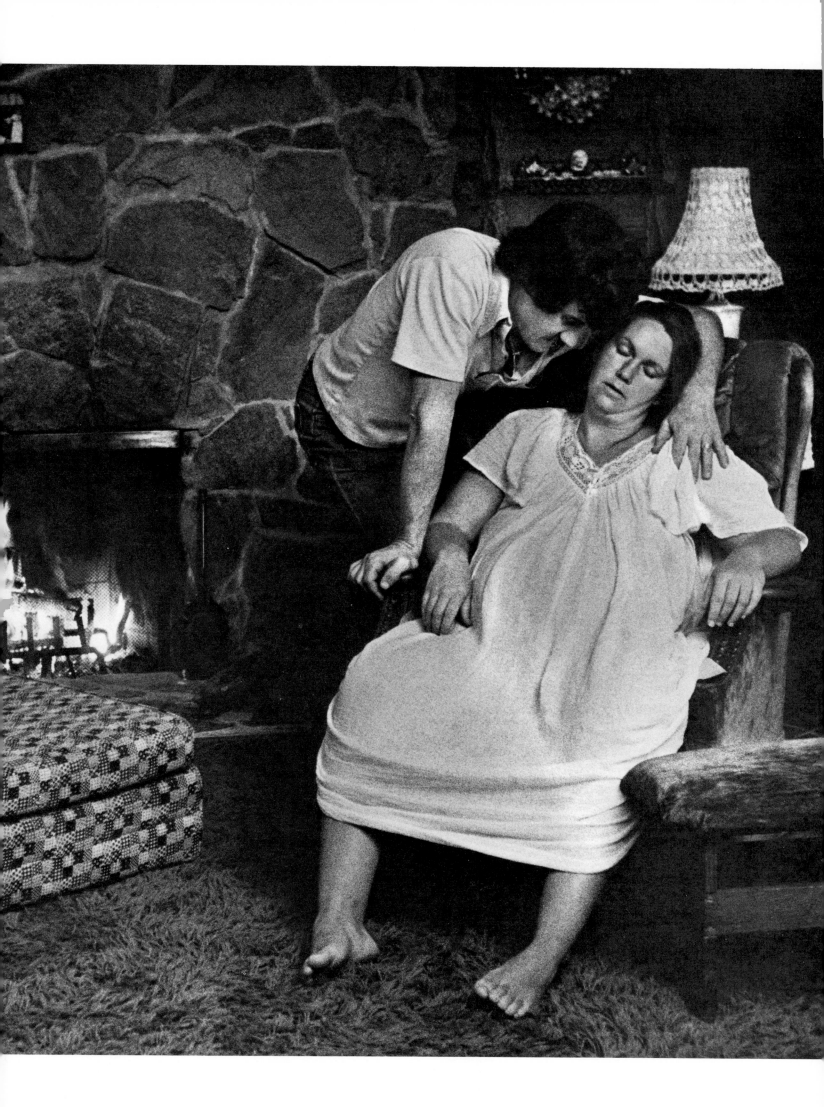

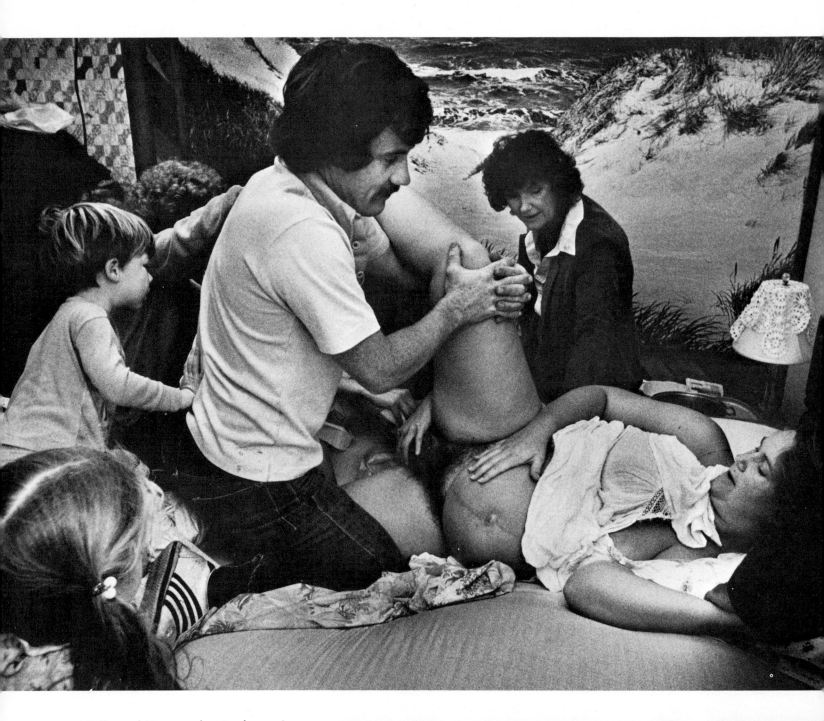

Molly and Kenny, the Anderson's children, arrive to witness the birth of their new brother, Charlie, who weighed in at 9 pounds.

Immediately after the moment of birth, which Jeanie observed through a mirror, Charlie was bonded to his mother and surrounded by his family.

Molley and Kenny telephone relatives with the news at 2:30 a.m. Charlie secures his connection to the outside world with a firm grasp on his mother's finger.

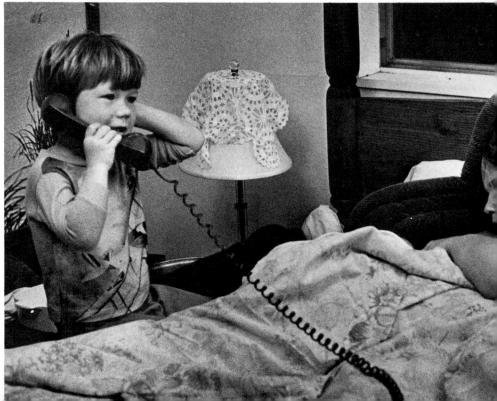

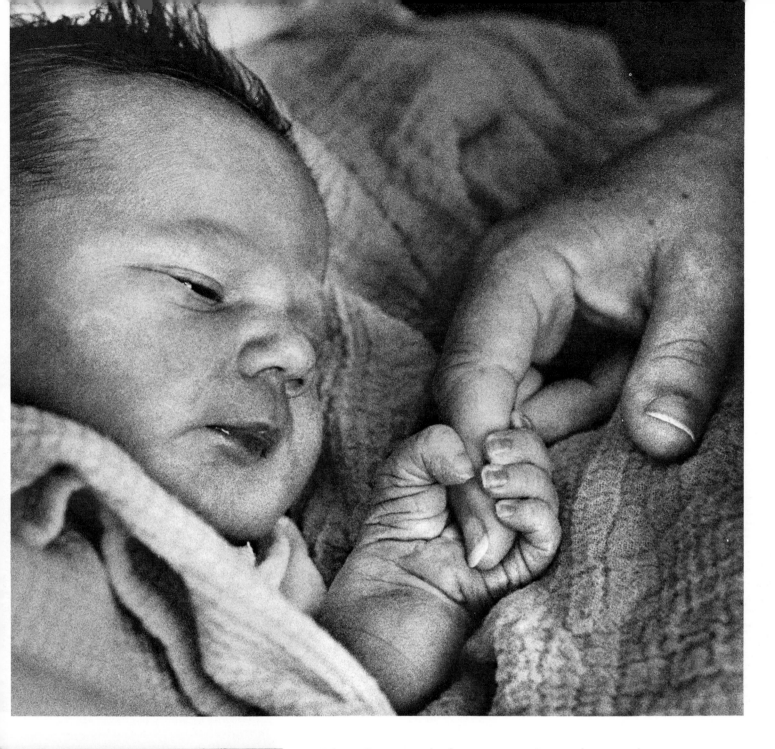

When Graverson had an opportunity to photograph the Anderson birth, he made numerous visits to get to know the family and the midwife who would attend Jeanie Anderson and her baby. "Waiting for the event was awesome," said Graverson. "Jeanie was two weeks overdue and everyone was calm. I was a wreck. Staying home evenings and weekends, I just knew the baby would be born while I was at a Dodger's game or something. But it all worked out; everyone had a job to do and mine was to photograph the birth of Charlie. People asked, 'how did you feel?' or 'why would you want to photograph that?' — Well, that evening held some of the warmest, most honest emotions I've ever felt or seen. To be there with a camera and good lighting — wow! We see a lot as photojournalists, enter people's lives whether it be happy or sad. The birth experience in such a warmly personal setting was incomparable."

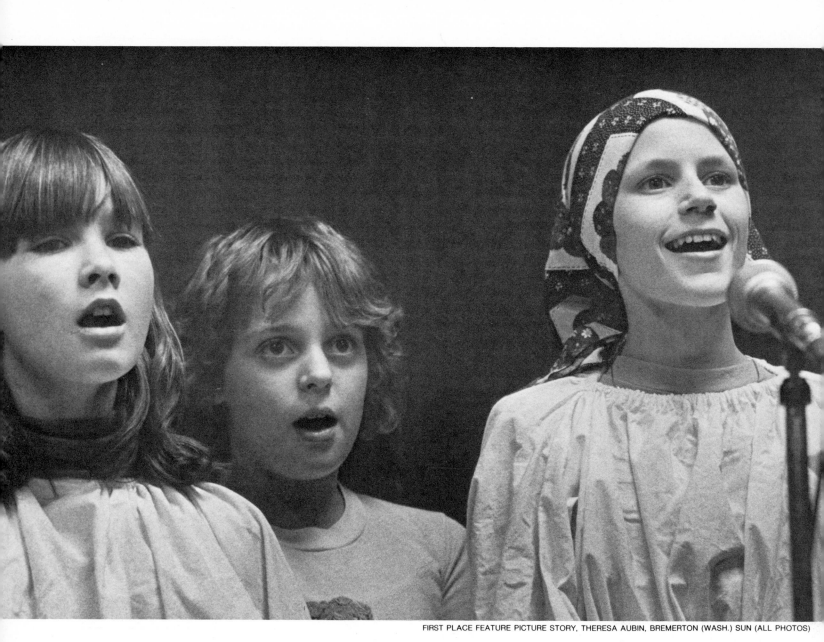

A family fights cancer with faith

"Love bears all things,
believes all things,
hopes all things,
endures all things."
I Corinthians 13:7 RSV

Paula Thompson, age 12, was told she had cancer in January of 1981. In October, more tumors were discovered in her lungs and doctors told Paula's parents that she had little time left to live. Shortly before the Thompson family knew of Paula's cancer, they had become Christians. Their newly found faith brought the family closer together and helped them face Paula's illness. In

November, donations from people in the county enabled the family to take a trip to Disney Land. In December, Paula was asked to portray an angel in a Christmas play and she eagerly participated although she was very weak. Joyfully she sang and, after the pageant, went carolling with the children in the group. At home, however, Paula was in great pain and often screamed for medicine.

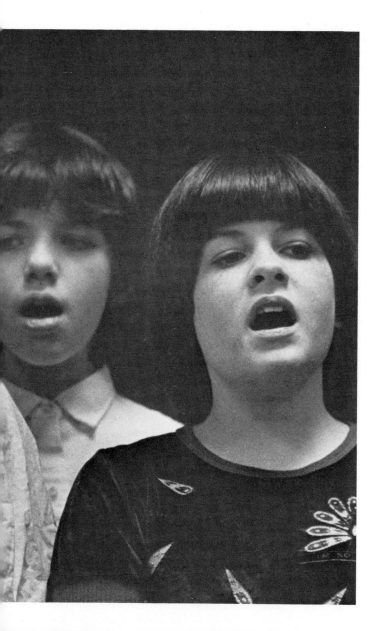

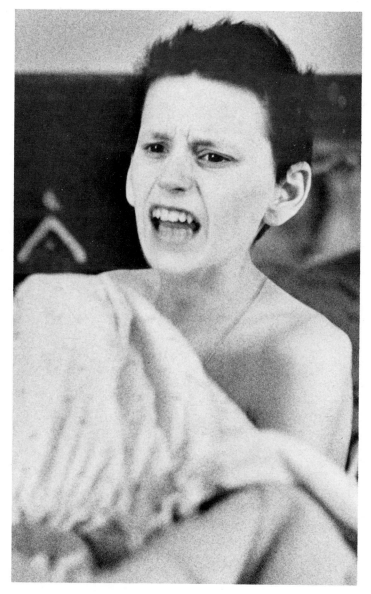

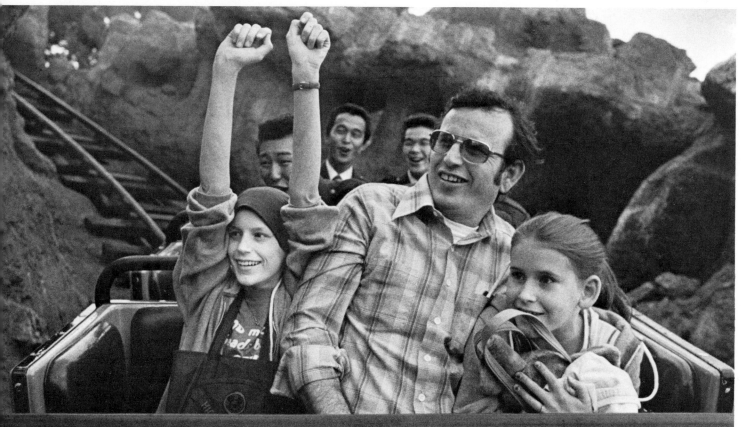

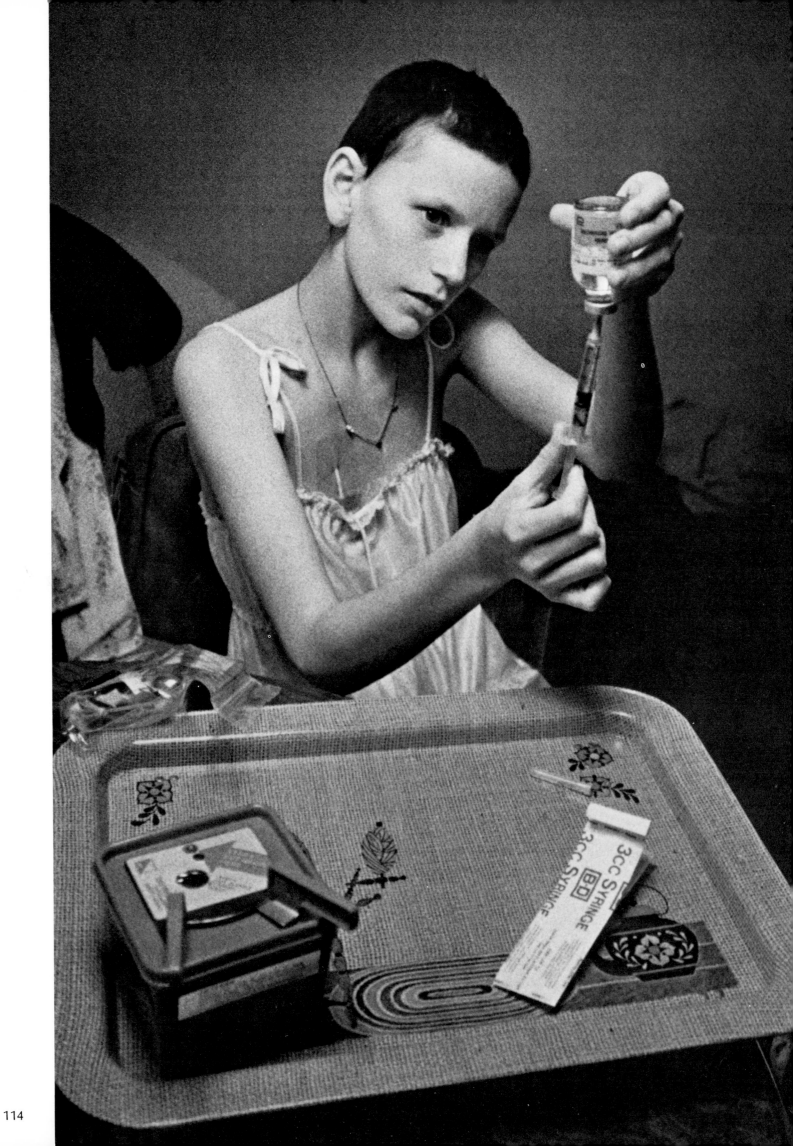

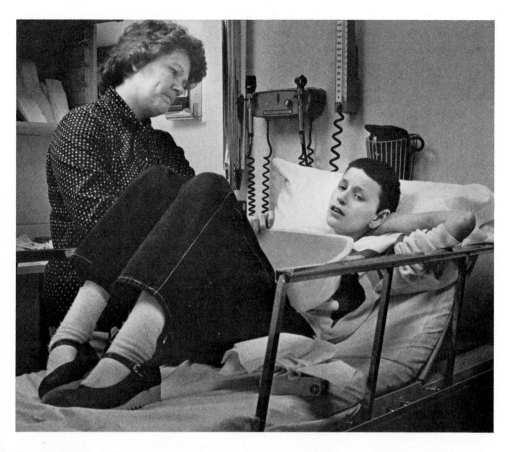

Much of Paula's time was spent in the hospital and she learned to administer her own drugs. A special tube was inserted directly into her chest to make it easier for her to do so.

Paula's mother, Michele, comforted her and stayed with her almost continuously while she remained in the hospital. Paula died January 1, 1982. She planned most of her funeral herself; she did not want it to be a morbid affair. She hoped that it would be a celebration of her belief that she would "be with Jesus." Her parents shared her faith and the funeral occurred in an atmosphere of joy among friends and relatives of the courageous child.

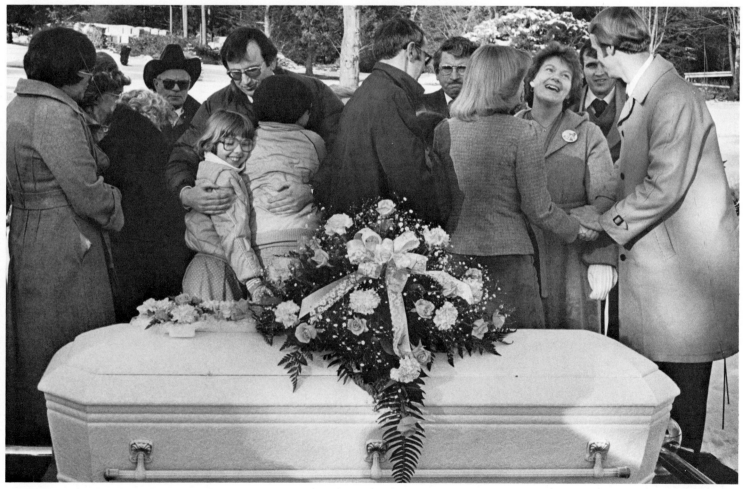

THERESA AUBIN, BREMERTON (WASH.) SUN (ALL PHOTOS)

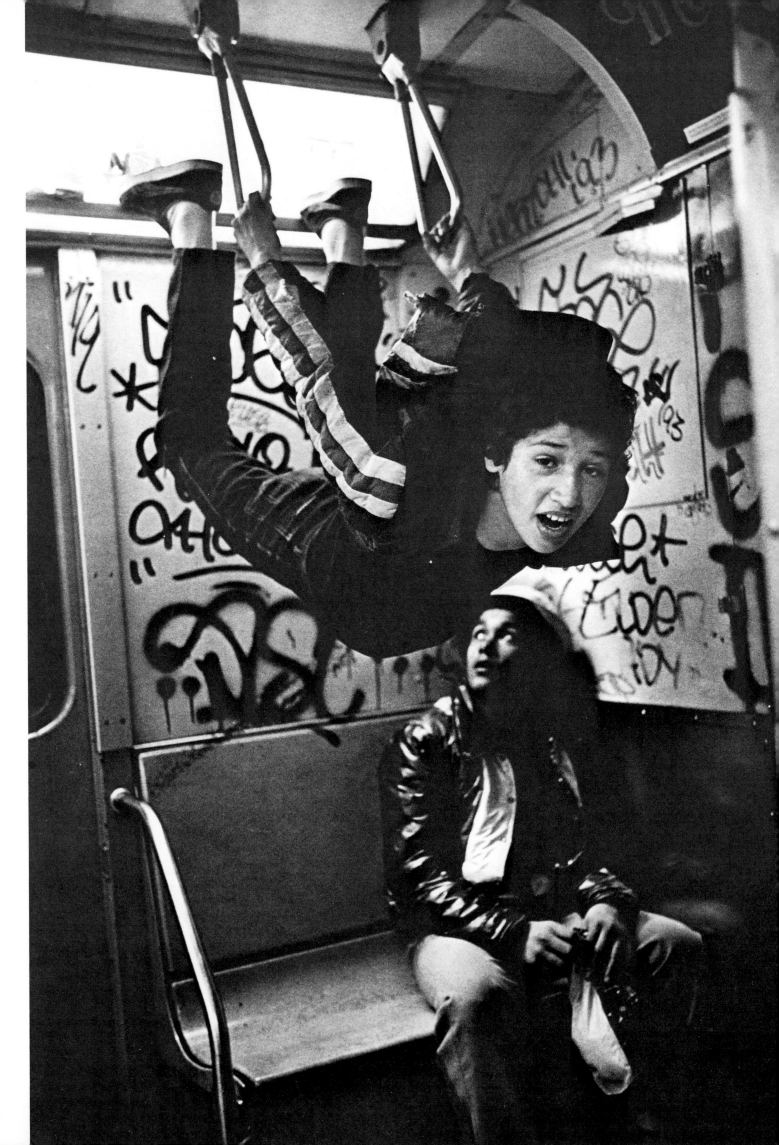

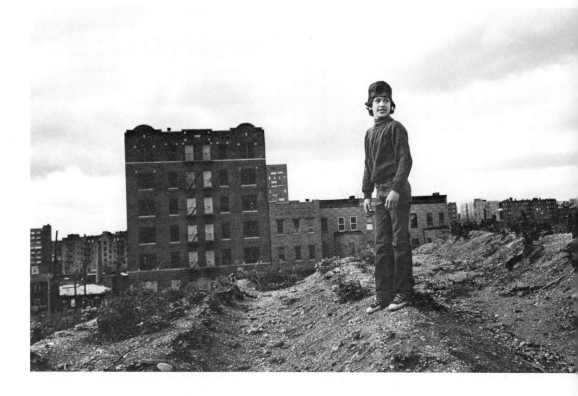

Rudi Gomez sells his body on the streets near Times Square, New York.
He is 14 years old.
The first time was at age 11.

Rudy, nicknamed Didi, and a friend take the subway through Times Square. When they return to their neighborhood, they have one or two ten dollar bills in their pockets. Easy money? No. But easier than earning by stealing or dealing. They call it hustling. The word prostitution is tabu. Fifteen of the twenty boys in Didi's block hustle. They are tough, streetsmart and charming when necessary.

At Didi's request we go to McDonald's. He sits, arms folded and checks me out. Coke? "No, thanks." Hamburger? "No, thanks." After many such conversations and about six months of hanging around in Didi's life, I, the photographer, am accepted. He has a job. I have a job, and the children of Times Square tend to accept whatever anyone does to make a living. It is as easy for Didi to sell himself as it is for a middle-class boy to have a paper route. And so, we understand each other.

"What would you like to be one day, Didi?" "I want a factory. Or a club, a Playboy Club, where all the girls come." He produces a cheerful grin. "And what would be your greatest wish now?" "A place of my own." His mood changes; his interest fades. Didi is easily bored.

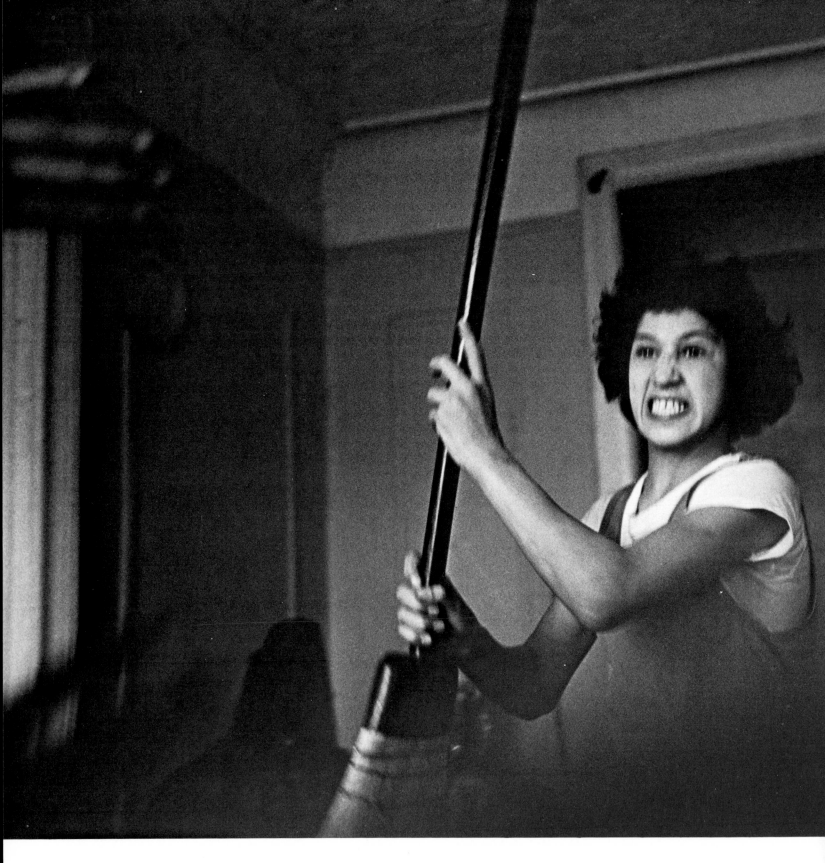

It took a long time before Didi let me come to his house. He would never tell me his home was horrible. He says his mother is okay, that his eight brothers and sisters are okay and that school is okay. Does he like his father? "Nah." He shakes his head. "He beats me up." The usual thing. Does his father work? "Nah." He got roach killer sprayed into his eye; now one is blue, the other brown. I learn from a third party that Didi's father is one of the old men warming his hands over the coalstoves among the street gangs, one who is laughed at by the children because he is constantly drunk.

The Gomez apartment is four holes in the wall for a monthly rent of $250. The place looks in danger of collapse. The furniture has apparently been sold piece-meal. There is a couch, an arm chair, TV, radio and a record player. Beds are mainly mattresses on the floor. The family receives $308 welfare money every two weeks, plus some non-monetary subsidies for heating oil, rent, health insurance and food.

Didi picks up a broom and strikes his younger brother in a moment of anger.

In their South Bronx home, Didi and his mother posed for this portrait. Didi is one of Efigenia Gomez' nine children. She works hard at caring for the family, but because she speaks English poorly, has trouble coping with American city life.

Does Didi's mother, Efigenia, know what he is up to? No, not exactly. When the police come to the house, it is mostly about some robbery or theft. Tuesday, Didi is due to show up at Family Court because of a smashed storefront window. His mother said he didn't do it. Do the children like their mother? The girls do. "The boys," say a sister, "look down on her. They all want Jordache jeans and she can't buy Jordache jeans with her welfare money."

A suspicious Didi breaks into our talk. He lowers himself toward the baby in the woman's arms and says, "Does he sleep or is he dead?" The women scream at him and chase him from the room. There is a loud exchange of obscenities between them.

On the chalkboard:

Brain Teaser

hat is the last number in this series?
ell how ... found it 77, 49, 36, 18, 18, 8

When Didi is hungry he goes to school where he gets a free lunch for welfare kids.

We go to Didi's school. "Ah, our playboy honors us with his presence for a change," says the teacher who also explains, "Didi hasn't done anything positive yet for himself in his whole life. From 182 school days last year, he went only 35 days."

Didi lines up with other students of the 6th grade to go to lunch. He is a little taller than his classmates because he was held back.

Didi clowns around with two girls and a boy from his neighborhood on the porch of an abandoned house. Although he hustles, he is not a homosexual and has normal relationships with girls his own age.

We made a deal with Didi. If he goes to school for 14 consecutive days we will finance his preparation for junior high school. On the 14th day Didi calls me from the Spofford Juvenile Center in the South Bronx. He is awaiting trial at Family Court. He and another boy were caught shoplifting at Alexander's. Didi says he was only trying on the shirt.

Family Court in the Bronx. The trials are open. Nothing surprises the judge. Didi was arrested 20 times and convicted 10 times to serve time in juvenile facilities and was dismissed on probation. The lawyer's plea includes a suggestion that Didi be taken from his environment for a year, treated by a psychiatrist and given an opportunity to build a different pattern of behavior. Is there such an institution I ask ... "No." says the lawyer.

Didi talks with a man on 42nd street in Times Square, and contacts one of his customers by phone.

A policeman and security guard lectured Didi after he'd been thrown out of a pinball arcade for bad-mouthing and other poor behavior.

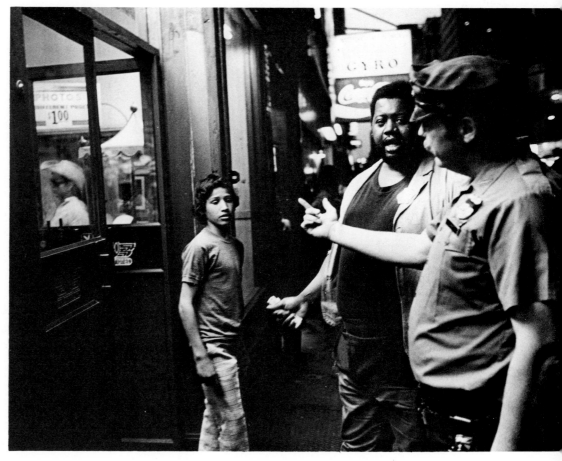

It took me two days to find out where the places are ... a pinball arcade at 8th and 42nd street, and on 7th avenue, the super pinball hall, Playland. On a Friday night, fifteen or twenty kids between 11 and 16 hang around looking for a customer. The first thing they say is neutral because of policemen in the area. "Do you have the time?" or "Can I borrow a quarter for a game?"

The deal is made among the electronic sounds of thunder and lightning from the space war machine. "Would you buy me something to eat?" Then when the basic situaiton is clear, a man might ask, "What do you do?" The boy tells him what he does and what he charges. Inexperienced kids may charge five to ten dollars. Good looking ones who know what they are doing charge $25. I saw a beautiful Cuban boy turn down an offer of $30, ask for $50 and get it. Didi's price is $30, or so he says.

Didi feigns a smile at a man just before being picked up in the pinball arcade in the subway at 8th Avenue in Times Square. The man with Didi is one of four who keep an apartment on 9th Avenue near Times Square for the purpose of bringing boys there for sex. The man, in his 60's, lives with his mother.

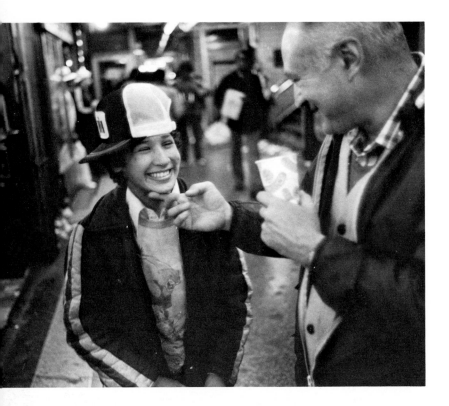

The kids don't consider themselves prostitutes. Nor do they consider themselves homosexuals. They have nothing. They have no skills. They sell what they have, their bodies, as coolly as possible. They say they have girlfriends. Perhaps 80% of the younger boys (12 to 15) are in no danger of becoming homosexuals. Unless they reach 16 and are still hustling in Times Square.

Cool as they are, the job is ugly. They rationalize what they are doing, considering many things still tolerable, as long as they are in control. Fondling in porno movies, posing for porno photos, offering manual sex in cars or oral sex in hotel rooms. Sometimes violence occurs. One boy was thrown from the second floor of a building because he refused the demands of two men. He still walks crooked-legged on 8th Avenue and threatens to shoot the men who injured him.

Didi is smart for his age. He avoids dangerous situations. He always insists on bringing someone along, usually his strong friend, Kid Joe. Joe sits in the living room and watches TV. Didi says, "I'm in charge. I tell them what to do!" He does know how to manipulate the men. Especially those who want or need desperately to be liked.

I know many of the men who hang around Times Square now. Few of them are real homosexuals. All kinds of men are there; the crude ones, the brutal ones, the cheap ones. Some are married; some in business, some educated. One is a cop. I have found them apparently unable to form adult relationships. Perhaps they never passed the stage of being frightened by women. Maybe they have such weak egos that they must buy weaker partners. The man of 60, a blue collar worker who I photographed with Didi, thinks of the kids as innocents. To him, they don't count. They are "numbers." This particular man has been living with his mother all his life. That is typical. To him, Didi is merely another 'chicken,' the slang term for child prostitutes in Times Square.

Didi has been successful at finding himself a steady friend. A chemist from New Jersey in his mid-thirties buys clothes for the boy and takes him to the circus and the museum. Didi says he met him when he was 11 and no longer has sex with him. I suspect he takes his younger brothers to his friend. I noted that one of Didi's brothers has been obviously different and depressed lately. What the kids are after is to find a man who will take them for the weekend, one who lets them stay at his house. It means more than money.

125

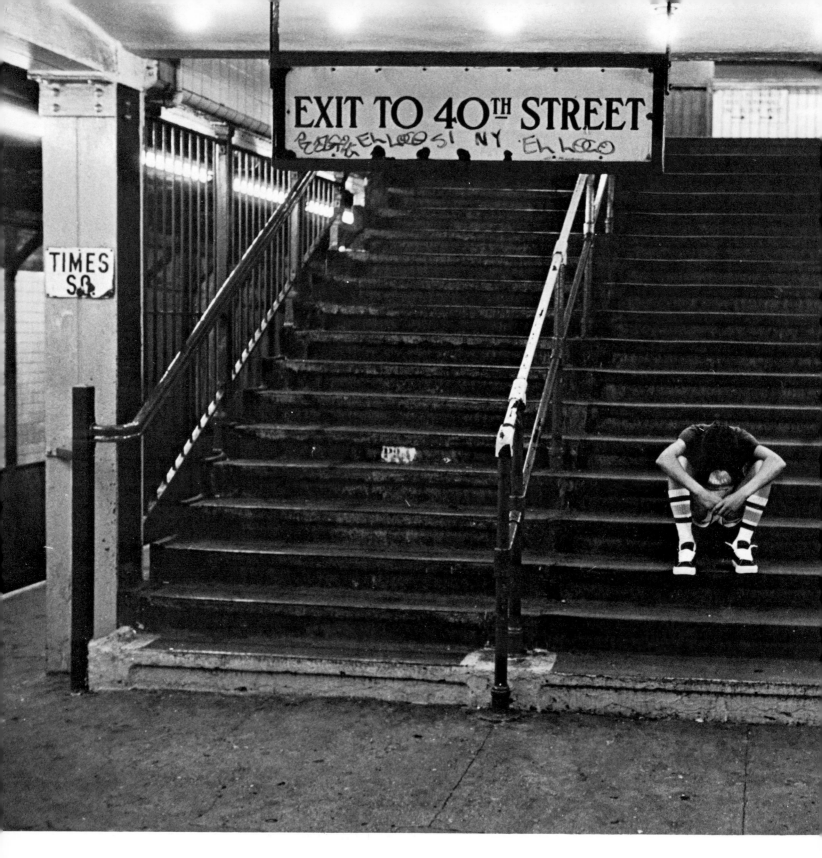

Didi can't take being at home too long. His real life is on the street. There he finds freedom, adventure, a sense of power. From his contacts he takes not only money, but recognition. He comes home only to shower or change clothes. He sleeps in subway cars, bus depots, trucks, under staircases in houses and, in the summer, in parks. A grocery store owner lets him sleep on a pool table in the back room, gives him a blanket and locks him in until morning. Sometimes he sleeps in a club house which gangs have made in abandoned buildings. His last club was set on fire by another gang.

Summer comes and goes and Didi is left with the rule of thumb of the social worker: nine out of ten times, the environment wins. Didi is cynical. He is the coolest of them all. He has learned to never show weakness and he allows no one close to him. He trusts no one.

Didi doesn't go to Times Square anymore. He has found himself a better job and can make $300 a week. Now Didi is the man of the house. What he does for a living is obvious. The dealer counts small folded envelopes and Didi takes them to the right people who are dependent on those small folded envelopes.

ALL PHOTOS 116-127: STEPHEN SHAMES, OUTLINE PRESS, NEW YORK

FOOTNOTE: "Child prostitute in Times Square was purchased by STERN magazine in Germany at the time Photojournalism/7 went to press. Photographer Shames spent almost a year and a half photographing the boy who is given the name, "Rudi (Didi) Gomez" in this story. While discussing this story with the editors, Shames explained that in his opinion, "objective journalism doesn't exist." He said that photographing life in the Bronx and Times Square can quickly "burn you out." There is a tinge of hope, however for the boy called "Didi." Primarily because of this story, Didi is back in school and at last report, was not selling heroin. The original text for this story was written by Eva Windmoller and included material transcribed from tapes made by Stephen Shames.

Vietnam: the battle comes home

In February of 1981, the wife of a Vietnam veteran who disappeared after leaving a suicide note, allowed me to share that crisis with her.
Subsequently, I was invited into the homes of other veterans to share their lives literally from the breakfast table to the funeral parlor.

The story demanded to be told and I was compelled to follow through in an effort to call attention to the veteran's problems. Ironically, I was at a point in my own life when I was asking myself where I was going from here, and the Vietnam veteran's stories seemed to me a microcosm of life experience.

It began about a year ago when I crossed the hallway from my office to visit my new neighbors — the Vietnam Veterans Outreach Center. What I learned there sent me back again and again. What I experienced made me want to help the public understand that the healing process cannot begin until the veteran feels welcomed home.

Photography is magic and I believe photojournalism is something we do, not talk about. The writing is equal to the photography and I believe in interaction with the subject. I do not believe that a photographer should be merely a fly on the ceiling. While I photographed these men and their families, I was blown away with the pain they experienced. When I talked about my work, I kept finding that someone always knew someone else who was having the same experience as the family I was photographing.

The suicide rate among veterans is alarming. The war has been over for more than ten years. Thousands of vets slipped unceremoniously back into the conventional life of the average American; unwelcomed, unrecognized and often scorned. Government and social agencies have just begun to learn to help Vietnam veterans re-order their lives and recover from the psychological wounds they suffer. For many, daily survival now is an equally tough war, often lost.

Awaiting counseling at the veterans' center . . .
it takes time for the psychological wounds to heal.

GORDON BAER, FREELANCE, CINCINNATI, OHIO (ALL PHOTOS, PAGES 129-139)

LESLIE MAJOR, A CINCINNATI FREELANCE WRITER ASSISTED BAER WITH THE ORIGINAL TEXT FOR THIS STORY.

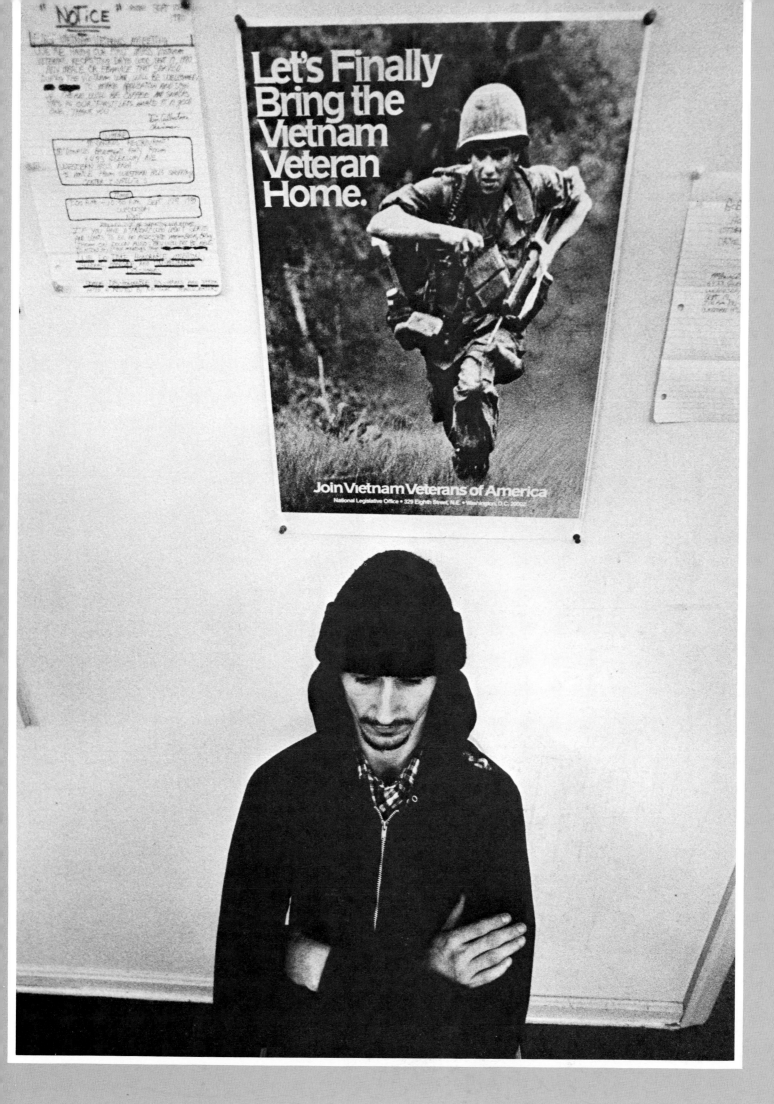

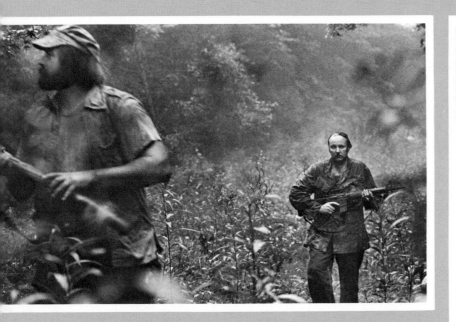

A Kentucky farm becomes a "Vietnam" for several veterans who need to let off steam.

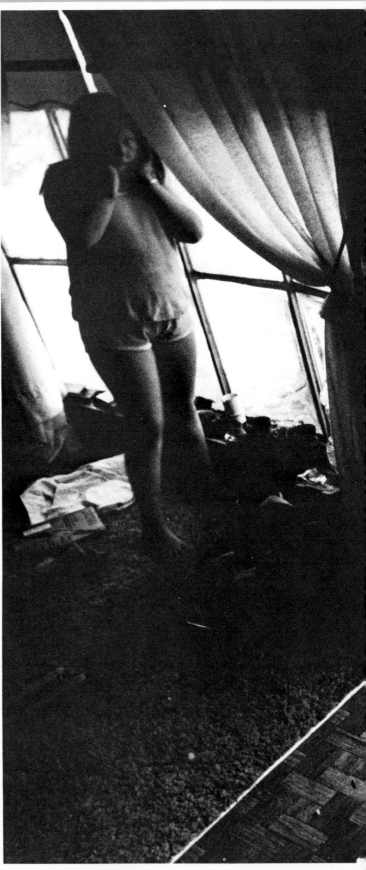

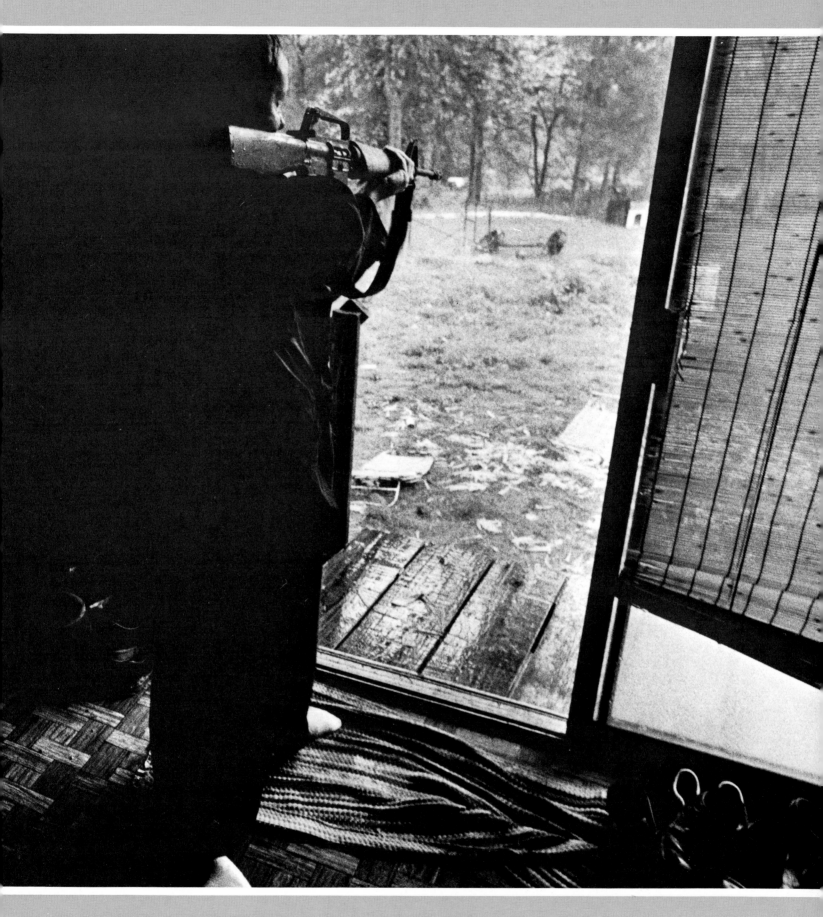

Just for fun, Bill fires an M16 into an old washing machine
in his front yard while his daughter protects her ears from
the blast.

Jobless for ten years and feeling useless.

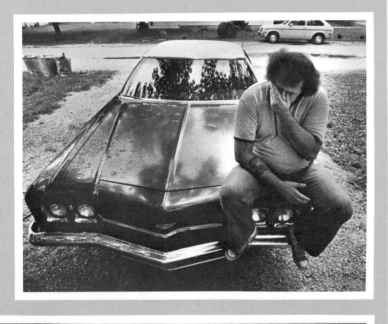

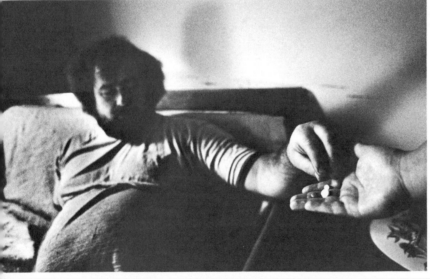

Drugs have become a part of John's life since he returned from Vietnam.

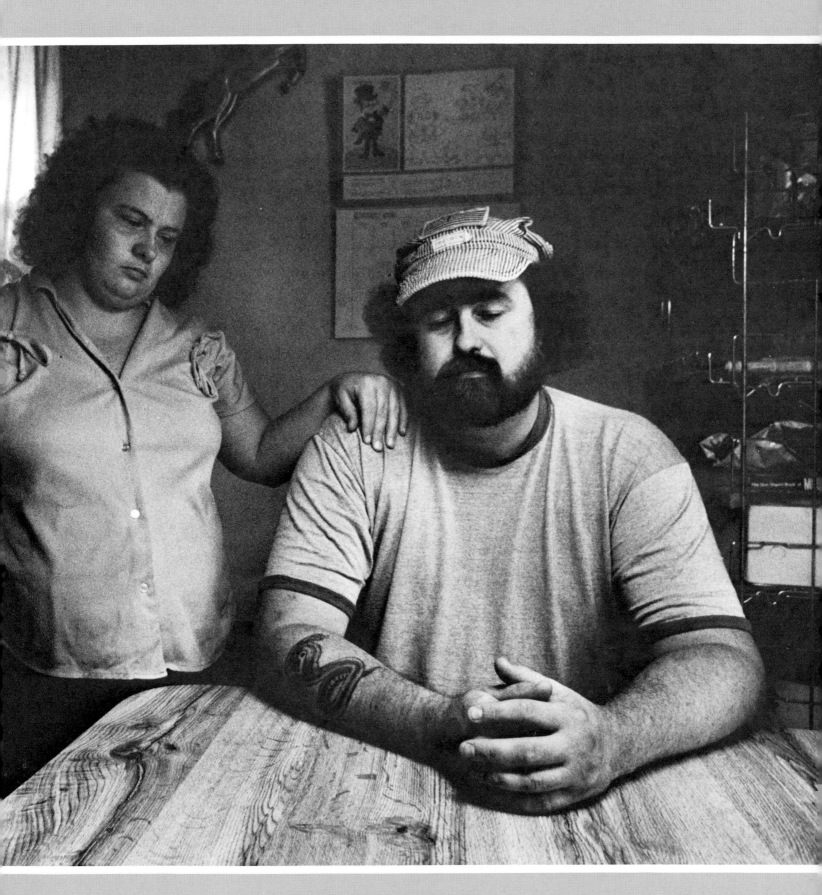

Vietnam veterans experience a high rate of unemployment. The Daniels family had filed for bankruptcy the morning this picture was made.

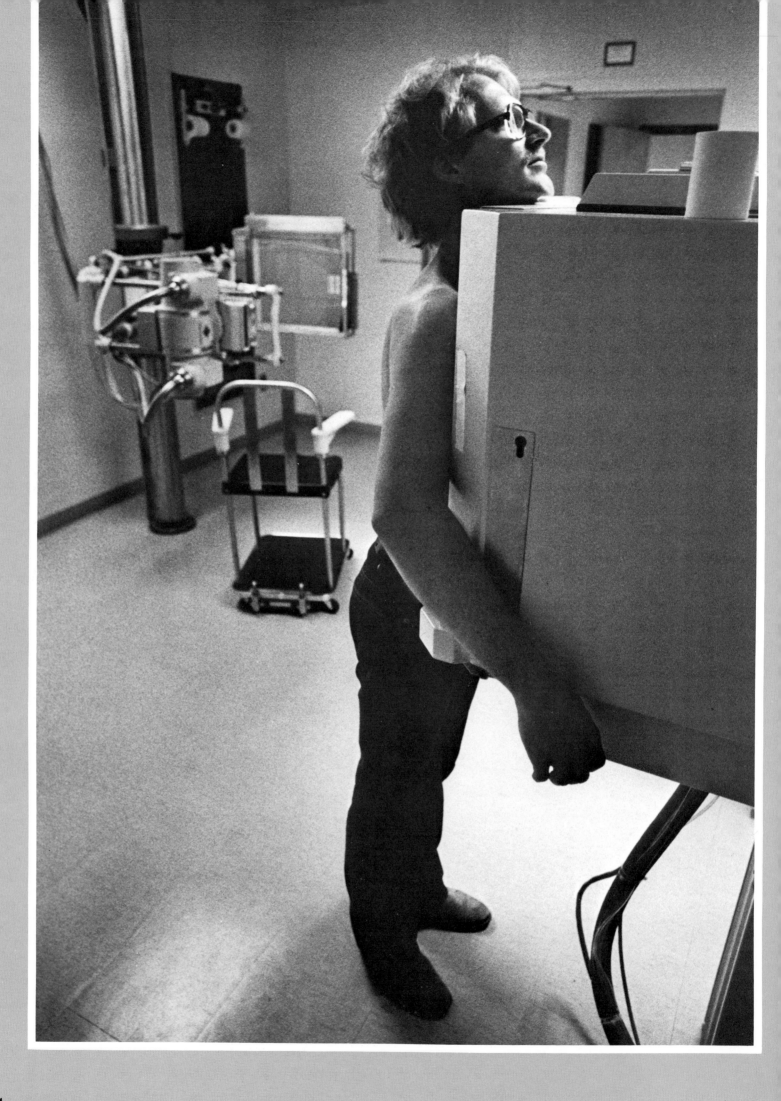

Another test to discover whether this veteran has suffered the effects of Agent Orange, the chemical defoliant used on the jungles and crops of Vietnam.

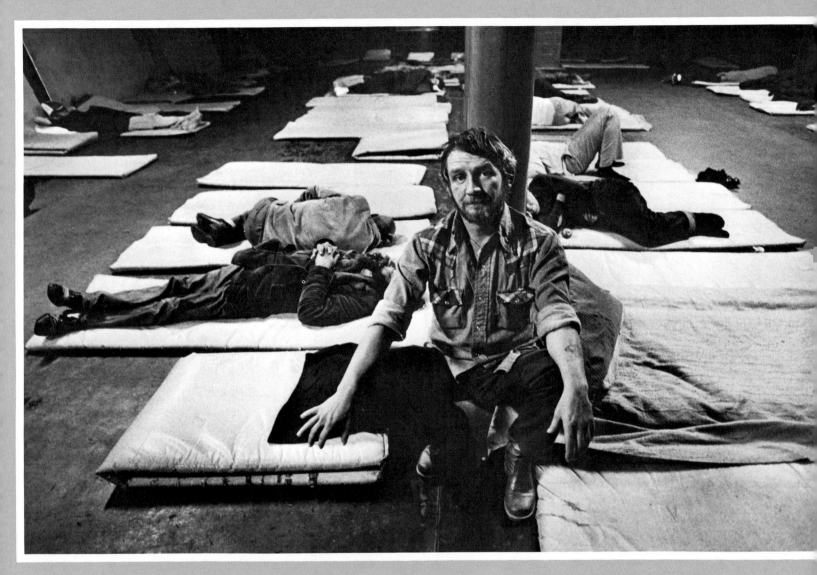

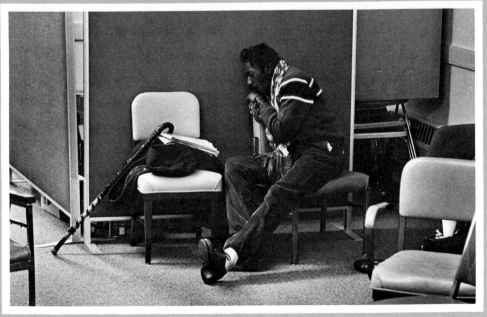

Charlie Kirk calls
the Drop-In Center home.

A common problem - joblessness; for this vet there was no work for 18 months.

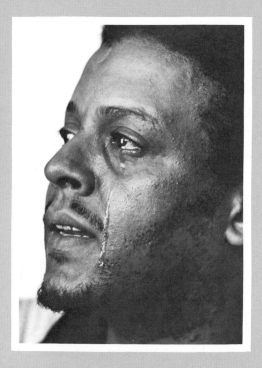

Everyday in Vietnam, Lou asked God to spare his life. He said he never thought to pray for his peace of mind.

Dennis suffers sleeplessness and checks on his children as often as five times a night.

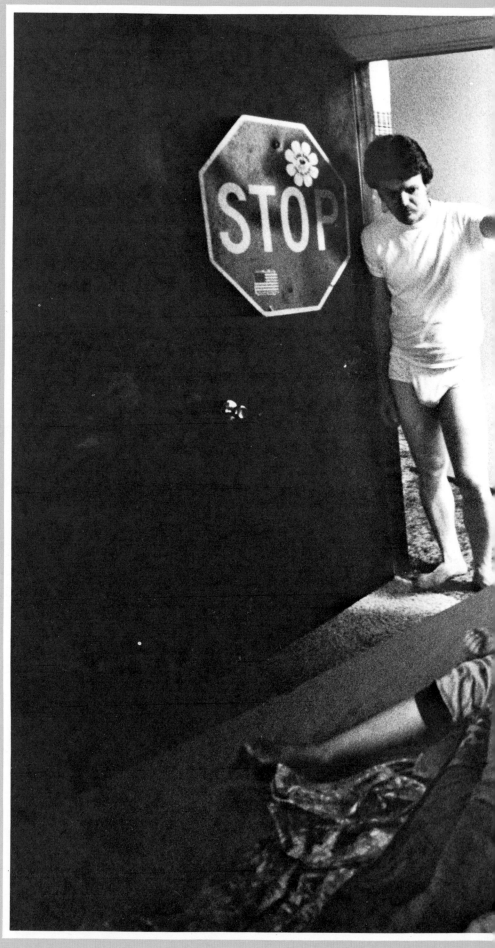

Wives of veterans meet weekly at the
Cincinnati Vet Center with other
members of a women's support group.

Marilyn Watson searches for her husband who disappeared
after leaving a suicide note. Her husband's car was found
near a river bank, but his death occurred in Vietnam.

THIRD PLACE PUBLISHED PICTURE STORY, WENDY WATRISS FOR LIFE MAGAZINE

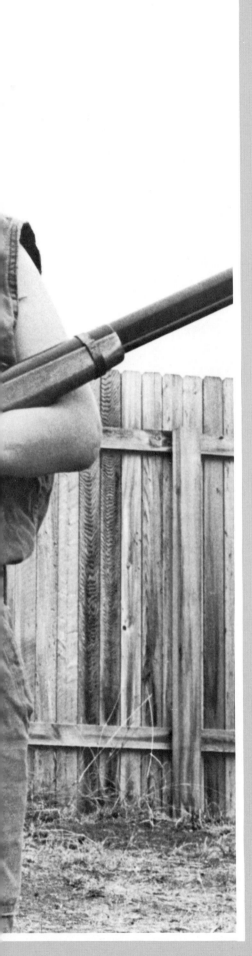

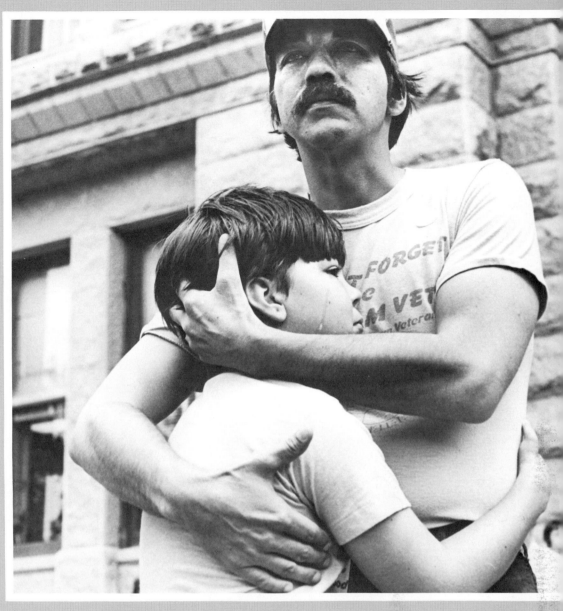

Tracking Agent Orange

Chloracne, virulent skin eruptions, came home with Dan Jordan from Vietnam in 1969. Other symptoms appeared much later: Bell's palsy, loss of sensation in head and arms, rectal bleeding, deformity and deafness in his sons. Other Vietnam vets had similar complaints: cancer, or liver failure. As the patterns of misery grow, thousands of Vietnam vets are blaming exposure to Agent Orange, the toxic herbicide used to defoliate jungles and destroy crops in Vietnam.

Both Michael and Chad Jordan, Dan's sons, were born missing fingers and some bones in their wrists and arms. "We had no idea our own government was using something on us that would cause our deaths and deform our children," said Dan.

141

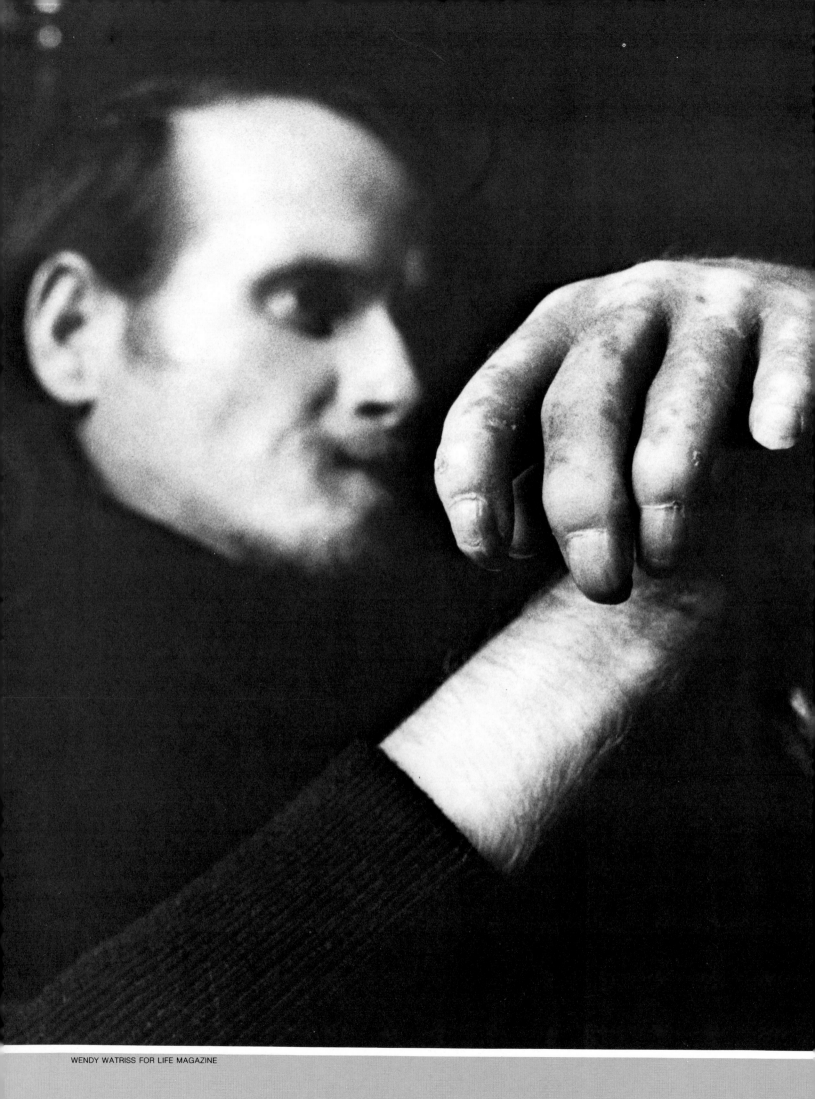

142

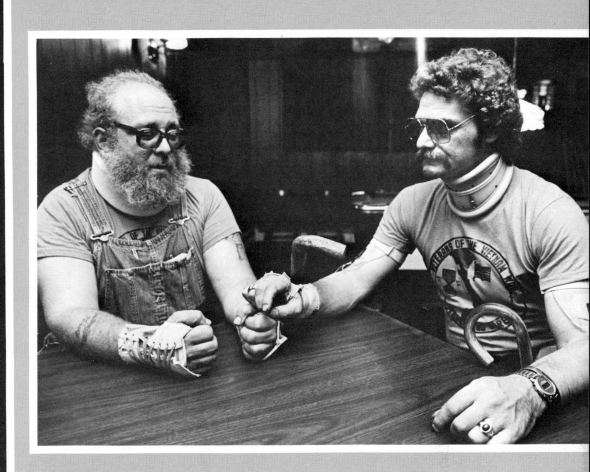

While horseplaying with Army colleagues in Pleiku, Jim Roxby was sprayed in the face with Agent Orange. When hospitalized, he was bleeding from the eyes and blind for nine days. Since his return to the U.S. his eyesight and health continue to deteriorate. His arms are stiff and the skin on his hands and torso is numb and leatherlike. Jim receives disability payments from Social Security and says, "I didn't have a damn thing wrong with me when I went into the Army."

Members of a support group of those exposed to Agent Orange, Douglas Rudolph and Mike Milne both suffer from deterioration of bones and muscles. Milne is completely disabled. Neither man receives disability payments from the Veterans Administration.

Spraying of Agent Orange was discontinued in 1971 although from the beginning (1962) statistics of miscarriages and birth defects caused mention of the effects to be prohibited in the South Vietnamese press. Last June Congress ordered the VA to begin treating conditions attributable to Agent Orange. Yet, the American government and the VA are still reluctant to say that there is a firm link between the suffering of these thousands of Vietnam vets and the use of the chemical by the government. Ironically, Agent Orange itself is not poisonous. The carcinogenic contaminant is dioxin, produced during the manufacturing process, and is known to be the most toxic substance yet synthesized. It would require only three ounces of dioxin to kill a million people.

Color combinations

There are two schools of thought on color photography. One is that color work requires a totally different way of thinking and that the photographer must re-orient his manner of seeing. A photographer who works in this school is like the artist who must study color theory and color psychology to be able to control his medium.

The second school of thought holds that color is an added element that may enhance or distort the subject. For the photographer who has mastered the use of light and exposure, it is a short leap from black and white photography to color.

There is truth in both viewpoints. Color photographs may show us more of what we like to believe about reality than what we actually see from behind a lens. Film can exaggerate or alter colors and allows us to play with combinations that surprise and excite.

Traditionally, black and white film conveys the sense of immediacy or urgency of a news event. Yet, a good example to the contrary is the Sadat coverage on pages 10-11, 14-15 in the opening section of this book. The event was expected to be one of brilliant pageantry. When the ceremonies turned to tragedy, nothing could match the immediacy of the color of blood.

The apple in the medicine cabinet, page 160, illustrates how a photographer can capitalize on dramatic contrasts in color and proportion for total effect.

Judges noted how a tiny splash of red can captivate as in the swimsuit picture on page 148. Colors tease the appetite in the food illustrations, pages 150-151. There is soothing enchantment in the comfortable colors of water and sky on pages 152-155. Colors satisfy our curiosity and stimulate our imaginations.

The challenge is to select the film and use the light so that the photograph conveys the message we wish to deliver to readers. Both schools of thought in color photography place high premiums on giving information to satisfy readers.

THIRD PLACE MAGAZINE SCIENCE AND NATURAL HISTORY, JOSEPH MCNALLY FOR DISCOVER MAGAZINE

Glowing at 2000° Farhenheit, a space shuttle cube is held by a barehanded technician. The tiles, made of pure silica, are the secret of the shuttle's re-entry success. They cool quickly, shielding the ship from heat.

Space-age technology allows for the inexpensive production of silicon chips used in calculators, computers and all sorts of electronic gadgets. Pac-man is the latest video game to craze the nation. Players spend millions of dollars and hours pushing buttons to watch one flashing electronic critter or war ship devour or destroy another. The machines have a voracious appetite for quarters eagerly supplied to them by video game addicts.

HONORABLE MENTION EDITORIAL ILLUSTRATION, ACEY HARPER, FT. MYERS (FLA.) NEWS PRESS

145

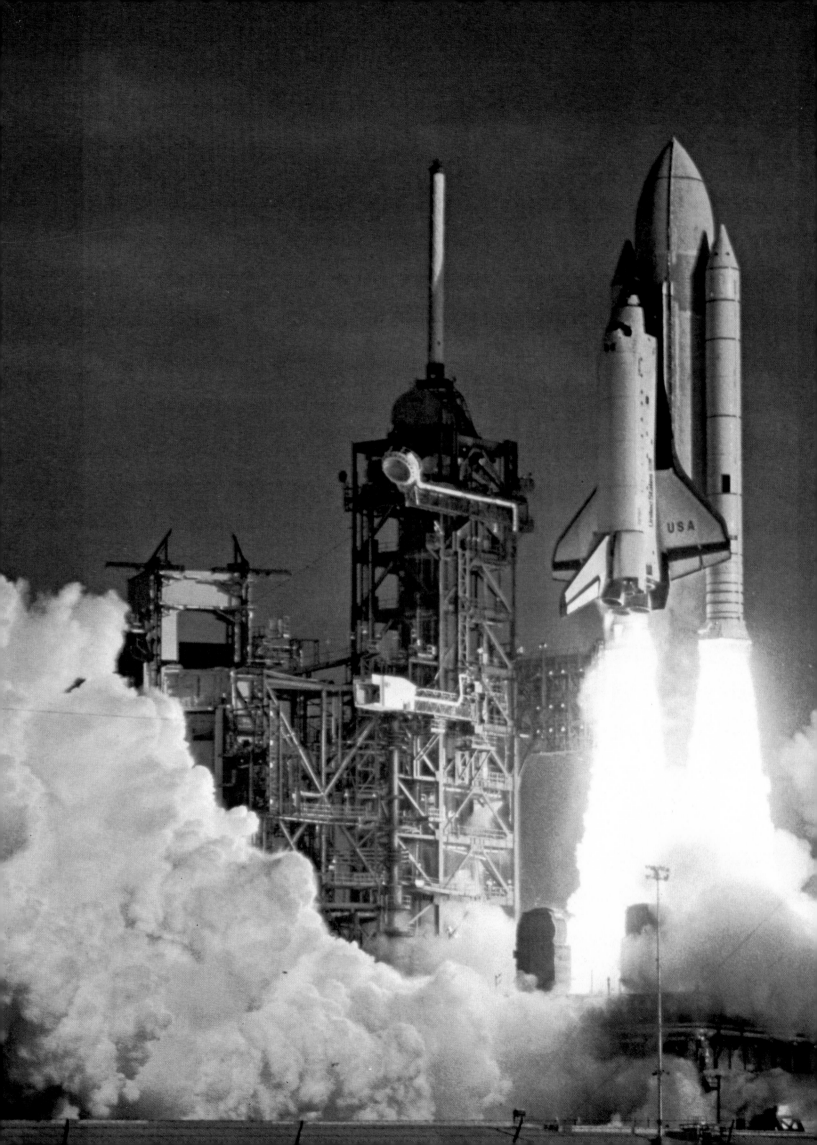

The launch of the space shuttle
Columbia on November 12, 1981
from Cape Canaveral, Florida

CHARLES L. TRAINOR, BILL REINKE, A.G. MONTANARI,
AND MICHAEL DELANEY, THE MIAMI NEWS
(STORY: PAGE 256)

HONORABLE MENTION FASHION ILLUSTRATION, NATALIE FOBES, SEATTLE TIMES

Color excites, enhances, emphasizes, enlightens, and seduces

FIRST PLACE FASHION ILLUSTRATION, BOB FILA, CHICAGO TRIBUNE

SECOND PLACE FASHION ILLUSTRATION, STEVE DOZIER, MIAMI HERALD

THIRD PLACE EDITORIAL ILLUSTRATION, MICHAEL COERS, COURIER-JOURNAL & LOUISVILLE TIMES

THIRD PLACE FASHION ILLUSTRATION, JOHN C. BEST, ABILENE REPORTER-NEWS

The variety of form, texture, light and color shown in these winning entries reflects photographers' control of technique, as well as sense of design.

Rhythm of composition and the dramatic touch of red in both swimsuit pictures fascinated the all-male panel of judges. One judge was intrigued by the zippered suit and sunglasses and said he appreciated the starkness, something he felt is symbolic of the fashions of the 1980s. The combination of color and texture was a winning quality in the picture titled, "BRRR". The underwater shot prompted a discussion on hydroponics (gardening without soil). Elements such as artist Dale Eldred's light panels, judges felt, was good use of environmental features for fashion pictures. The reflective panels are on a walk in front of an art museum. Reviewing the entries in this category, one judge quipped that it helps to have cooperative models in stunning clothes when making fashion pictures.

Peaches, a school lunch and Cioppino (a seafood stew) are photographs made for the purpose of whetting the appetite. Like fashion illustration, food illustration sells something and provides photojournalists opportunities to mix art with routine assignments. When successful, the photographs stand without words unless those words are recipes. The beauty and simplicity of such photographs belies the amount of time and difficulty usually required to produce them.

The atoll of Kayangel is like a living creature. The brown is exposed reef at low tide, the blue is shallow underwater sand and the green-black is the island vegetation. Kayangel is part of the Republic of Palau in the Caroline Islands of the Western Pacific.

The live embryo of a swell shark
from Japan is visible in its
streamlined egg case still attached
to its yolk-sack food supply.

HONORABLE MENTION MAGAZINE SCIENCE AND NATURAL HISTORY DAVE DOUBILET FOR NATIONAL GEOGRAPHIC MAGAZINE

SECOND PLACE MAGAZINE SCIENCE AND NAURAL HISTORY DAVID DOUBILET FOR NATIONAL GEOGRAPHIC MAGAZINE

The whale shark is the largest shark
in the world. This forty foot
specimen, surrounded by divers,
was photographed off Cabo San
Lucas, Baja, Mexico. The whale
shark is rare and survives on
plankton in the warm waters of the
world's oceans.

The fish-as-brush photograph was made as an illustration for a monthly arts calendar. Pat McDonogh used fish and primary colors to tie together ideas about art and that which is characteristic of southwest Florida.

PAT MCDONOGH, FORT MYERS (FLA.) NEWS-PRESS

FIRST PLACE PICTORIAL, GARY PARKER, FLORIDA TIMES-UNION & JACKSONVILLE-JOURNAL

THIRD PLACE MAGAZINE SELF-EDITED PICTURE STORY. HARALD SUND, FREELANCE, SEATTLE. WASH. FOR LIFE

Spray from a sprinkler system on a Florida golf course created a ghost-like light at sunrise on a foggy morning.

Tufa formations rise like tombstones in a dying lake in Northern California. This and several equally dramatic waterscapes were produced by Sund for a LIFE magazine story on the great water shortage in the southwest United States. The story was published in July, 1981.

It was late afternoon, Easter Sunday in Torun, Poland. Matthew Naythons photographed these city dwellers while shopping that day. They were unaware of his presence. The diffused light of a wintery sky enhanced both the mood and color of the picture.

FIRST PLACE MAGAZINE FEATURE PICTURE, MATTHEW NAYTHONS, GAMMA-LIAISON FOR TIME MAGAZINE

GARY PARKER, FLORIDA TIMES-UNION & JACKSONVILLE JOURNAL

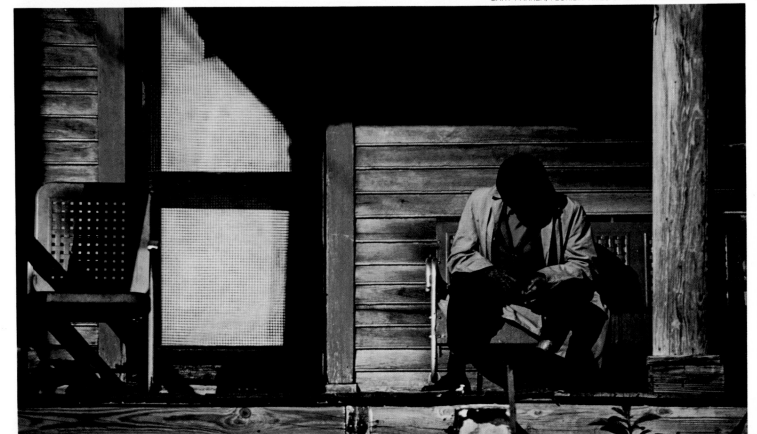

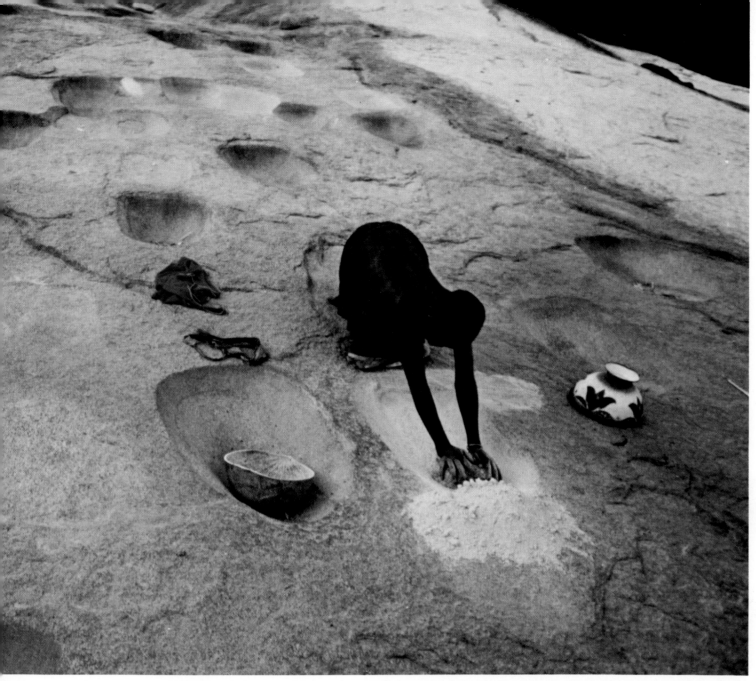

On a sunny winter day in Florida, a ghetto resident snoozes in the sunshine on his front porch. The photographer's comment: "It was probably colder inside than out."

Women in Lafon, southern Sudan, grind sorghum into flour on the side of a granite boulder. Years of use have pock-marked the granite with bowl-like depressions. When one gets too deep, the women begin another.

SECOND PLACE MAGAZINE PORTRAIT, THOMAS HOEPKER FOR GEO MAGAZINE

A young girl who served as an attendant to a geisha was called a kamuro. She accompanied the older woman, helped carry the tea vessels and offered her shoulder as a balance for the geisha, who walked in high clogs. Today a kamuro is found only in places such as the Sumiya teahouse in Kyoto, which is a living museum of authentic eighteenth-century Japanese life.
(GEO magazine)

FIRST PLACE MAGAZINE PICTORIAL, JOSE AZEL, FREELANCE FOR GEO MAGAZINE

For Haitian refugees, freedom begins behind a fence. Miami's Haitian community has grown to more than 35,000 people and fresh arrivals number almost 1,000 per month. While awaiting sponsorship or a job, this refugee works out with construction rods in a detention camp.
(GEO magazine)

THIRD PLACE MAGAZINE PHOTOGRAPHER OF THE YEAR, NEIL LEIFER FOR TIME MAGAZINE

MAGAZINE PHOTOGRAPHER OF THE YEAR, HARRY BENSON FOR LIFE MAGAZINE

HARRY BENSON FOR NEW YORK TIMES MAGAZINE

The medicine cabinet ran with a story on holistic medicine and homeopathy. Art director Gail Karpel and Kevin Higley set up the shot in graphic editor Tim Anderson's bathroom. Photographer Higley sat on top of a toilet with his back against a wall.

Since 1976, Ed Koch has been mayor of New York City. He helped reverse a steady loss of jobs, balance the city budget and convince New Yorkers that the city could be saved. Like all big city mayors, he faces more budget problems in 1982.

For the first time in eight years of exile, Alexander Solzhenitsyn and his wife, Natalya, shared their goal of unmasking the U.S.S.R.'s bitter history with a photographer and a reporter. Harry Benson had two and one half hours to capture the Russian writer on his 50 acres of Vermont woodland.

Singer Tony Bennett, heartthrob of the Fifties and still popular in the Eighties, practiced for a night club engagement in his New York apartment. Benson wanted a different angle and stood on the chair to get the shot.

SECOND PLACE EDITORIAL ILLUSTRATION, KEVIN HIGLEY, GANNETT ROCHESTER NEWSPAPERS

HARRY BENSON FOR PEOPLE MAGAZINE

John Birks (Dizzy) Gillespie delivers a commencement address to the graduates at Fairleigh Dickinson University in Rutherford, New Jersey.

When Harry Benson asked Fred Astaire and his wife, jockey Robyn Smith, to dance for him, first Fred said yes and Robyn said no. Then she said yes and he said no. The closest Benson got to a dance picture was when Fred crossed his legs in an elegant Astaire pose and Robyn rode out of the picture on a bicycle.

CARY HERZ, STAR-LEDGER, NEWARK, N.J.

THIRD PLACE MAGAZINE PORTRAIT/PERSONALITY, DAVID HUME KENNERLY FOR TIME MAGAZINE

Secretary of State Alexander Haig Jr. was the subject of the March 16, 1981 cover story for TIME magazine. Haig feels the prime threat to peace in the world is Soviet expansionism. He is praised and criticized for his tough stands on U. S. foreign policies.

The Royal Wedding of England's Prince Charles and Princess Diana was one of glorious and proper English pageantry. They left St. Paul's Cathedral in a royal carriage to breakfast at Buckingham Palace, waving to throngs of well-wishers.

IAN BERRY/MAGNUM FOR LIFE MAGAZINE

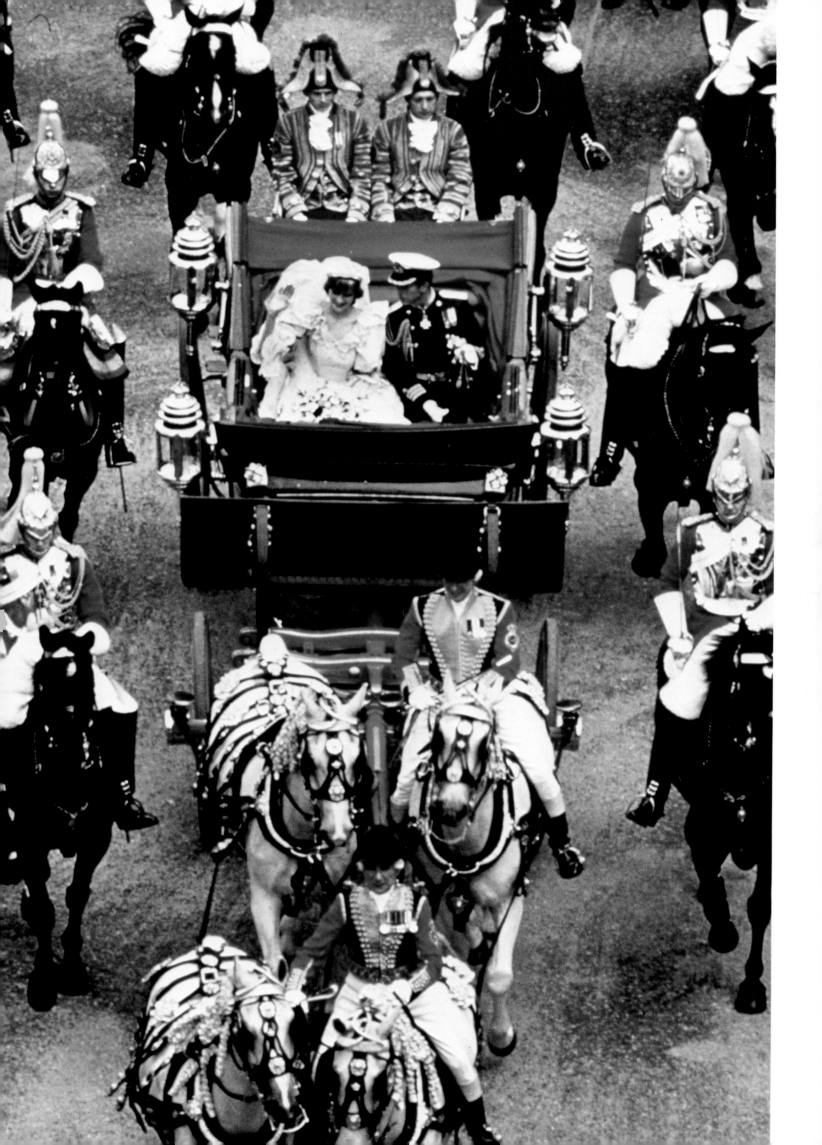

HONORABLE MENTION FASHION ILLUSTRATION
MICHAEL BRYANT, SAN JOSE MERCURY NEWS

A cover picture for a spring fashion section was to have been shot with the model in front of a yacht harbor. Michael Bryant saw the skiff, talked to the owner who agreed to row the boat, then photographed the girl in an informal pose. The result was one of elegant simplicity. (Original in color.)

Gallery owner Donald Vogel owns the painting, "Nana," an art piece famous in this country in the 1930s. The nude attracted long lines of admiring fans and Vogel remains one of her staunchest supporters, says photographer Eli Grothe.

Finland's greatly beloved actress, Ella Eronen said to Jodi Cobb, "I'm too old to be photographed, but I'll let you photograph Madame. "Madame" was her most famous role, for which she is dressed in both the portrait and the painting behind her. Her husband painted the portrait many years ago. (Original in color)

SECOND PLACE PORTRAIT PERSONALITY, RANDY ELI GROTHE, DALLAS MORNING NEWS

JODI COBB, NATIONAL GEOGRAPHIC

MAGAZINE THIRD PLACE FEATURE PICTURE STORY, REBECCA COLLETTE FOR GEO MAGAZINE

Three contemporary visions of woman are displayed on this spread: what woman once was in the American tradition, what some are in plastic worlds of fashionable entertainment and what some might be in the context of a professional military career. The photographs re-emphasize that no one definition of female fits all women and that, in style and activity, the individual defines her (or his) own image. One satisfying element of the craft of photography is that the photographer can choose to tell the truth about a situation or, in the challenge to illustrate an idea, can use human models to make a statement of his (or her) own ideas.

The question is only: to whom is the photographer speaking and for what purpose?

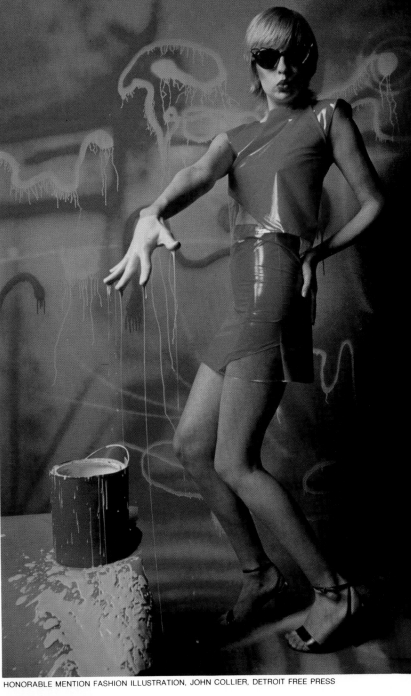

HONORABLE MENTION FASHION ILLUSTRATION, JOHN COLLIER, DETROIT FREE PRESS

STEVE RICE, HARTFORD COURRANT

169

During prayers at an Anglican convent in Duxbury, Mass., Bill Greene was unable to take Sister Clarissa's picture. He learned she was responsible for the guest house, knocked on the door and found the lead picture he wanted.

Aided by her imagined mentor, the cow's head, Louise Durkee "takes flights of fantasy across the boundaries that define traditional dance forms." She performs before sellout crowds in the northwestern United States.

A judge said the picture intrigues because the man in the doorway appears to be part of the wall.

PATROCINADOR-CASABLANCA
ARTE POR L. MONTERO
ASST. LILI
GRACIA & PARODI

Yavapi Indian tribal chairman, Norman Austin, looks with disdain toward Interior Secretary James Watt during a press conference. The Indians were fighting efforts by the United States Government to build a dam that would flood the Yavapi reservation, threatening the future of the 350 member tribe. The dam was to be built as part of the Central Arizona Project, a plan to bring water to Arizona from the Colorado River.

Senator Robert Byrd watched national television evening news regarding reports of plans of a Libyan hit squad to assassinate President Ronald Reagan. In the background, Byrd's staff aides paid close attention.

Oil lobbyists Robert Anderson and Donald Lanetti took front row seats during hearings held in the House Energy and Natural Resources Committee on the feasibility of a mineral productions severance tax.

HONORABLE MENTION NEWSPAPER PORTRAIT/PERSONALITY, JUDY GRIESEDIECK, THE HARTFORD COURANT

GARY PARKER, FLORIDA TIMES-UNION & JACKSONVILLE JOURNAL

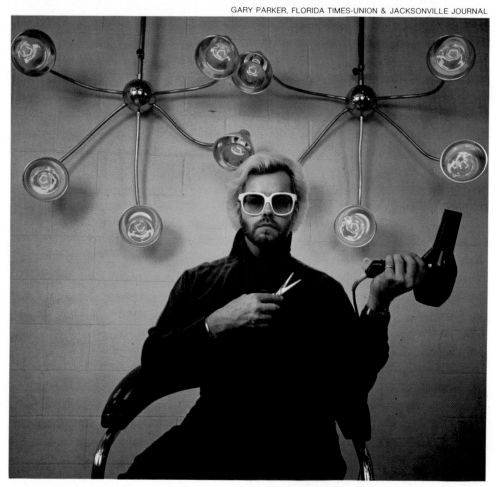

The twins were attending a reunion of a dance school class they attended as children. One of the classrooms was pink and lavender which added a delightful touch to the picture.

Blow dryers, heat lamps and $200 scissors reflect the image of a modern hair stylist. Black roots under bleached hair is supposedly "the latest thing."

During a tour of his home state, Arizona, U.S. Senator Barry Goldwater scowls for the cameramen at a press conference.

THIRD PLACE NEWSPAPER PORTRAIT/PERSONALITY,
JACK W. SHEAFFER, ARIZONA DAILY STAR, TUCSON, ARIZ.

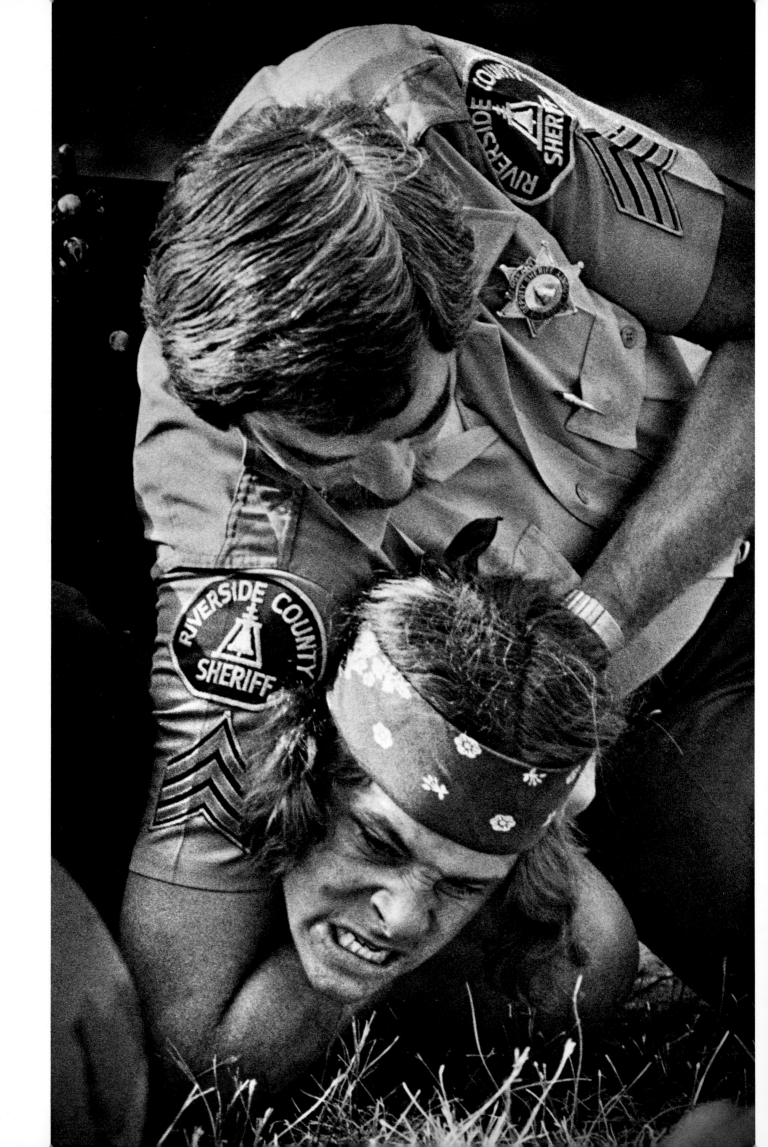

Trouble began for Riverside, Calif., deputies when a group of bikers arrived at a Labor Day bluegrass festival. The officer subdued the man who tried to punch him.

The little leaguer missed a play during a game. Resembling an angrier version of the buccaneer on the boy's helmet, his coach emphasized a point at the sidelines.

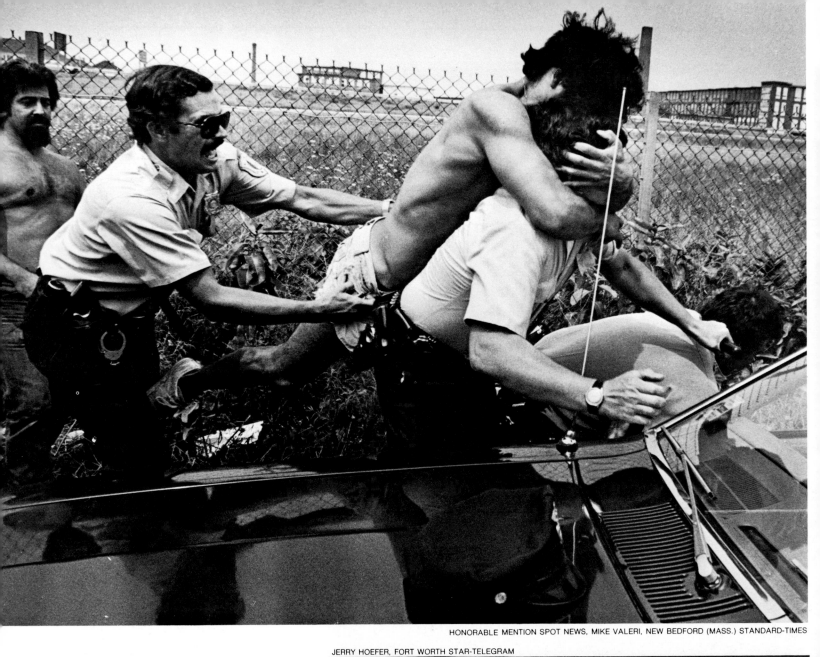

JERRY HOEFER, FORT WORTH STAR-TELEGRAM

An over-zealous policeman and a hot-headed union man sparked a melee during the second week of the seafood workers' strike in New Bedford, Mass. Several arrests were made up and down the line of fish plants. The union was protesting wage cutbacks. Mike Valeri said that a bottle to be used in the fighting was broken close to his face.

A Dallas Maverick player, Tom LaGarde, committed an undetected foul against Mark Oberding, a San Antonio Spur player, during an NBA game. Jerry Hoefer shot the picture 90 feet above the basket from a catwalk in the Dallas Reunion Arena. Hoefer used a 300mm/2.8 lens. The foul lasted long enough to get three frames.

GENE SWEENEY, JR., FLORIDA TIMES-UNION & JACKSONVILLE JOURNAL

Dennis Wit of the Jacksonville Tea Men interfered with goalkeeper Volkmar Gross of the San Diego Sockers during a playoff game of the North American Soccer League in Jacksonville, Fla. Gross successfully deflected the ball, but another player kicked it in for the game-winning goal. Gross appealed the obvious foul, but officials allowed the score. Gene Sweeney said that, after the Sockers complained about the poor officiating, the NASL requested a copy of the photo to use in training officials.

SECOND PLACE SPORTS PICTURE STORY, FRED BARNES, THE GRAND RAPIDS (MICH.) PRESS

SECOND PLACE SPORTS ACTION, DAN PEAK, KANSAS CITY STAR

Two members of the Howard City (Mich.) High School football team struggled against each other while clutching footballs during a harness drill. The drill was part of a "conditioning camp" preparing players for the coming season. Fred Barnes said the team was undefeated in their last 27 games.

A Kansas City Chiefs' defensive back knocked down a Seattle Seahawk receiver who had just caught a pass at an AFC game in Kansas City.

When April Saul approached her former employer, the Baltimore Sun, about doing a picture story on women's rugby, the paper liked the idea but couldn't afford to give her the time she needed.

Saul did the story on her own time. Even though, she admitted, shooting sports was one of her weaknesses, she followed the Chesapeake Women's Rugby Club on its Sunday games and weekend road trips.

The club includes women in their twenties and thirties, "a bunch of lawyers, teachers, social workers and secretaries" who "pride themselves on their grit in the face of injuries and exhaustion, and reward themselves after a tough game by guzzling beer and rivaling male ruggers with their bawdy songs." The women play for the love of it and compete against college teams — the woman in pain is Dee Dee Dawson of Maryland's Towson State College.

The Chesapeake Women's Rugby Club liked the 5-foot two-inch, 105-pound writer/photographer and asked her to join. Saul declined, completed the story and sold it to the Baltimore Sun.

FIRST PLACE SPORTS PICTURE STORY, APRIL SAUL, FREELANCE-THE BALTIMORE SUN (BOTH PHOTOS)

HONORABLE MENTION NEWSPAPER FEATURE PICTURE, JOHN J. GAPS, III, FREELANCE, IOWA STATE DAILY

Boston center Jawann Oldham reached through the hoop to block a shot by Fort Worth's Allan Bristow. Oldham was called for the foul.

Breaking the world record at chess marathoning wasn't easy for this student at Iowa State University. The chessboard had to accompany him everywhere.

FIRST PLACE SPORTS ACTION, JOHN E. HALL, DALLAS TIMES HERALD

The Notre Dame football team listened attentively as Coach Jerry Faust tried to ignite them before the second half against Florida State. It didn't work.

Before U.S. Open winner, David Graham, took the difficult shot, Vicki Valerio was in the crowd in the picture. She squeezed through the gallery, raced around the green and crawled through the spectators. Graham slapped the ball on the green and the crowd applauded.

VICKI VALERIO, THE PHILADELPHIA INQUIRER

A title bout in professional boxing is like declaring a two hour war between two people several months in advance. The photographer must remain in a fixed position and hope for a good angle on a lightning jab.

In 1981, Larry Holmes made a comeback after three years of obscurity. He squared off against Trevor Berbick, Leon Spinks and Renaldo Snipes whose face he rubberized. Though Ron Kuntz has had considerable success with boxing, he feels it is the hardest sport to cover.

Lupe Pintor, WBC bantamweight champion, guts challenger Jose Uziga. Pintor retained his title in the fight held in Houston. Photographer James McNay fought for the picture, bobbing and weaving for fifteen rounds with a judge seated directly between him and the ring.

Florida's cruiserweight champion, Tony Servance, rendered Homer Jackson semi-conscious with this right hook. Servance is now the Southeastern United States champ. The cruiserweight division is between light heavyweight and heavyweight.

RON KUNTZ, UNITED PRESS INTERNATIONAL

JAMES E. MCNAY, THE HOUSTON POST

BILL WAX, GAINESVILLE (FLA.) SUN

Experts considered the fight a tossup. The press dubbed it, "The Showdown." When both Sugar Ray Leonard and Tommy Hearns appeared at the same place four months before the fight, Shelly Katz secretly sealed off the motel ballroom, set up his equipment and waited out a psychological battle between the two. In one of four publicity pictures, Leonard and Hearns grapple and glare.

FIRST PLACE MAGAZINE SPORTS PICTURE, DIRCK HALSTEAD, TIME

Everyone expected a tremendous match and it was. Going into Round 13, Tommy Hearns was leading in points and Sugar Ray Leonard's left eye was swelling shut.

In the thirteenth round, Leonard began a withering assault that sent Hearns to the ropes. Hearns climbed back in the ring and was again knocked through the ropes. The round ended before the referee's eight count. In the fourteenth round, Leonard pounded Hearns for nearly two minutes before the referee stopped the fight. Sugar Ray Leonard was the welterweight champion of the world and $11 million richer. The fight itself grossed $36 million — the richest single sporting event in history.

After Leonard beat Hearns, Sugar Ray went after the junior middleweight crown. He scored a ninth round TKO against Ayub Kalule, a Ugandan living in Denmark, then flipped for the fans in Houston.

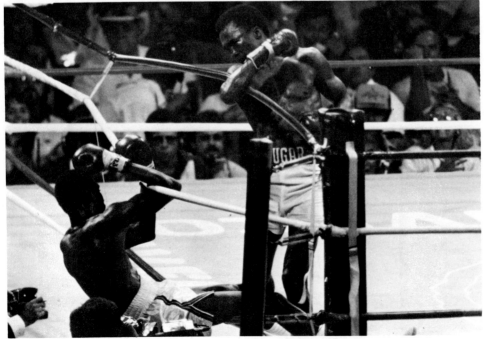

RICH LIPSKI, UNITED PRESS INTERNATIONAL

THIRD PLACE NEWSPAPER SPORTS FEATURE
BETTY TICHICH, HOUSTON POST

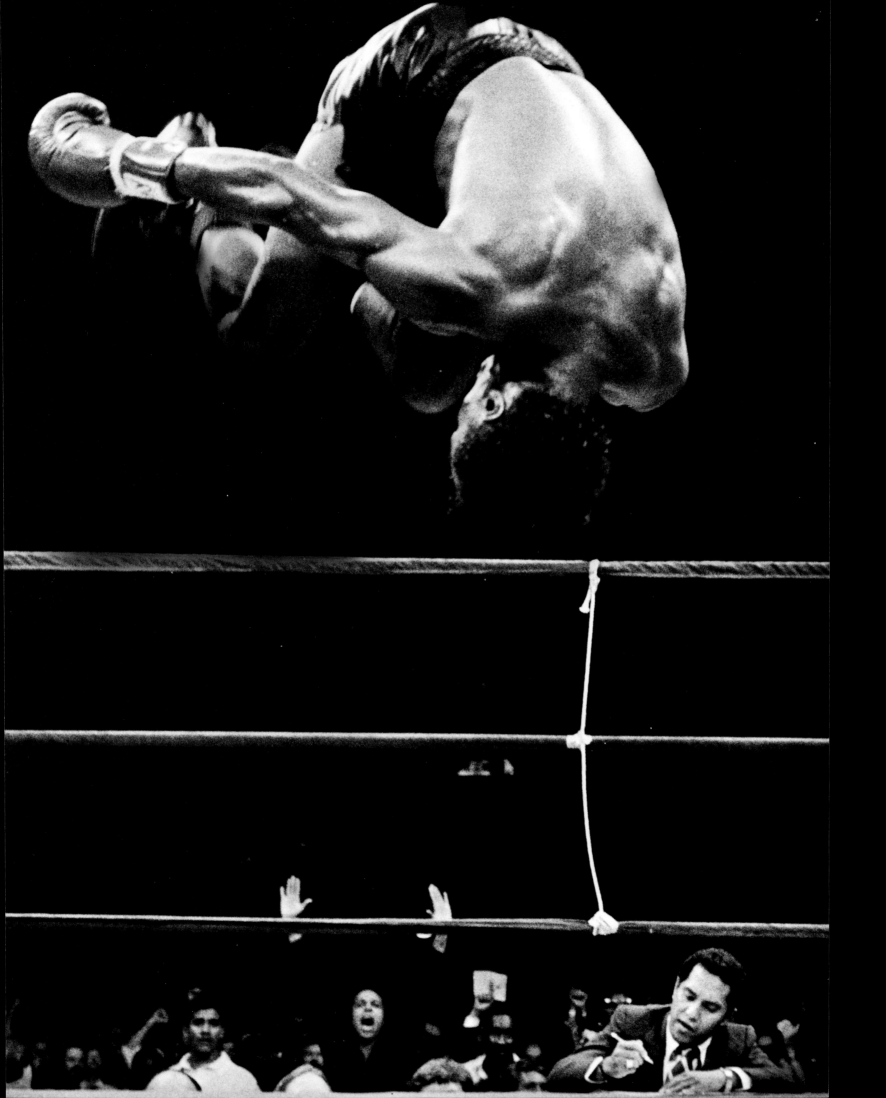

THIRD PLACE NEWSPAPER PHOTOGRAPHER OF THE YEAR, GARY PARKER, FLORIDA TIMES-UNION & JACKSONVILLE JOURNAL

Gary Parker was packing up to leave when a player from Terry Parker High School in Jacksonville, Fla., hit a game-winning homerun. Parker got a picture of the celebration.

Photographer George Wilhelm was covering Veterans Day ceremonies. The ROTC unit had been standing at attention for half an hour when he noticed a junior member whisper to the person next to him. Then the boy fainted, barely breaking his rigid stance.

GEORGE WILHELM, SIMI VALLEY (CALIF.) ENTERPRISE

ENTHUSIASM

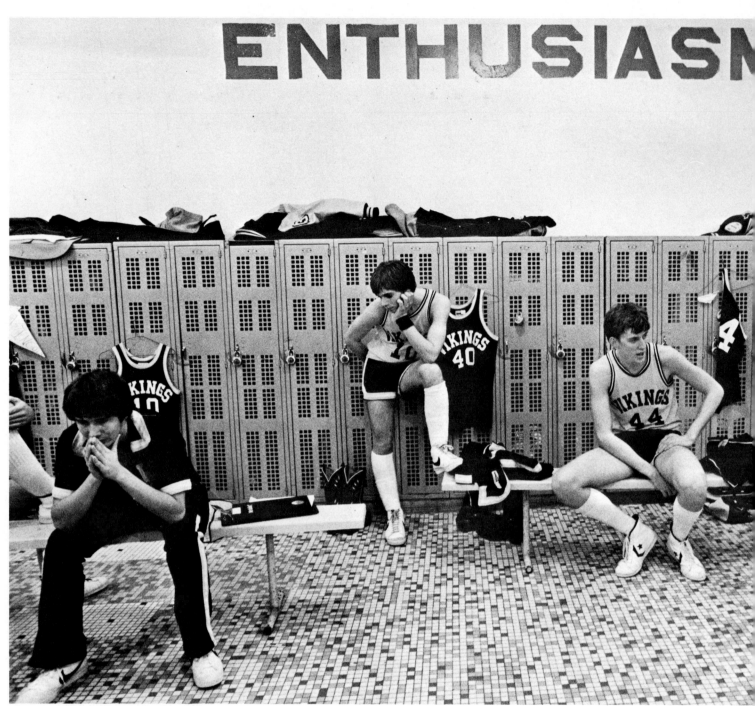

In contrast to the word on the wall, four of five starters for the Lamont (Mo.) Vikings High school basketball team sit in disbelief after a disappointing one point loss to a semi-finals competitor.

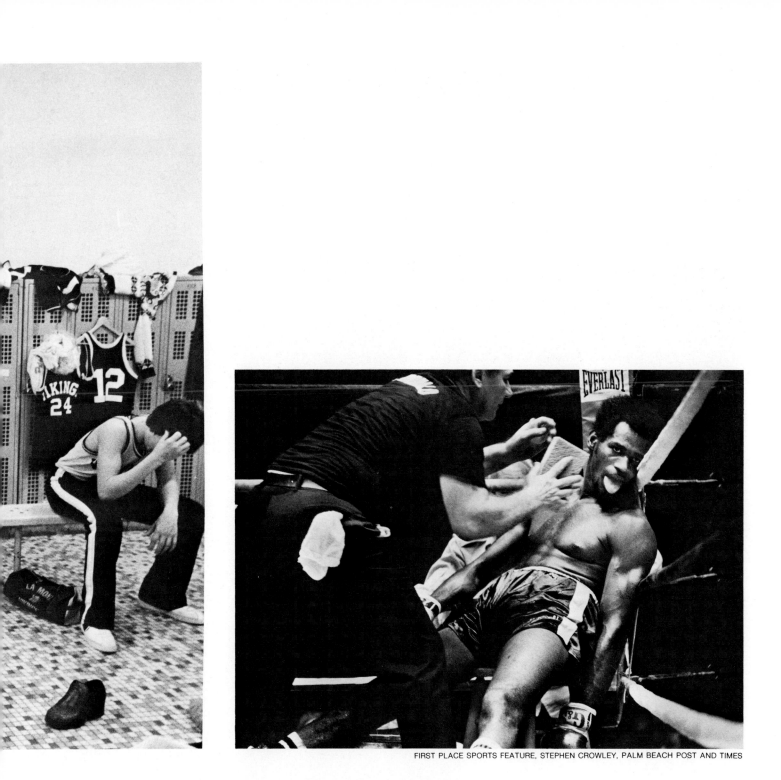

Leon "Nightlife" MacDonald shows signs of fatigue during a Florida middleweight title bout. McDonald went on to successfully defend his title.

George, 16, was the subject of a picture story about deaf and blind kids having to spend the summer at home since the Florida legislature failed to fund a summer program. George plays with his 14-year-old sister who tries hard to occupy his time but cannot care for him the way the school can. Gary Parker says that, within two weeks of the story's publication, funds were provided and the children were returned to school.

HONORABLE MENTION SPORTS FEATURE, MARK GRAHAM, DENTON (TEXAS) RECORD-CHRONICLE

North Texas State University's Louis Haynes shows a photographer his fumble recovery style during picture day.

GARY PARKER, FLORIDA TIMES-UNION & JACKSONVILLE JOURNAL

The boy dragged the hose from his yard to cool down runners at the 32-kilometer mark during the Palos Verdes, Calif., Marathon. Michael Rondou walked about 15 miles of the run, carrying his equipment. It was a hot day and he wanted to get in the water himself. Bleach was used to accentuate highlights.

Folks at a Gainesville, Fla., car wash were surprised when Texas Bill Thorpe and Cajun, his 1,800 pound bull, showed up for a "hosing-down." The long, cool one suited old Cajun just fine. When not performing at the Gator Roundup World Championship Rodeo, Texas Bill and his animal show visit local schools.

Ron Tarver was watching a ballet exhibition at the Dance Masters of America Dance Competition in Muskogee, Okla., when Mary Fite paused in the hallway before her routine. Tarver said that within moments the shaft of sunlight was gone.

John Kaplan was driving to Ohio University when he came upon this accident just east of Athens, Ohio. The car hit the embankment and flipped over. The driver passed the sobriety test. Miraculously, no one was hurt.

SCOTT HENRY, LAS VEGAS REVIEW-JOURNAL

The plight of Donna Duck began at the Sahara Country Club in Las Vegas and spread around the world. She eluded capture for several weeks. Finally, volunteers caught her and found that the arrow pierced only the fleshy part of her breast. A veterinarian removed it and, after a brief convalescence, Donna was reunited with her mate. The juvenile who shot her voluntarily turned himself in.

DALE GULDAN, NEWSPAPERS, INC.

In a split second of concentration, players wait for the ball to pass through the hoop at the Milwaukee Bucks versus Philadelphia '76ers game. Seconds later, they were halfway down the court in the other direction.

Pete Souza found two cats eyeing a bird stuck between two windows.

PETE SOUZA, THE CHANUTE (KAN.) TRIBUNE

Looking like fish in a bowl, three children peer out of their camper window, checking out a California traffic jam.

MARK E. REIS, COLORADO SPRINGS SUN

While on a "behind the scenes" story about the Cheyenne Mountain Zoo in Colorado Springs, Mark Reis found two Asian lions not available for public viewing. The zoo boasts 12 of the 275 Asian lions known to exist. Unfortunately, the Asian lion is less popular than the African lion because it doesn't have a great mane. Therefore, surplus lions are kept in private pens.

FIRST PLACE SCIENCE/NATURAL HISTORY, REINHARD KUENKEL, GEO (ORIGINAL IN COLOR)

SECOND PLACE SPORTS PICTURE, WALTER SCHMITZ, GEO (ORIGINAL IN COLOR)

On the Serengeti Plain in Tanzania, mud itself is precious. Not only does it signal water's presence, mud has bacteria-retarding minerals. A coating of mud also holds off the vicious hordes of biting insects — a fact known to all young zebras.

HONORABLE MENTION SCIENCE/NATIONAL HISTORY, STEPHEN J. KRASEMAN, FREELANCE (ORIGINAL IN COLOR)

A European favorite since World War I, motocross is rising in popularity and sophistication in the U.S. Motocross events are held in any weather with fewer serious accidents than auto racing. The best bikes cost at least $60,000. A professional may earn up to $400,000 a year. This racer uses his foot for support through a turn.

The mountain lion's range and numbers have been declining since the 1500's. Though it prefers elk and deer, it will prey on domestic stock. Since its re-classification as a big game animal in 1971, the lion population in the U.S. has shown a slight gain. Stephen Kraseman tracked and photographed mountain lions for two years.

Halfway through the NASCAR race at the Pocono Raceway in Long Pond, Pa., a fawn ran across the tracks toward the infield. The yellow signals flashed and the drivers slowed down. The car was traveling so fast that Steven Falk shot only one frame with both car and deer. The fawn later was captured by track personnel and returned to the woods.

Canine Rights and Responsibilities, Chapter 18: Dealing With Trucks. *Identify the problem. Never show fear but take no chances with random linear events — keep all four paws on the ground! Define and attack the problem with every available resource. Solve the problem. Return to normal routine. Damn pickups!*

STEVEN M. FALK, ASSOCIATED PRESS

HONORABLE MENTION FEATURE PICTURE STORY, BOB MODERSOHN, DES MOINES REGISTER

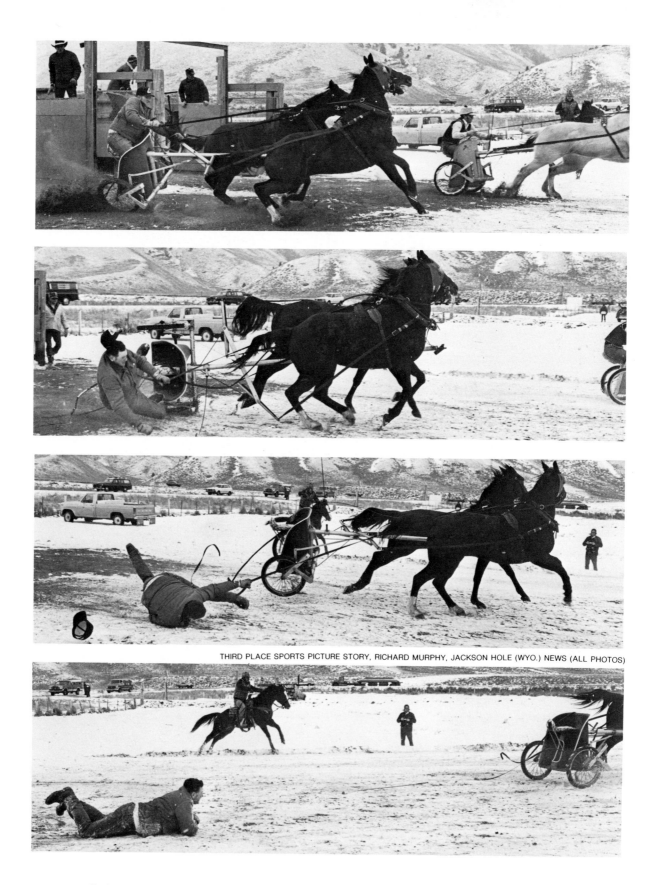

THIRD PLACE SPORTS PICTURE STORY, RICHARD MURPHY, JACKSON HOLE (WYO.) NEWS (ALL PHOTOS)

Dave Paulk lost control of his cutter team and spilled at the starting gate during the Shriner's Invitational Cutter Races held at Melody Ranch near Jackson Hole, Wyo. Before the races, teams are reviewed and matched as evenly as possible. At the end of the quarter mile, the cutters are rarely more than a length apart.

During the 64th lap of the Indianapolis 500, Danny Ongais was entering Turn 3 when his racer veered headfirst into the outside wall. It took rescuers 15 minutes to free him from the wreckage. Ongais was not seriously burned, but suffered compound fractures in his right leg, a broken left arm, and chest contusions.

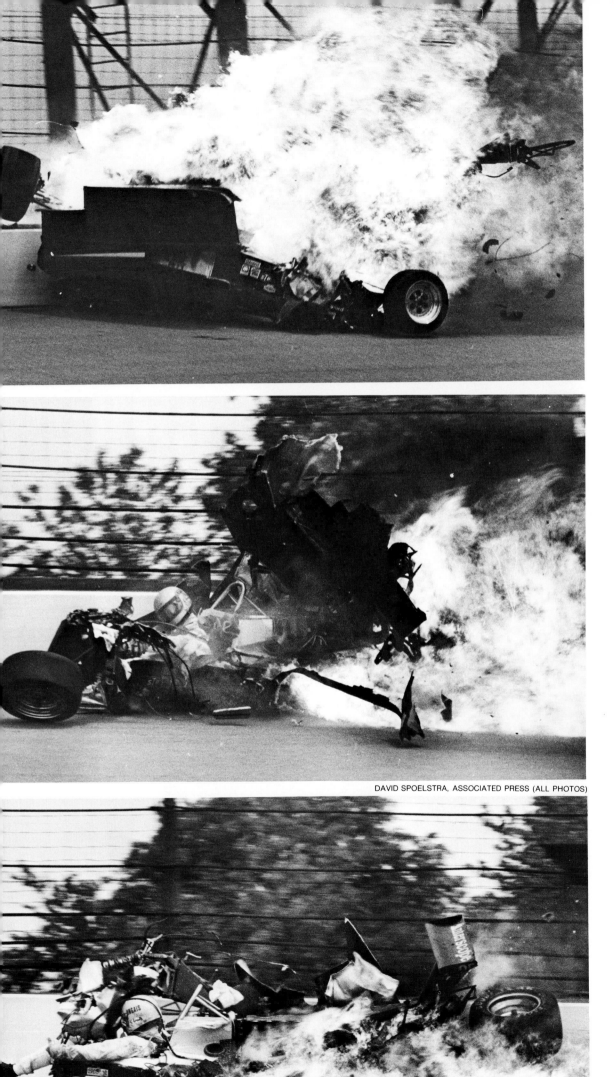

DAVID SPOELSTRA, ASSOCIATED PRESS (ALL PHOTOS)

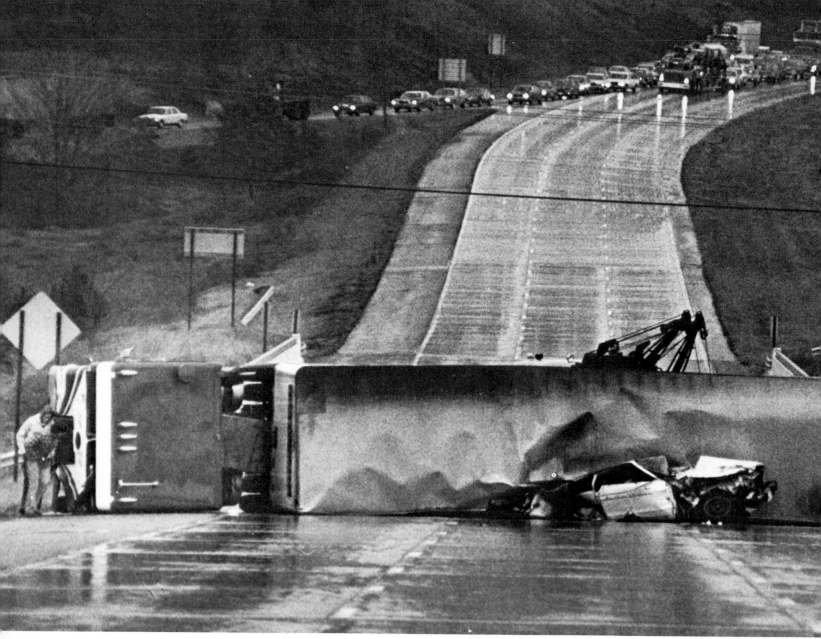

TENNEY MASON, PATUXENT PUBLISHING CO.

During a freezing rain on eastbound I-70 twenty miles west of Baltimore, a tractor-trailer crushed a Datsun. The Datsun lost control coming up the hill. The truck swerved to avoid it, hit two cars parked in the median, then flipped over on the Datsun. Eugene Greer, the driver of the truck, was treated and released. Vera Thomas, the driver of the car, suffered serious back, leg and facial injuries. She believes she would be dead had she been wearing a seatbelt.

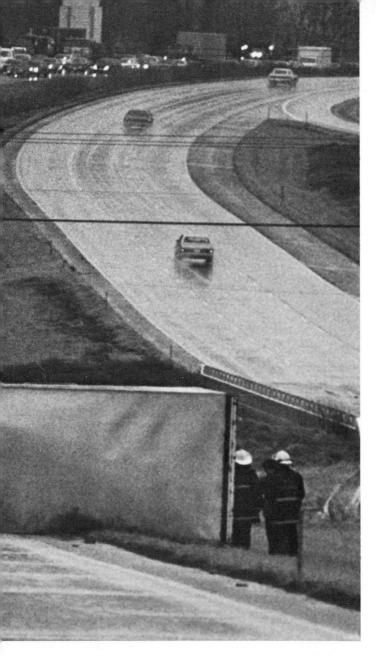

Photographer Jimi Lott found Emma Hart, 86, more concerned with the contents of her mailbox than the problem faced by the truck driver behind her. A load shift toppled bales of hay just beyond the Hart residence.

JIMI LOTT, SPOKANE CHRONICLE

GEORGE WILHELM, SIMI VALLEY (CALIF.) ENTERPRISE

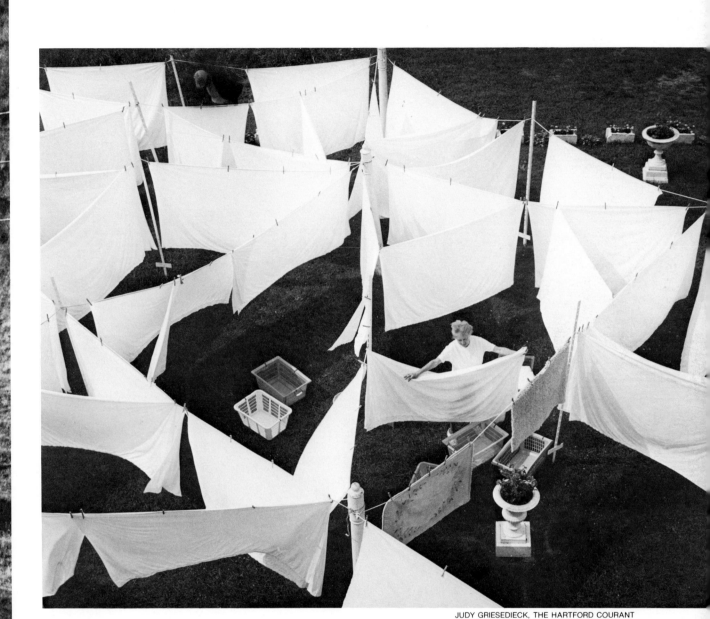

JUDY GRIESEDIECK, THE HARTFORD COURANT

The world's largest hot air blimp crash-landed into power lines after a steering mechanism failed. Aboard was Malcom Forbes, publisher of FORBES magazine. After the crash, he was still thinking about buying it.

Elizabeth Riley, manager of Hadley's Guest House in Watch Hill, R.I., created a maze of sheets on wash day. Photographer Judy Griesedieck was staying at the inn and shot the picture from her window on the second floor.

Kevin Manning was figuring out the best shot of a house near Fairgrove, Mo., when Osward Hankins and his pet goat, Suzette, dropped by to see if the house would last through the winter. The house is in a remote pasture of Hankins' farm.

Although the picture did not run because the horizon wasn't quite "right," Michael Bryant did succeed in getting a cable car picture with a little different angle. The photo was to have accompanied a story on the financial troubles San Francisco is having with its cable car system.

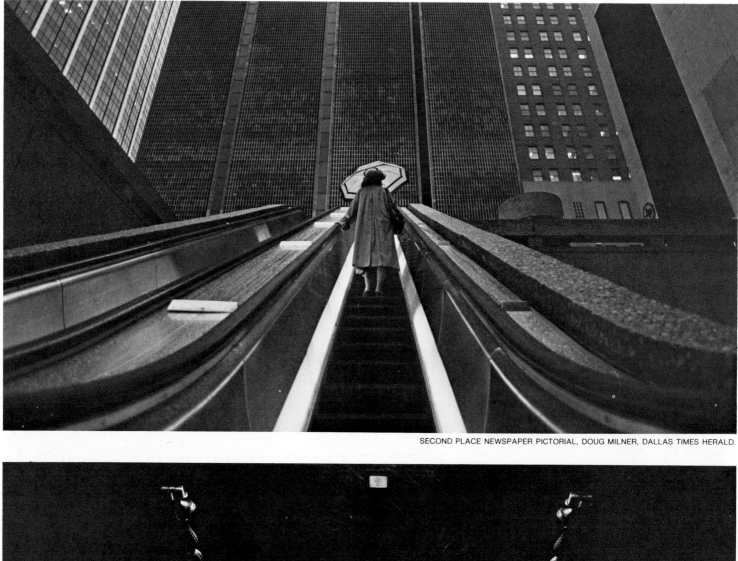

SECOND PLACE NEWSPAPER PICTORIAL, DOUG MILNER, DALLAS TIMES HERALD.

THIRD PLACE NEWSPAPER PICTORIAL, NURI VALLBONA, COLORADO SPRINGS SUN

While doing a rain feature for the Dallas Times Herald, Doug Milner wandered into One Main Underground — a subterranean shopping center in Dallas. He found the escalator and waited for someone to leave.

RUNNER-UP NEWSPAPER PHOTOGRAPHER OF THE YEAR, BRAD GRAVERSON, THE DAILY BREEZE (TORRANCE, CALIF.)

Amid concrete, steel and glass, a pair of Californians found a highrise spot for a noontime jog.

After a city council meeting at the Colorado Springs City Hall, photographer Nuri Vallbona took several shots of people using the stairs. Only the man with a bag and an empty box was in the spot she wanted.

***OVERLEAF** (pp. 220-221): Passengers detrain at the foot of Detroit's Renaissance Center. The Renaissance Center was completed in 1979 and has given new life to downtown Detroit. It contains offices, shops, restaurants, theatres and a hotel. Deborah Booker said that future cities will look similar to this.*

The night-lit offices of the Cities Service Company silhouette the spire of the Holy Family Cathedral in downtown Tulsa. Dave Kraus bleached the print slightly to heighten contrast.

Atop 25 foot poles, students of Ohio Edison's lineman's school played catch with a basketball to gain confidence. If they dropped the ball, they had to climb down, retrieve it, then climb back up.

Hartford, Conn., police had to wait out this burglary suspect. Jerome Weaver, 16, made 20 leaps between three buildings in 45 minutes.

With 80% of the climb behind him, "Spider Dan" Goodwin grinned as he passed the 83rd floor of the John Hancock Center. To climb the world's tallest structure, he thwarted cascades of water, broken windows, an angry police chief, fire commissioner and mayor. Photographer Richard Derk shared a seat with a couple in a restaurant to get this shot.

The Lexington Bryan High School basketball team was picked to win the state championship of Kentucky. They lost in the closing seconds of the first playoff game to Mason County High School. This dejected player tried to get out of sight but chose the wrong hallway.

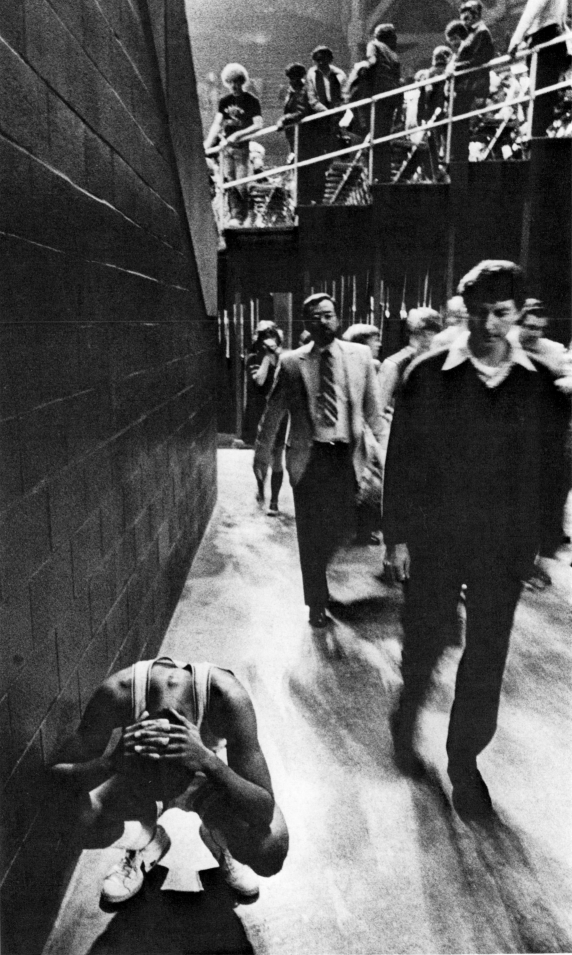

NEWSPAPER PHOTOGRAPHER OF THE YEAR, DAN DRY, COURIER-JOURNAL AND LOUISVILLE TIMES

THIRD PLACE NEWS PICTURE STORY
RICHARD DERK, CHICAGO SUN-TIMES

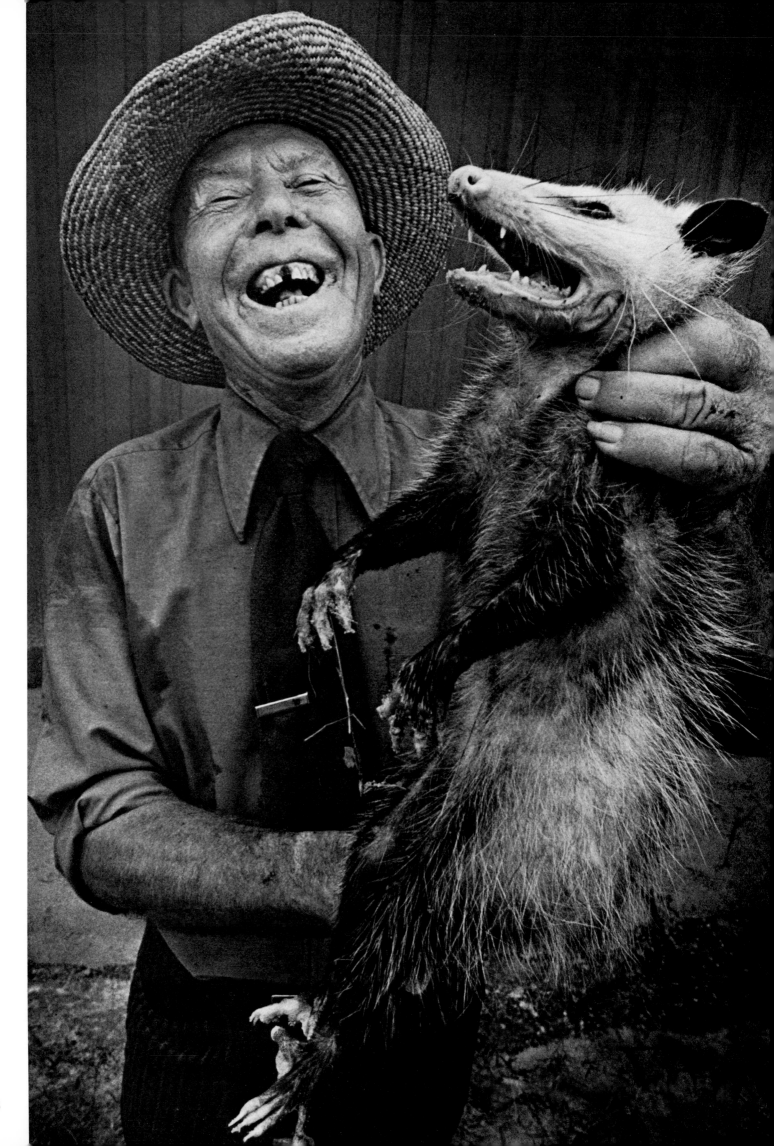

The annual Possum Festival in Wausau, Fla., is unique in that it is held in a rural area and is completely uncommercialized. Events include square dancing, a corn pone cooking contest, greased pig catching, greased pole climbing, gopher races, pig calling, husband calling, rooster crowing, cow lowing and belly sliding. One of the men grabbed a live possum and exclaimed to Gary Parker, "I'm a-gonna out grin 'im!"

The grand finale of the Possum Festival is the crowning of the Possum Queen.

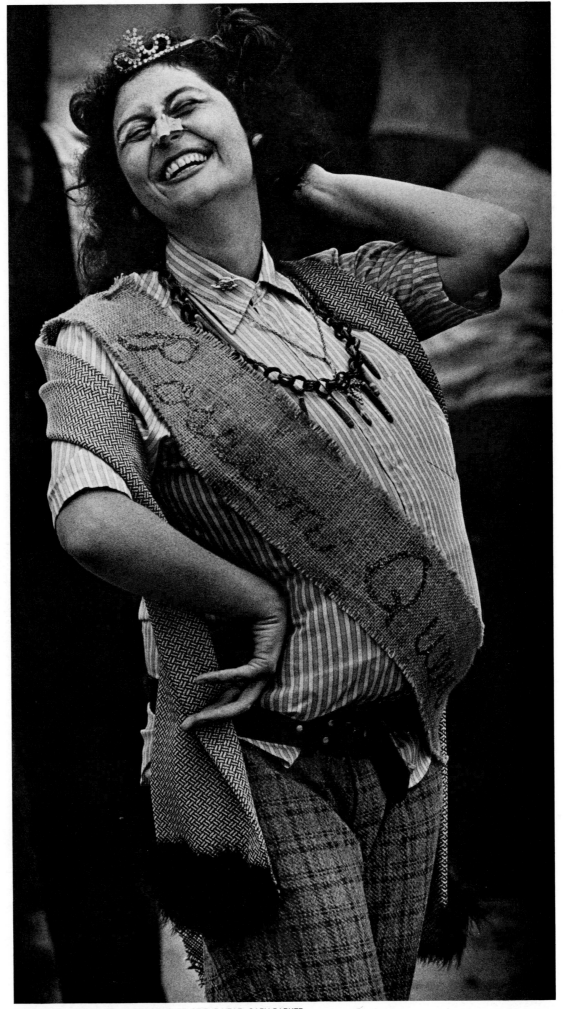

THIRD PLACE NEWSPAPER PHOTOGRAPHER OF THE YEAR, GARY PARKER,
FLORIDA TIMES-UNION AND JACKSONVILLE JOURNAL (BOTH PHOTOS)

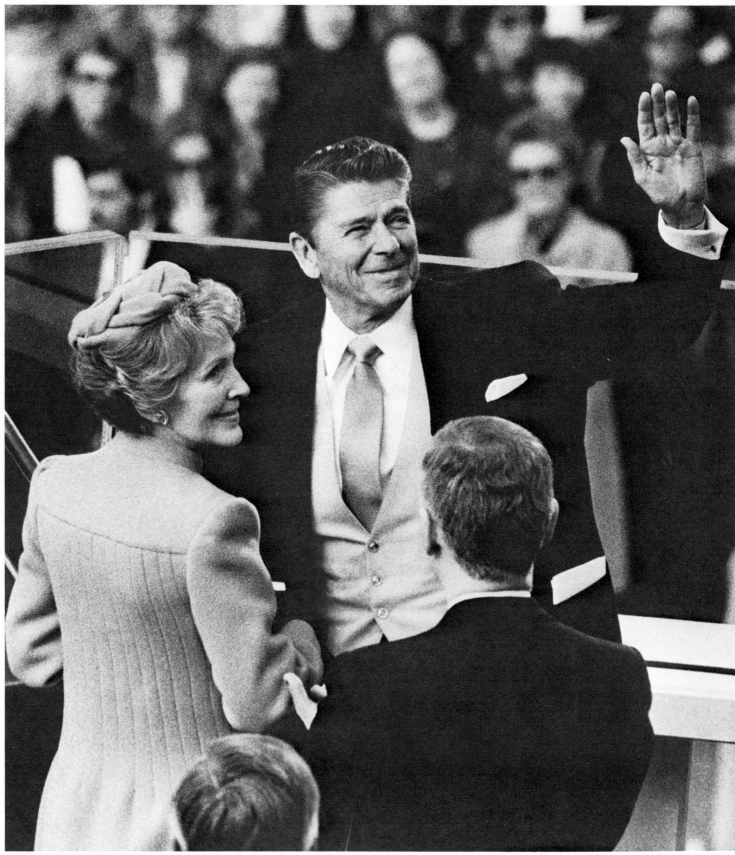

DAN DRY, COURIER-JOURNAL AND LOUISVILLE TIMES

Shortly after taking the oath of office, Ronald Reagan, the 40th President of the United States, and his wife, Nancy, waved to crowds from the inaugural platform.

Reagan's first public appearance after the assassination attempt was to attend commencement ceremonies at Notre Dame University. It was also a reunion with actor Pat O'Brien. Both starred in the movie, "The Gipper."

DOM NAJOLIA, CHICAGO SUN-TIMES

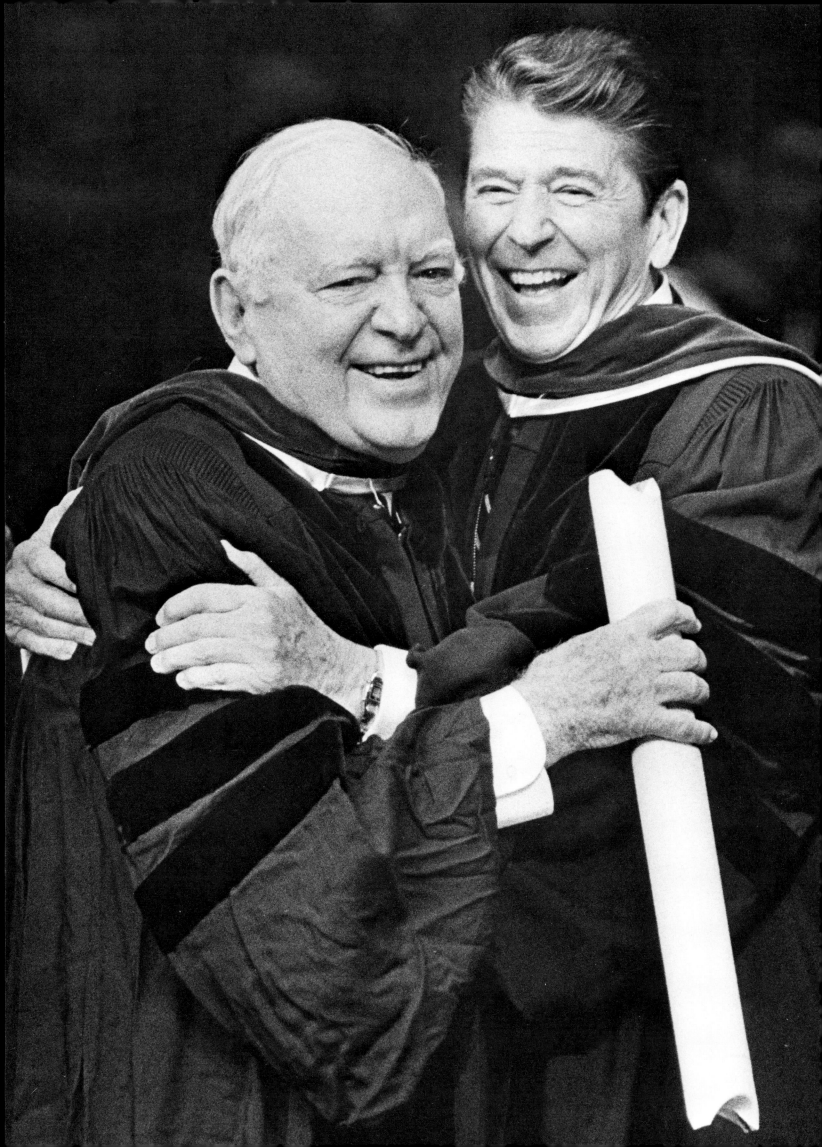

JACK LENAHAN, CHICAGO SUN-TIMES

Actress Paula Lane, a Marilyn Monroe look-alike, was sitting in the audience at a benefit at Bughouse Square in Chicago. She was waiting to go on stage when she spied Jack Lenahan.

Colonel H. Harding Isaacson attended the Debutante Ball in New York City. He had gone to 150 such affairs and, when asked why, he replied, "I like young girls."

PAT CROWE, NEWS-JOURNAL CO., WILMINGTON, DEL.

With determined grace, Sister JoEllen starts a lawn mower. She mowed the grounds around a retreat of an Anglican order of women, the Sisters of St. Margaret, in Duxbury, Mass.

Necks craned at a Veterans Day ceremony in Norfolk, Va. A colonel had suddenly dropped to his knees, then fired a salute with a toy cannon.

Jerome Chagaris, 9, needed to call a friend but was too short to reach the coin slot. He climbed into the booth and stayed for the entire call. Photographer Michael Asher was cruising in his press car, screeched to a halt, grabbed his camera and shot a roll of film. After the picture appeared, a government agency dealing with obstacles for the handicapped requested a copy.

Anthony Zollos of Cleveland knew how to phone from a car and relax at the same time. Returning from a baseball game, photographer Mark Duncan passed, turned around, parked nearby and snuck around behind his car. Taking the picture was no problem. The man was "totally engrossed in the conversation."

SECOND PLACE NEWSPAPER FEATURE PICTURE STORY, JOSEPH W. RIMKUS, JR., MIAMI HERALD (ALL PHOTOS)

Chester Ervin, 4, was skeptical about the benefits of a higher education. He peered apprehensively into the classroom at the Devonaire Elementary School in Miami. His kindergarten teacher, Maria Francis, spotted him and he hid. She discovered his hiding place and reached for him. Chester fled, but she caught him. He struggled and was introduced to his classmates anyway.

Shakespeare wrote the scenario in 1594. Carol Guzy captured it with a camera in 1981.

"A withered hermit five-score winters worn might shake off fifty, looking in her eye ... "

Until, of course, "Some carry-tale, some please-man, some slight zany ... that smiles his cheek in years and knows the trick to make my lady laugh when she's disposed." "Love's Labour's Lost" IV.iii.

"Old Joe" didn't trust reporters and wouldn't give Carol Guzy his name. After the picture ran in the Miami Herald, he wrote her a letter thanking her and explaining how he'd "travelled across the country on a shoestring budget."

HONORABLE MENTION NEWSPAPER FEATURE PICTURE STORY, CAROL GUZY, MIAMI HERALD (ALL PHOTOS)

Bob King was out cruising for a feature picture when he found Lorne Gradine puffing his cigar and Ross O'Gray his pipe. The two were longtime roommates at Residential Services, Inc., a home for the multiple-handicapped in Duluth, Minn. They liked to get outside whenever possible for a smoke and a chat.

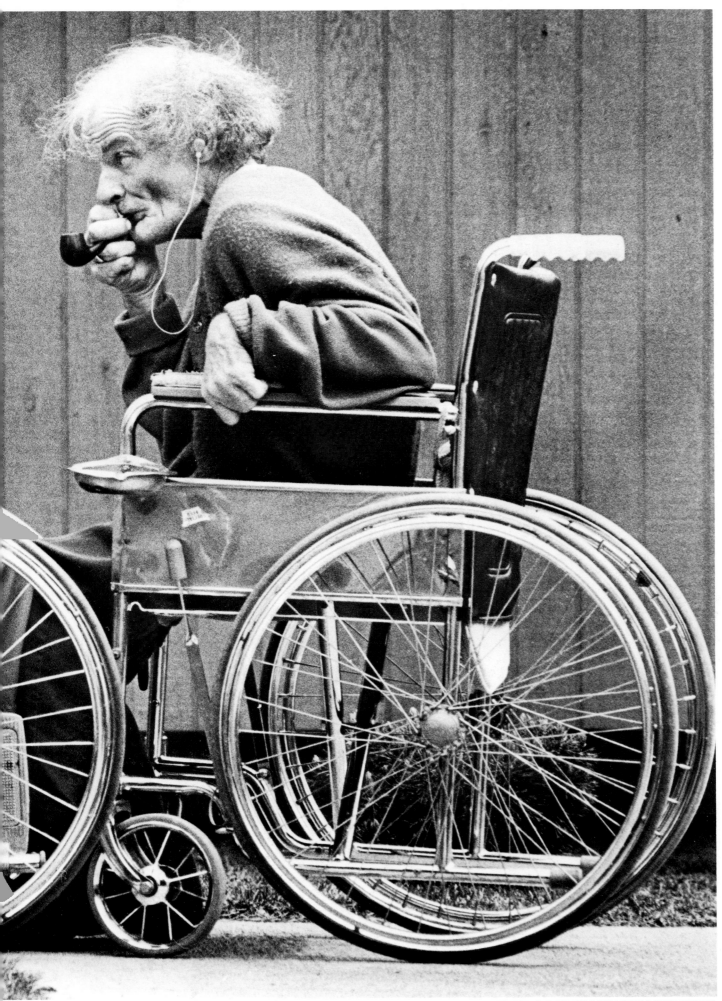

HONORABLE MENTION NEWSPAPER FEATURE PICTURE, BOB KING, DULUTH (MINN.) HERALD/NEWS TRIBUNE

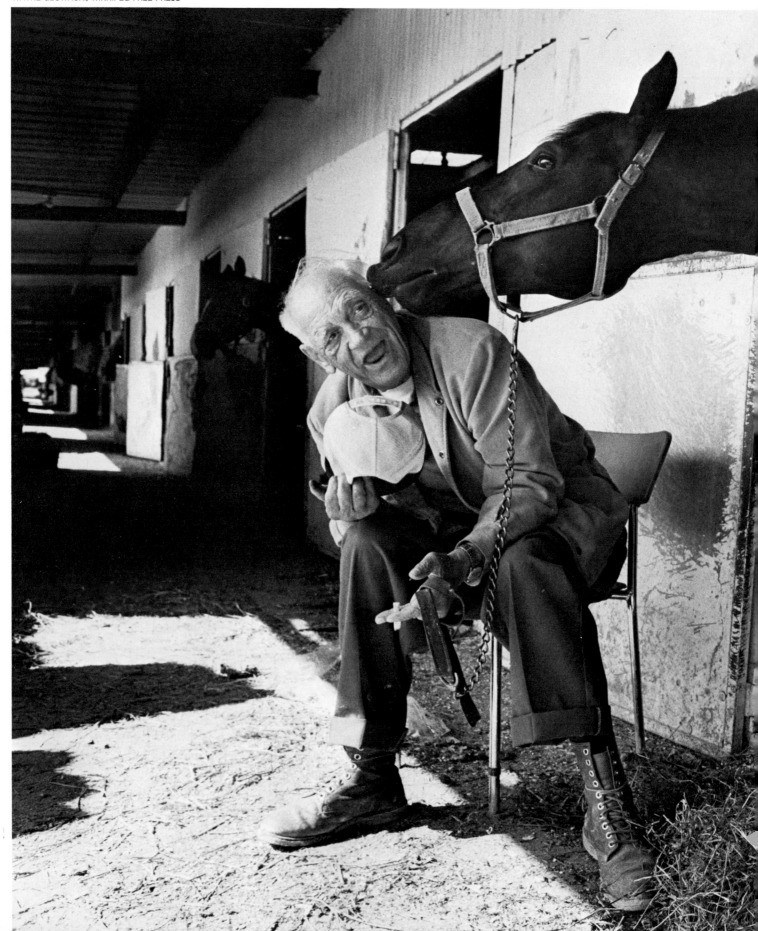

On the campaign trail, Mayor Ed Koch of New York City traded a kiss for a cookie and possible vote.

When Art "Smokey" Evans dropped by to visit his old friend, Nice Hound, at Winnipeg's Assiniboia Downs, the horse was wearing turbulator boots. The boots operate like miniature whirlpool baths and reduce swelling and inflammation in a horse's ankles. Wayne Glowacki was waiting for a horse trainer when Nice Hound gave Smokey a "juicy nuzzle."

243

James Barclay, 93, gave Ottilia Luttenberger, 95, a kiss after they were named the oldest man and woman at the Michigan State Fair. "I didn't expect all this today," Ottilia said. The fellow Detroiters were strangers before they met on Senior Citizens Day at the fair.

Kelly Lucas greeted her husband, Tony, aboard the destroyer Caron and found a quiet place aft to get reacquainted. The Caron, part of the Atlantic Fleet Naval Surface Force, had docked in Norfolk, Va., after completing a six month tour with the 6th Fleet. It was Bill Ballenberg's first coverage of a homecoming.

CARLOS OSORIO, THE DALLAS MORNING NEWS

The homecoming celebration at the Dallas-Fort Worth Airport ended and a dazed ex-Iranian hostage, Johnny McKeel, was led to the car that would take him back home to Balch Springs. A boy gave him a flag and he got in the car. He waved it mechanically while waiting for his mother — oblivious to the flashbulbs of Carlos Osorio and the other photographers.

The Winners:
39th Pictures of the Year

GARY FANDEL, COLUMBIA MISSOURIAN

Dan Dry, Harry Benson and Gordon Baer received cameras, trophies and cash on Photo Day during the Journalism Week festivities at the University of Missouri School of Journalism - Columbia, April 14, 1982.

Newspaper Photographer of the Year

Dan Dry, Courier-Journal & Louisville Times
Runner-up: Brad Gaverson, The Daily Breeze, Torrance, Calif.
Third place: Gary Parker, Florida Times-Union &
 Jacksonville Journal

Magazine Photographer of the Year

Harry Benson, LIFE
Runner-up: Kevin Fleming, National Geographic
Third Place: Neil Leifer, TIME

World Understanding Award

Gordon Baer, Freelance,
 "Vietnam: The battle comes home"
Judges' special recognition: Kent Kobersteen, Minneapolis
 Tribune, "Global poverty/The darkening future"

the winners:

Newspaper Division

Spot News

First - Don Rypka, United Press International,
"Reagan — target"
Second - Photographer anonymous, Associated Press,
"Assassin at work"
Third - Tim Rivers, Ft. Lauderdale News/Sun Sentinel,
"Haitians drown off Hillsboro beach"
Honorable Mention - Mike Valeri, New Bedford. (Mass.)-
Standard Times
"Resisting Arrest"
Honorable Mention - Ron Edmonds, Associated Press,
"The moment"

General News or Documentary

First - Barbara Laing, The Post, Athens (Ohio),
"Hostage homecoming"
Second - Wayne Scarberry, Roanoke (Va.) Times & World
News, "Opposite directions"
Third - John H. Sheally, II, Virginian Pilot/Ledger-Star,
(Norfolk) "Big brass blast"

Feature Picture

First - Owen Stayner, Herald Journal, Logan, (Utah),
"The wedding banquet"
Second - Rachel Ritchie, Providence (R.I.) Journal,
"That drive-in religion"
Third - Mary Schroeder, Detroit Free Press,
"My new friend"
Honorable Mention - John J. Gaps, III, Freelance - Iowa
State Daily, "The game must go on"
Honorable Mention - Bill Greene, Patriot Ledger, Quincy
(Mass.), "Determination"
Honorable Mention - Bob King, Duluth (Minn.)
Herald/News Tribune, "A smoke and a chat"

Sports Action

First - John E. Hall, Dallas Times Herald, "Goal tending"
Second - Dan Peak, Kansas City Star, "Rolled over"
Third - Michael Rondou, Long Beach (Calif.) Press
Telegram, "10 K to go"

Sports Feature

First - Stephen Crowley, Palm Beach Post & Times,
"Tired boxer"
Second - Dick Van Halsema Jr., Sedalia (Mo.), Democrat,
"Locker room let-down"
Third - Betty Tichich, Houston Post,
"Sugar Ray Leonard does a flip"

Sports Feature

Honorable Mention - Eric Mencher, St. Petersburg Times &
Evening Independent,
"Coach berates Little League player"
Honorable Mention - William Hodge, Long Beach (Calif.)
Press Telegram, "Hi, mom"
Honorable Mention - Mark Graham, Denton (Texas)
Record-Chronicle, "Diving team?"

Portrait/Personality

First - John Sheckler, New Bedford (Mass.) Standard
Times, "His father's eyes"
Second - Randy Eli Grothe, Dallas Morning News, "Gallery
owner Don Vogel & 'Nana'"
Third - Jack W. Shaeffer, Arizona Daily Star, (Tucson)
"The Goldwater scowl"
Honorable Mention - Judy Griesedieck, Hartford Courant,
"Twins in pastel room"

Pictorial

First - Gary Parker, Florida Times-Union & Jacksonville
Journal, "Foggy sunrise over golf course"
Second - Doug Milner, Dallas Times Herald,
"An 'up to the rain' feature"
Third - Nuri Vallbona, Colorado Springs Sun, "City hall A.M."
Honorable Mention - Gary Parker, Florida Times-Union &
Jacksonville Journal, "Seagull flying past rusted-out ship"
Honorable Mention - Richard Derk, Chicago Sun-Times,
"Winter's last dusting of snow"

Food Illustration

First - Gary Parker, Florida Times-Union & Jacksonville
Journal, "Cioppino"
Second - Barry Wong, Seattle Times, "Peaches"
Third - Barry Wong, Seattle Times, "School lunch"
Honorable Mention - Kim Smith, Fort Myers (Fla.)
News Press, "Soup and pasta"

Fashion Illustration

First - Bob Fila, Chicago Tribune, "Brrr"
Second - Steve Dozier, Miami Herald, "Floating swimsuit"
Third - John C. Best, Abilene (Texas) Reporter-News,
"Reflections of Spring"
Honorable Mention - Natalie Fobes, Seattle Times,
"Contours"
Honorable Mention - John Collier, Detroit Free Press,
"Paint"
Honorable Mention - Michael Bryant, San Jose Mercury
News, "Lazy days in style"

Magazine Division

Editorial Illustration

First - Sarah Leen, Columbia (Mo.) Daily Tribune,
"The new patriotism"
Second - Kevin Higley, Gannett Rochester Newspapers,
"Alternative medicine"
Third - Michael Coers, Courier-Journal & Louisville Times,
"Hydroponics"
Honorable Mention - Acey Harper Fort Myers (Fla.)
Newspress, "Pac maniac"

News Picture Story

First - Tommy Price, Richmond (Va.) Newspapers,
"Return of the hostages"
Second - Ron Edmonds, Associated Press,
"A sad day in March"
Third - Richard Derk, Chicago Sun-Times,
"Because it's there"
Honorable Mention - Durell Hall, Jr., Courier-Journal &
Louisville Times, "City of sorrow . . . Atlanta"
Honorable Mention - Edward Noble, Oakland Press, Pontiac
(Mich.), "Rescued to die"

Feature Picture Story

First - Theresa Aubin, Bremerton (Wash.) Sun,
"Paula Thompson: A battle lost"
Second - Joseph W. Rimkus, Jr., Miami Herald,
"The first day of school"
Third - James Baird, Times-Advocate, Escondido (Calif.),
"Making marines"
Honorable Mention - Carol Guzy, Miami Herald, "Old Joe"
Honorable Mention - Bob Modersohn, Des Moines Register,
"Damn pick-ups"

Sports Picture Story

First - April Saul, Philadelphia Inquirer, "Women's rugby"
Second - Fred Barnes, Grand Rapids (Mich.) Press,
"The camp of dust and blisters"
Third - Richard Murphy, Jackson Hole (Wyo.) News,
"Horse racing: Jackson Hole style"

News Or Documentary

First - Makram Gadel Karim, Gamma-Liaison for Time,
"The assassination of Anwar Sadat"
Second - Ian Berry, Magum for LIFE, "Royal wedding"
Third - Jake Rajs, LIFE, "Hostage parade"
Honorable Mention - David Alan Harvey, National
Geographic, "Cambodia train"
Honorable Mention - Olivier Rebbot, Newsweek,
"Death in El Salvador"
Honorable Mention - George Clark, Atlanta Constitution &
Journal/LIFE, "Atlanta murders"

Feature Picture

First - Matthew Naythons, Gamma-Liaison for Time,
"City dwellers"
Second - Jose Azel, Freelance for GEO, "Cubano"
Third - Rebecca Collette, GEO, "Women in military"

Sports Picture

First - Dirck Halstead, Time,
"Leonard vs Hearns title fight"
Second - Walter Schmitz, GEO, "Mud bike"
Third - Shelly Katz, Black Star for Inside Sports,
"Countdown to Showdown"

Portrait/Personality

First - Robert Azzi, Woodfin Camp & Associates,
"Sadat and Sinai"
Second - Thomas Hopeker, GEO, "Kyoto girl"
Third - David H. Kennerly, Time,
"Secretary of State A. Haig"

Pictorial

First - Jose Azel, Freelance for GEO, "Working out"
Second - Robert Caputo, National Geographic,
"Grinding flour in Lafon"
Third - David Doubilet, National Geographic,
"Kayangel atoll"
Honorable Mention - Jebb Harris, Courier-Journal Sunday
Magazine, (Louisville) "Dawn on the big south fork"
Honorable Mention - David Alan Harvey, National
Geographic, "Warm wool"
Honorable Mention - James L. Stanfield, National
Geographic, "Victoria Falls, Zimbabwe"

the winners:

Magazine Division cont.

Science/Natural History

First - Reinhard Kuenkel, GEO, "Zebra"
Second - David Doubilet, National Geographic,
 "Shark egg case"
Third - Joseph McNally, Discover, "Space tile"
Honorable Mention - Stephen J. Krasemann,
 "Mountain lion drinking"
Honorable Mention - David Doubilet, National Geographic,
 "Whale shark"

Published Picture Story

First - Bruno Barbey, LIFE, "Poland"
Second - Jose Azel, Freelance for GEO, "Dade county"
Third - Wendy V. Watriss, Freelance for LIFE,
 "Agent orange"

Self-Edited Picture Story

First - Kevin Fleming, National Geographic,
 "An act of infamy"
Second - Stephen Shames, Outline Press,
 "Child prostitute"
Third - Harald Sund, Freelance for LIFE,
 "America the dry"
Honorable Mention - Bill Pierce, TIME,
 "Children of war, Northern Ireland"

Editing Awards

Newspaper Picture Editor
 Bert Fox, Medford (Ore.) Mail Tribune
 Judges' special recognition: David M. Yarnold, San Jose
 Mercury News

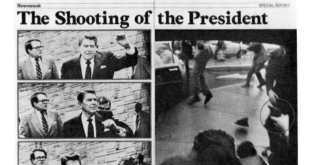

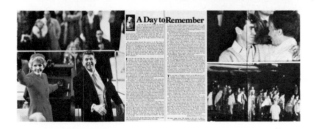

Magazine Picture Editor
 Jim Kenney, Newsweek
 Judges's special recognition; Susan Waters,
 Louisiana Life

Newspaper-Magazine Picture Editor
 James Noel Smith, Westward, Dallas Times Herald

Best Use of Photographs by a Magazine
GEO

Best Use of Photographs by a Newspaper
The Virginian-Pilot,
Norfolk (Va.)

Published Newspaper Picture Story - Self Produced

SELF-PRODUCED PICTURE STORY, FIRST PLACE, TOM REESE, COLUMBIA MISSOURIAN

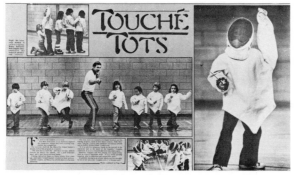

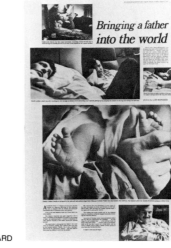

SELF-PRODUCED PICTURE STORY, SECOND PLACE, JOHN METZGER, ITHACA JOURNAL

SELF-PRODUCED PICTURE STORY, THIRD PLACE, LORI BORGMAN, EUGENE REGISTER GUARD

BILL KUYKENDALL

THOMAS HOEPKER

GEORGE LOCKWOOD

Judging the 39th POY
*The panel selected 111 entries
as winners in the 1981 competition*

Six judges at the 39th Pictures of the Year competition held at the University of Missouri-Columbia campus February 1-3, lauded and questioned the entries from 1,259 photographers. Of those considered, 295 pictures are included in this volume, representing the work of 159 photographers including the winners.

The judges were Woodfin Camp, director of Woodfin Camp & Associates picture agency;

John Dominis, freelance photographer and former LIFE photographer and picture editor for PEOPLE and SPORTS ILLUSTRATED; James Gordon, editor of News Photographer magazine and professor of photojournalism at Bowling Green (Ohio) State University; Thomas Hoepker, freelance photographer and former executive editor of GEO magazine; Bill Kuykendall, owner/photographer of First Light Productions and freelance for corporate and industrial publications; and George Lockwood, assistant managing editor of the Milwaukee Journal.

Two panels of three judges each reviewed the entries in the preliminary rounds then came together to select final winners. That division

Review and discussion in final rounds ..

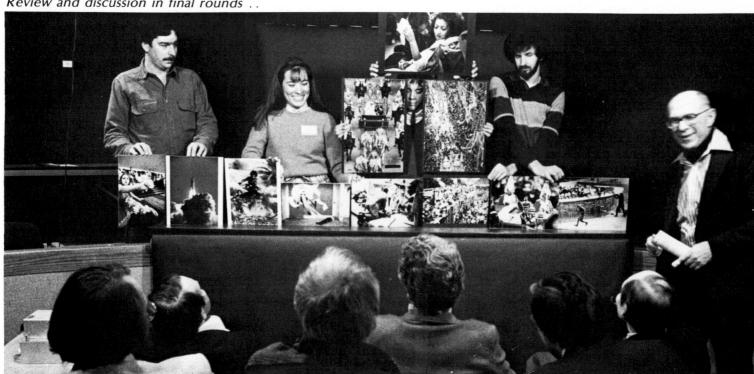

PORTRAITS: KIM FOWLER, COLUMBIA MISSOURIAN

JOHN DOMINIS

WOODFIN CAMP

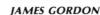

JAMES GORDON

of responsibility speeded up the judging but the process still required three and one half days for viewing the nearly 15,000 single pictures. Another change for 1981 was the elimination of the three-board story presentation. Entrants could submit up to six single boards. The changes gave photographers an opportunity to submit longer stories.

Paula Nelson, an undergraduate student of photojournalism at UMC coordinated the contest details and supervised the work of student volunteers, 50 of whom flipped, carted, sorted and catalogued pictures. It is the willing labor of journalism students at UMC which guarantees the smooth and

efficient handling of the Pictures of the Year competition.

The POY competition was directed by Professor Angus McDougall of the University of Missouri-Columbia.

The POY competition, on which this book is based, is jointly sponsored by the University of Missouri School of Journalism, the National Press Photographers Association and is financed by a grant to the University from Nikon, Inc. The awards distributed on Photo Day during Journalism Week in April, total $12,000 in cash, and include Nikon cameras and University Columns trophies as well as plaques and certificates for the winners.

The vote is serious business.

Index to photographers

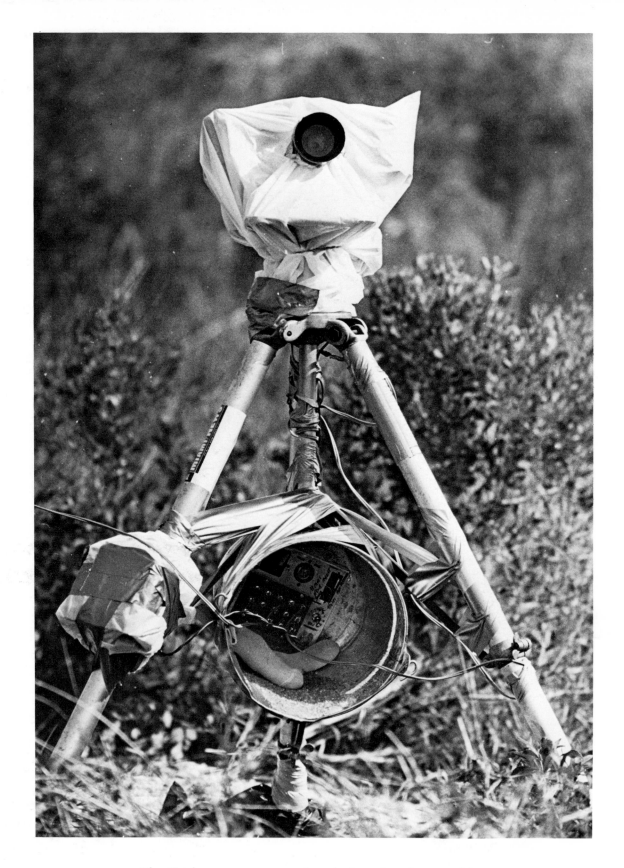

The Bucket ... a contraption designed and created by Miami News photographers to capture the dramatic shot of the space shuttle, Columbia. (pages 146-147) Chief Photographer Charles Trainor and his crew of inventors combined a tripod, a home-built circuit board, a standard mop bucket, some baby socks to hold the silicate gelatin packed around the electrical connections, and a non-automatic camera for which the proper exposure had to be estimated 24 hours before lift-off. "We learned a lot," said Trainor. What he meant was that for the second shot, the Miami News team took two models of "The Bucket." The result was a full color display in LIFE's Pictures of the Year issue as well as what is published here in the color section of the best of Photojournalism/7.